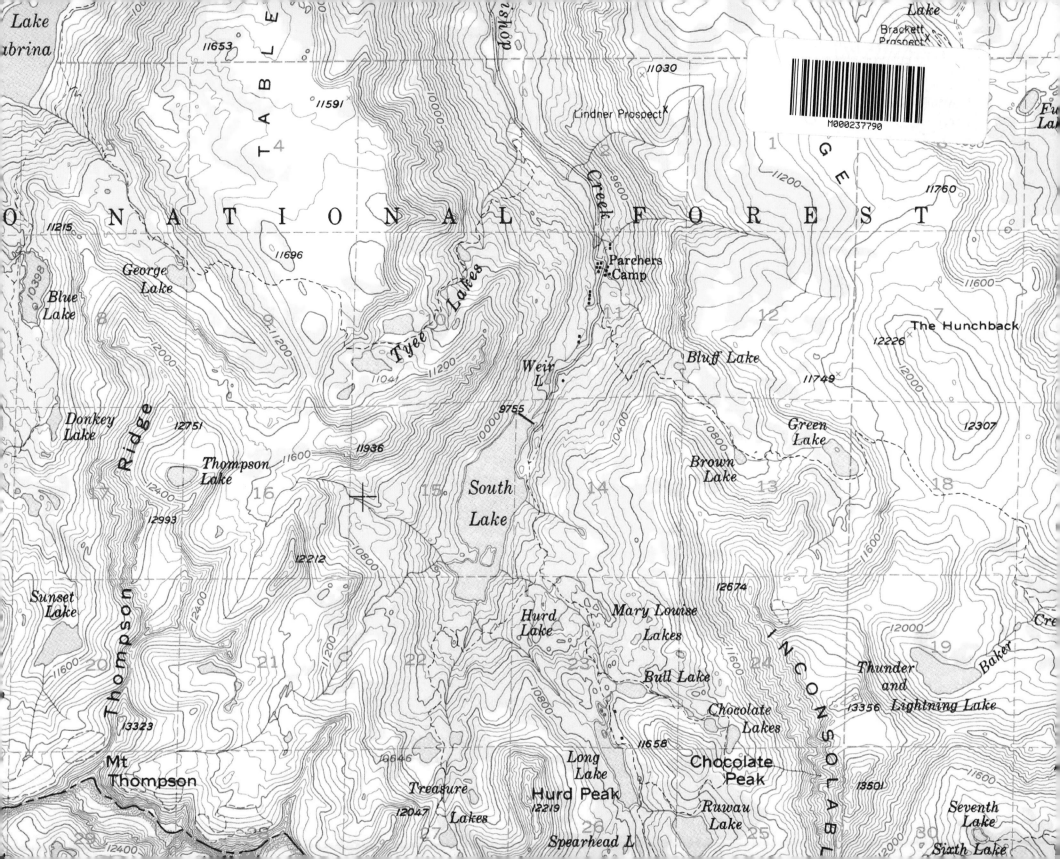

Fred Weyman

HIGH SIERRA
THE RANGE OF LIGHT

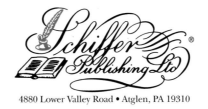

Schiffer Publishing Ltd®

4880 Lower Valley Road • Atglen, PA 19310

Topographic maps courtesy of the US Geologic Survey
Type set in Trajan Pro/Museo/Avenir LT Std

ISBN: 978-0-7643-5344-4
Printed in China

Published by Schiffer Publishing, Ltd.
4880 Lower Valley Road
Atglen, PA 19310
Phone: (610) 593-1777; Fax: (610) 593-2002
E-mail: Info@schifferbooks.com
Web: www.schifferbooks.com

For our complete selection of fine books on this and related subjects,
please visit our website at www.schifferbooks.com. You may also write for a free catalog.

Schiffer Publishing's titles are available at special discounts for bulk purchases for sales promotions or premiums. Special editions, including personalized covers, corporate imprints, and excerpts, can be created in large quantities for special needs. For more information, contact the publisher.

We are always looking for people to write books on new and related subjects.
If you have an idea for a book, please contact us at proposals@schifferbooks.com.

To my mother, Trine-Liv (Stensrud) Weyman,
who described her experience in the mountains of her Norwegian homeland,
"If there is a God, you are closest to God in the mountains."

10/14/18

Dear Christy

Happy Birthday! I hope this
book brings you inspiration and
further pursuits and adventures in
the mountains... for many years
to come. Love Guy, Hauna, Gabriel, Teah & Matteo

CONTENTS

FOREWORD

As nineteenth century artists and photographers encountered California's Sierra Nevada—what John Muir dubbed the "Range of Light"—they were impelled to capture and share its montane beauty. Their work played a central role in the push to protect the range's rugged peaks, deep valleys, and ancient forests.

Subsequent legislation—from the 1864 Yosemite Grant Act to the 1916 creation of the National Park Service and the 1964 Wilderness Act—carved out oases of natural splendor in the Sierra and across the nation. Yet the protections embedded in those acts can only go so far. Those of us who cherish our national parks and wilderness areas bear a responsibility to respect and steward them as best we can.

Today, as in the 1800s, photos like the ones contained in this collection continue the legacy of art as inspiration for the preservation of our public lands. Fred Weyman's photos, captured over years of work and play in the Sierra, can both inspire those who have never set foot in the Range of Light and evoke deep-rooted memories for those intimately familiar with these mountains.

The Weyman photo that first caught my eye shows the view from Mercur Peak, in Yosemite's northwestern corner, across Cherry Creek Canyon into the Emigrant Wilderness (p 33). It is far from a typical Yosemite scene—no Half Dome, no El Capitan, no giant sequoias. Gazing at the primeval landscape calls to mind Muir's "benevolent, solemn, fateful mountains," and leaves you awash in a sense of history. This place existed eons before we walked the earth. The boundaries drawn around our parks and wildernesses are mere blips in their life spans. These photos blur such borders and remind us that actions taken in Yosemite, or in Emigrant, or in our own backyards extend beyond human made map lines.

Throughout this collection Weyman emphasizes the processes that have shaped the Sierra, telling the scientific story behind the beauty. He draws us into the present, documenting lakes that are transitioning into meadows, and inspires us to look ahead to the future. Tectonic shifts, flowing glaciers, and fierce storms have sculpted these mountains. What marks will we leave?

As Yosemite National Park's primary philanthropic partner, Yosemite Conservancy supports research that enhances our understanding of Sierra landscapes, water, and wildlife; restoration work that balances ecological protection with accessibility; and youth programs that inspire a new generation to fall in love with the mountains. Groups working in Sequoia and Kings Canyon National Parks, at Lake Tahoe, and throughout the surrounding wilderness areas are similarly dedicated to preserving, studying, and stewarding our public lands. Together, we work to ensure the Range of Light remains a haven of beauty and biodiversity, and stays true to Muir's description of his favorite mountains as at once "extremely rugged" and "hospitable."

The fate of this western wilderness, and the ability of future generations to experience the humbling sense of standing on Mercur Peak, or at the edge of an unnamed alpine lake, lies with all of us. As you dive into this collection, I hope you will be drawn into the landscape, into the stories of natural and human forces that have shaped the scenery, and emerge inspired to play a part in protecting this singular place.

Frank Dean
President and CEO, Yosemite Conservancy

Yosemite Conservancy thanks Fred Weyman for generously donating a portion of proceeds from this book to support efforts to preserve and protect Yosemite National Park. To learn more about the Conservancy visit yosemiteconservancy.org.

INTRODUCTION

"The mighty Sierra, miles in height, and so gloriously colored and so radiant, it seemed not clothed with light but wholly composed of it, like the wall of some celestial city, surely the brightest and best of all the Lord has built." – John Muir

There are usually many hours of scenic splendor, hard physical labor, and anticipation while hiking to a high Sierra pass from a low east side trailhead, and Paiute Pass, although relatively easy, is no exception. Inspiration from the scenery replaces expended energy, producing a fatigued euphoria at the top. Upon my arrival at the pass an elderly woman stood amid a group of weary younger people sprawled on the surrounding rocks. Marveling at the long awaited scene on the west side of the pass, "Wow!" was about all I could manage to say as I stopped next to her. With a thick Germanic accent she immediately replied, "These are the most beautiful mountains in the world." In our discussion that followed the Belgian lady listed an extensive set of alpine treks she had made on every continent. Her relaxed presence in her tired group gave her words admirable credibility. She had seen more mountain ranges than the well-traveled Muir and they reached the same conclusion.

The sources of the Sierra's unique beauty begin with geology and incorporate elements of its geography, meteorology, glaciology, and biology. The geologic history of the Sierra Nevada is complex, not completely understood, and the subject of ongoing research. Throughout the history of the range, and even before the mountains started to rise many years ago, geologic processes were setting the stage for future allure. Although the Sierra is known for its light colored granite, there are several places where other rock types play a role. Prior to any uplifting, much of what is now western North America was submerged under a shallow part of the Pacific Ocean and, over millions of years, accumulated eroded sediments several kilometers thick from the adjacent mainland. In some places cyclical variation in water depth and corresponding oxygen levels during sedimentation produced alternating red, iron rich layers and white iron poor layers. Although most of these sediments have been eroded away, remnants are scattered throughout the range, providing colorful highlights on light and dark rocks. In the Convict and McGee Creek basins these ancient sediments, the oldest rocks in the Sierra, dominate the landscape and have been metamorphosed, twisted, and contorted into strikingly beautiful formations.

John Muir recognized that the granite was the source of much of the Sierra's uniqueness and beauty when he said, "Then it seemed to me that the Sierra should be called, not the Nevada or Snowy Range, but the Range of Light." Light colored rock not only has its own radiant quality, but like the pale trunks of birches, beeches, and sycamores reflect the colors around them, it provides a blank canvas on which ambient light can paint.

The story of the Sierra's light granite begins when the range began to rise about 120 million years ago when the western edge of the North American Plate collided with the Farallon Plate. Due to its higher density the Farallon Plate slid beneath the North American Plate, forming a classic subduction zone similar to those currently found around the Pacific Rim of Fire. As the Farallon Plate descended it heated and liquefied into magma plutons that intruded the overlying North American Plate. Some of this magma, especially in the northern part of the range, reached the surface, forming volcanoes and lava flows. During the next forty million years hundreds of plutons slowly cooled and solidified two to four miles beneath the surface, forming a large solid batholith of granitic rock. These plutons varied in chemical and mineral composition. Those with higher concentrations of quartz, the most common mineral in all of them, were the lightest in color. They were also the most recently implanted and solidified farther east than the earlier, darker, western granites.

Over the next seventy million years erosion removed much of the material that was above the batholith, but it took one more geologic step to get these lighter granites to form the highest peaks on the crest of the range. Still continuing today, this process began approximately ten million years ago when complex, incompletely understood forces pushed the eastern part of the batholith upward, causing the crust to fracture at the Owens Valley fault on the eastern edge of the range. This fault occurred in the ideal spot to put the lightest of the granites at the Sierra crest in many places, especially in the south. Had it occurred farther east or west the highest peaks would have been formed from darker rocks.

The Owens Valley fault caused the Sierra to become a separate block of crust with its western edge anchored in California's Central Valley, while the eastern edge rose about 7,000 feet. This created the range's tilted profile with a gentle western slope and steep eastern slope. In contrast to older mountain ranges, this rapid and recent uplift gives the Sierra peaks their steep, rugged character, lively cascading streams, and young lakes that have not yet filled with sediments.

The deep batholith was also responsible for the Sierra's most iconic feature, Half Dome, as well as the other numerous domes and similar exfoliating structures. The deep granite formed under great pressure from the overlying material. The depth also caused the intruding magma to cool slowly, forming granite with a uniform structure and without many internal fractures. As the confining pressure was reduced by surface erosion the granite expanded, causing sheets of rock to fracture off like the layers of an onion, a process that continues today.

The next process that shaped the Sierra's beauty was glaciation. Between two and half million and ten thousand years ago four major glaciations occurred in the Sierra Nevada. These glaciers—up to 4,000 feet thick—sculpted everything they touched into "all kinds of fanciful forms for the sake of beauty" (John Muir). Located on the leading edge of the continent next to the vastest body of water on the planet, the Sierra was perfectly geographically situated to wring moisture from Pacific storms and create large thick glaciers.

Dramatic waterfalls are a key component of the Sierra's charm, especially in Yosemite Valley. In most cases these features owe their existence to the hanging valleys created by the huge glaciers that scoured the range. Since large heavy glaciers deepen valleys faster than their smaller tributaries, high waterfalls result when the glaciers melt, leaving the tributary's valley terminating high above the main valley's floor.

Glaciers were also responsible for the thousands of Sierra lakes that Muir recognized as being a primary element of the range's attractiveness: "Among the many unlooked-for treasures that are bound up in the Sierra solitude, none more surely charm and surprise all kinds of travelers than the glacier lakes." Three glacial processes created lakes. Most Sierra lakes were formed when glaciers scooped out lake basins from softer sections of bedrock before riding over harder, more resistant bedrock downstream. A few lakes, such as the one that previously filled Yosemite Valley, were formed behind dams of terminal and recessional glacial moraines. Kettle lakes were formed on flat

areas when heavy chunks of ice separated from retreating glaciers and formed shallow lake basins by compressing the underlying material.

Although the Sierra is known for its soaring vertical cliffs, steep spires, and jagged peaks, at several places the glaciers created areas of contrasting tranquil terrain that provide the hiker with physical and visual relief from the lengthy tiring ascents and pounding descents. Along with all the smoothed glacial valleys throughout the range, the notable broader flats include Hope Valley, just south of Lake Tahoe; Tuolumne Meadows in Yosemite; Humphries Basin and French Creek plateau in the John Muir Wilderness; Upper Basin in Kings Canyon National Park; and Tyndall and Bighorn Plateaus in Sequoia National Park.

The Sierra's distinctive climate contributes to its visual appeal in a number of ways. Areas above 6,000 feet get very little rain, with most precipitation falling as snow during winter and early spring. The summer months are warm and dry, with low humidity. This lack of moisture during the growing season results in an open and transparent forest with little undergrowth. Long sight lines and easy off-trail hiking add pleasure to travel in the high country. Occasional forest fires contribute to this effect by removing underbrush but sparing the larger trees.

The sparse rain that minimizes erosion and runoff helps preserve the clarity of scenic lakes and greatly slows their conversion to scenic meadows. All Sierra lakes are gradually being filled with sediments and there are many examples of lakes that are midway between open water and meadows. A lake's volume, altitude, basin size, and proximity to sediment catching upstream lakes are all factors that determine how quickly it is converted to a meadow.

Faced with the Sierra's beauty, my photographic impulse on my first Sierra hike was to reveal it to people who were unlikely to ever experience it: my family in Pennsylvania, friends in many places, and even Californians who have never even been to a trailhead, much less hiked away from one. In all my other trips the goal never really changed; to find scenes that draw in the viewer like I was drawn in and convey what it is like to stand in these mountains so engulfed in scenery that it is often difficult to choose which direction to look. I could have written more eloquent and evocative descriptions of the beauty and my personal responses to the Sierra experience, but I have intentionally avoided this to not bias or restrict viewers' reactions.

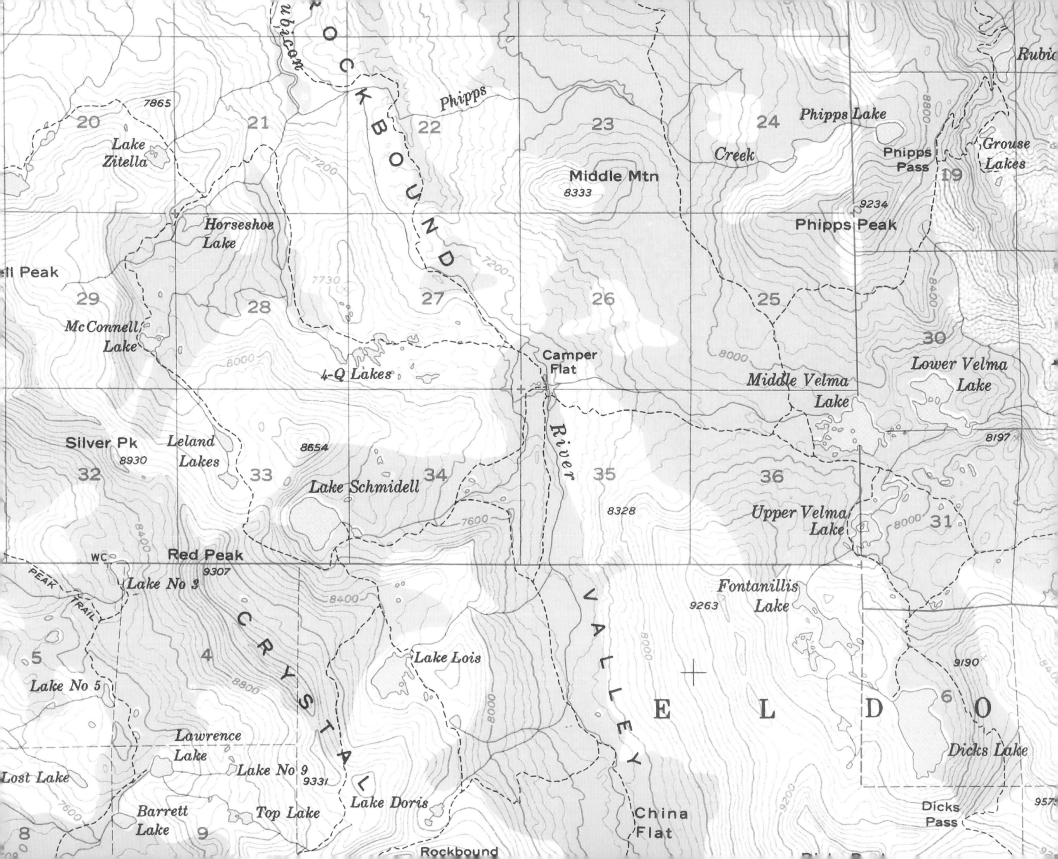

LAKE TAHOE AREA

"The water is clearer than the air, and the air is the air the angels breathed." – Mark Twain

The geology of the northern Sierra differs slightly from farther south in the range. Here much of the surface consists of lava that flowed from fissures and peaks, covering large areas. Although most of the region's lakes were created by glaciers, Lake Tahoe was primarily created when two faults running north-south—one on either side of the lake—allowed mountains to rise above the Tahoe basin. Lava flowing from Mt. Pluto on the northern shore dammed the Truckee River, the basin's outlet stream, and created the lake. Subsequent glacial action created Emerald Bay and reshaped parts of the lake's western shoreline.

Lake Tahoe Rock Garden

"Thus every attempt to appreciate
any one feature is beaten down
by the overwhelming influence
of all the others." – John Muir

Several years after my most recent Sierra trip I discovered this John Muir quotation that perfectly described one aspect of my approach to creating representative Sierra images. There are innumerable enchanting individual objects worthy of being the sole subject of a portrait, such as this lichen laden rock, but without context the viewer gets a mischaracterized and diminished Sierra experience of being surrounded by attractive elements.

This rock garden sits just below Herlan Peak (8,840 ft.), more than 2,600 feet above Lake Tahoe's northeast corner. The Flume Trail traverses the slope about 1,000 vertical feet below this peak. Much of the distant haze just above the lake is smoke from the previous evening's Fourth of July fireworks at South Lake Tahoe trapped by an inversion layer in the basin.

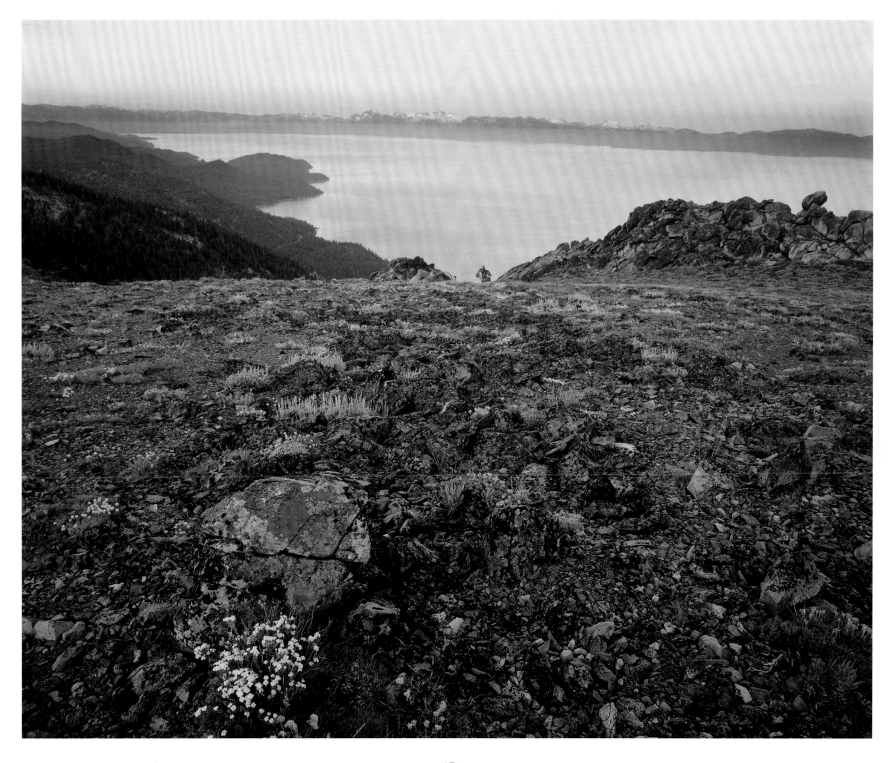

Sand Point, Lake Tahoe
The foreground in this photo was a compromise between what I wanted to include and exclude and where I could stand on the scattered rocks.

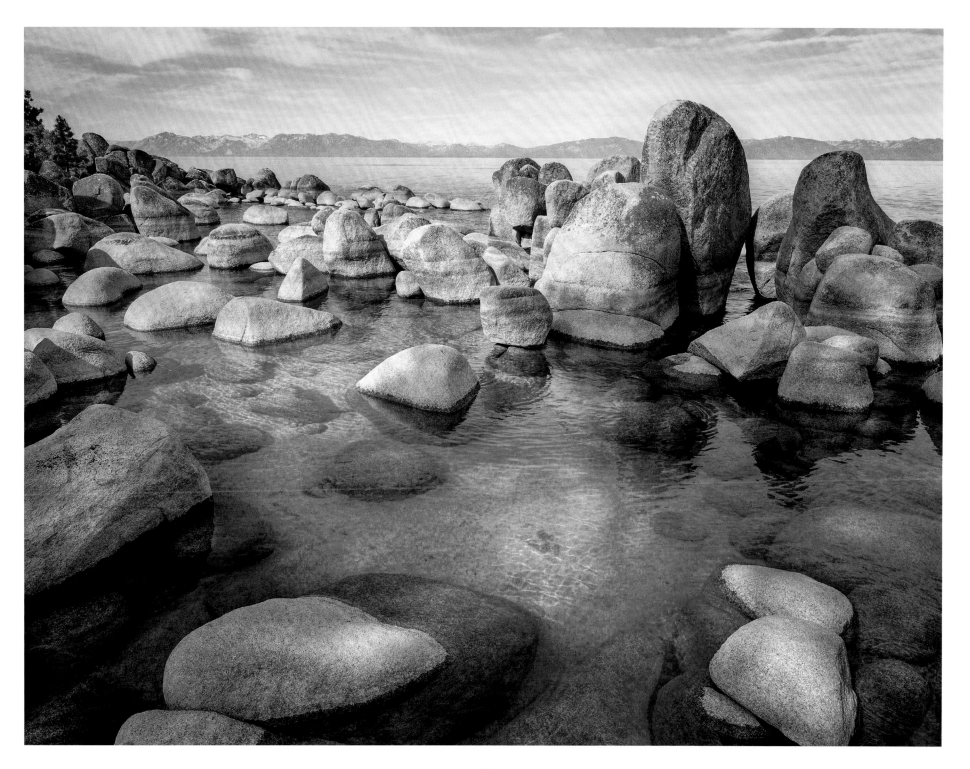

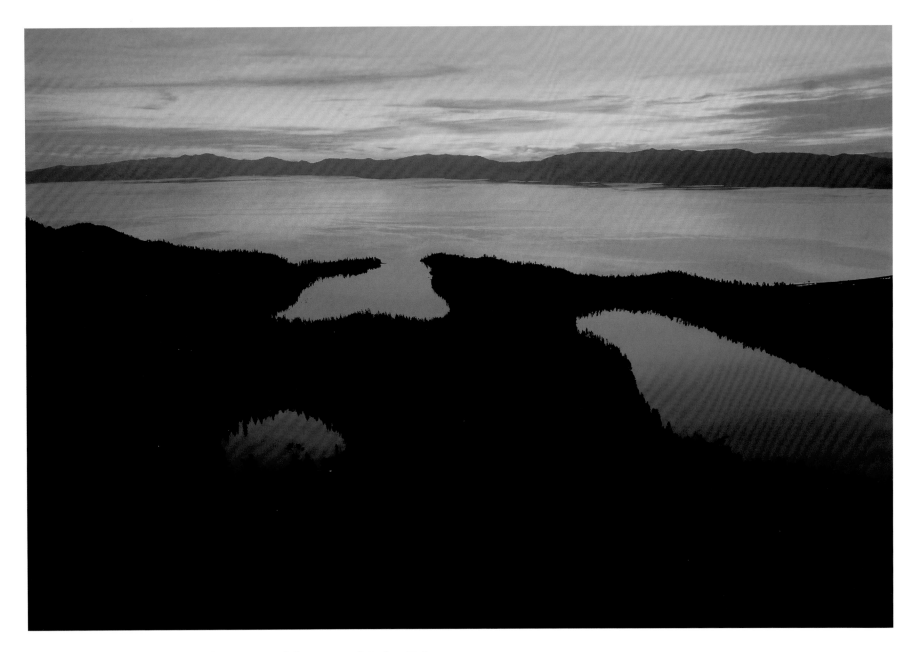

Granite Lake, Cascade Lake, Emerald Bay, and Lake Tahoe
The first light of the morning following the sunset on the right.

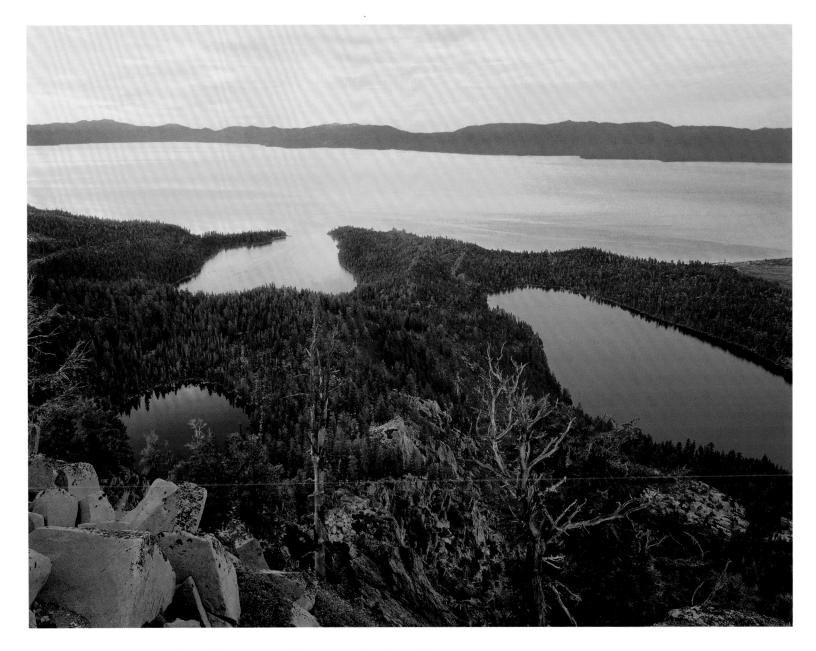

Granite Lake, Cascade Lake, Emerald Bay, and Lake Tahoe

As soon as I "saw" the view from the southernmost of Maggies Peaks (8,700 ft.) on the topo map I had a feeling it would be dramatic. The short, steep (about two miles, with 1,700 ft. of elevation gain), and very scenic hike yields this fine view of Lake Tahoe and nearby glacial lakes. I waited for a day when the weather satellites showed a persistent light band of clouds over the area and was treated to this wonderful summer sunset.

A "continuum of depth" is how a friend described the eye-leading feature that I often seek when composing landscapes; far more eloquent than my previous description: multiple levels of depth without large breaks in between.

Emerald Bay

I had tried twice before to get good clouds at sunrise to add color to the silhouette of Emerald Bay and Lake Tahoe. This time I was too late for the twenty-minute hike up to my preferred location. Instead, I composed this scene from a pull out on the road. In retrospect, I like this angle better. The higher angle shows more of the bay and lake, but without the foreground presence of the silhouetted trees it lacks depth and has more of the detached look of an aerial photograph.

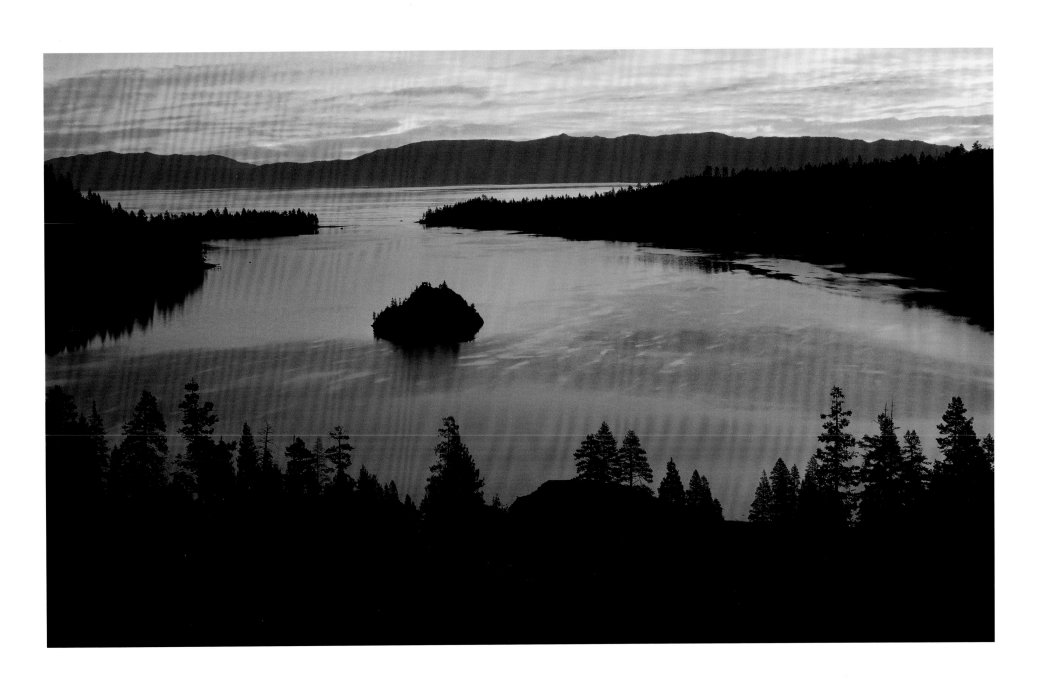

Lake Aloha

It is easy to tell from maps that Lake Aloha (8,116 ft.), six miles southwest of Lake Tahoe, has the most elaborate shoreline of any Sierra lake. Although Desolation Wilderness is at a lower elevation and less remote than the southern Sierra, it has a wonderful collection of treeline glacial lakes that are relatively easy to access. Part way up the eastern slope of Pyramid Peak I found this angle that maximized the shoreline convolutions and minimized large patches of rock slabs that distracted from the effect.

Lake Aloha

Lakes are one of my favorite subjects because they provide dramatic lines to use in the composition. Their surface color and texture often contrast sharply with the surrounding terrain. However, here the intricate shoreline and reflective surface of Lake Aloha all but disappeared into the glacially-carved granite.

Carson Pass Aspens

Hope Valley, on the east side of Carson Pass (8,573 ft. upper left), is known for tree-lined alpine meadows, meandering streams, and fall aspens. It was while scouting this Hope Valley image that I taught myself that when faced with a pleasing scene, always turn around and see if there is a nearby higher view point that will give better depth. In this case, the scene by the road was good, but it was even better from the prominent lava outcrop just behind me.

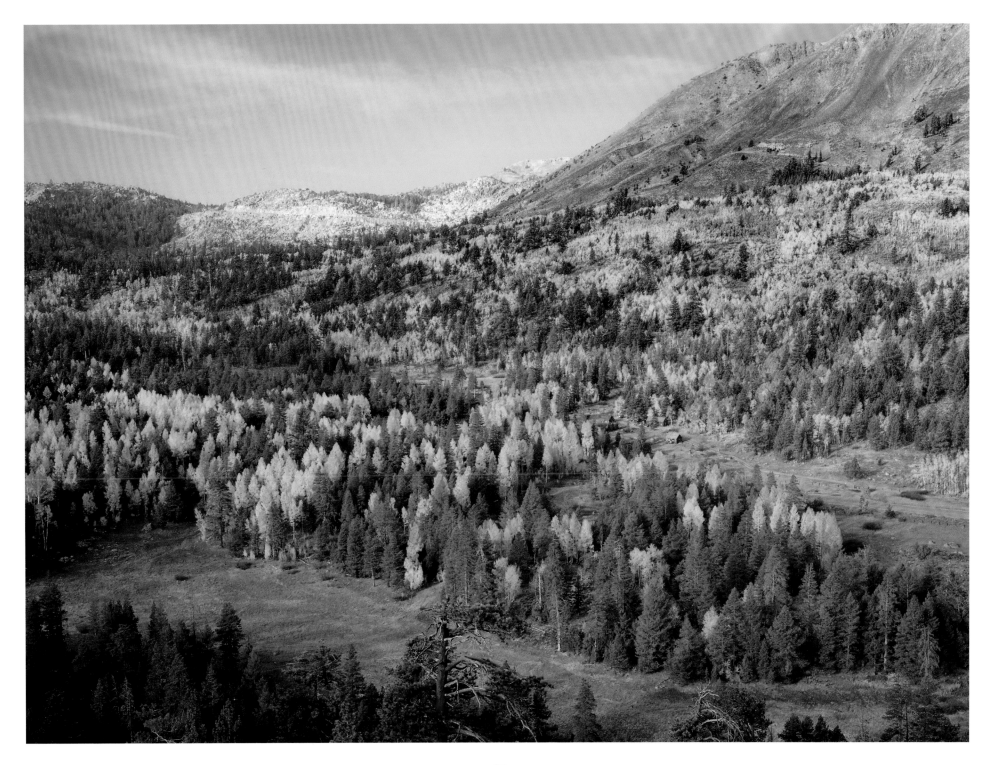

Carson Pass

The Fourth of July is a good time to look for the summer wildflower displays on the ridge north of Carson Pass. Elephants Back (left 9,585 ft.) and Round Top (right, 10,381 ft.) form the backdrop for this patch.

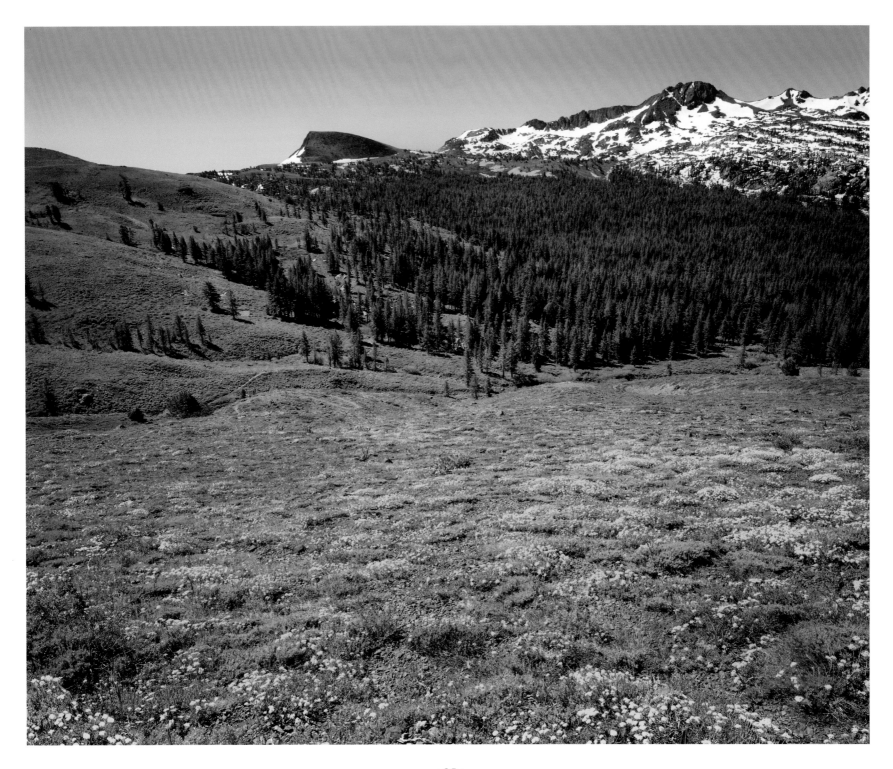

Headwaters of the Truckee

"Write as I may, I cannot give anything like an adequate idea of the exquisite beauty of these mountain carpets as they lie smoothly outspread in the savage wilderness. What words are fine enough to picture them? To what shall we liken them? The flowery levels of the prairies of the old West, the luxuriant savannahs of the South, and the finest cultivated meadows are coarse in comparison." –John Muir

The ridge going north from Carson Pass is an easy day hike or ski from Carson Pass. In early summer Mule ears, Paintbrush, Lupine, and other wildflowers bloom on the gentle slopes overlooking the headwaters of the Truckee River. Meiss Lake (8,400 ft.) is in the near distance. To the north, barely visible through the haze, Lake Tahoe fills the distant basin.

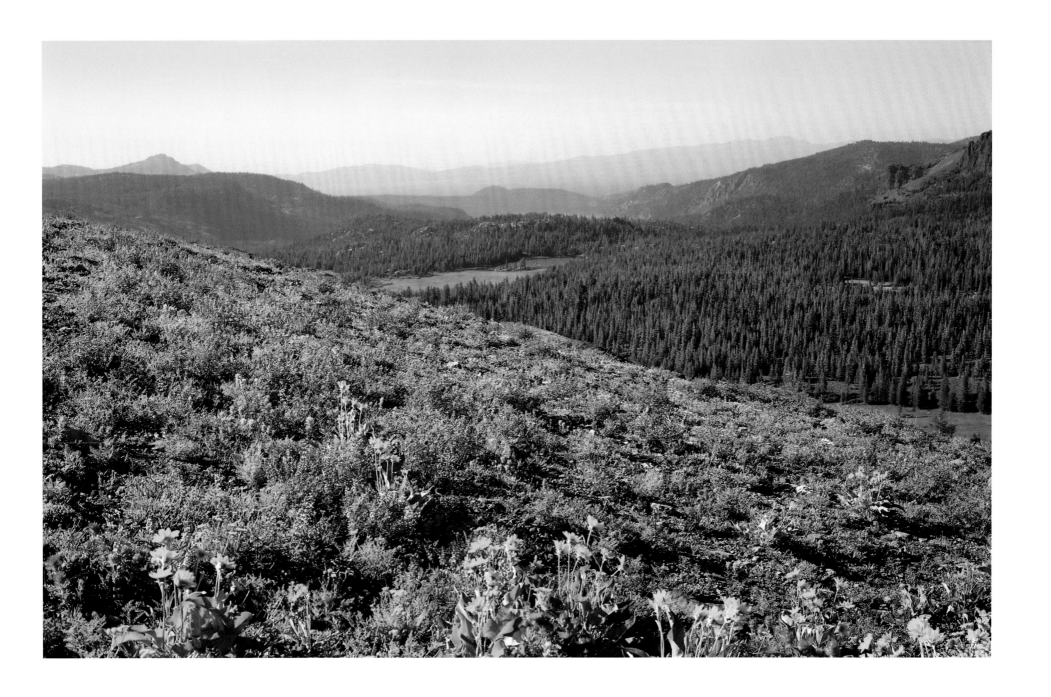

Koenig Lakes

Koenig Lakes (9,600 ft), near Sonora Pass in Toiyabe
National Forest, are closer to Yosemite National Park than
Lake Tahoe, but geologically the area's many layers of lava
flows more closely resemble the Tahoe area. These layers
are visible on the cliffs on the right.

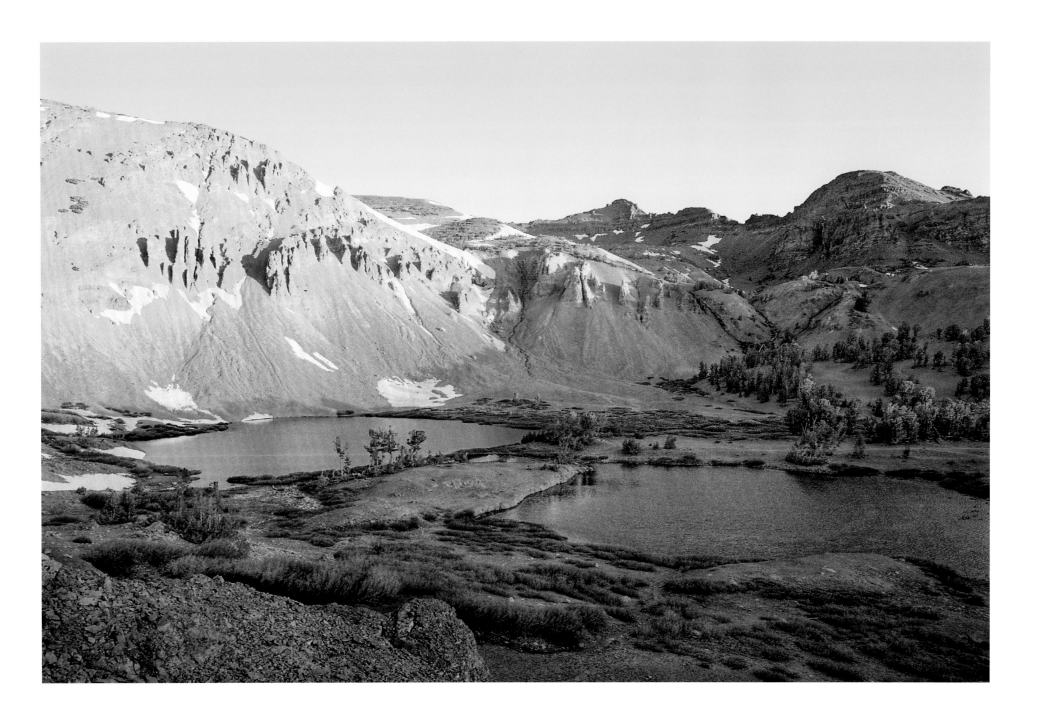

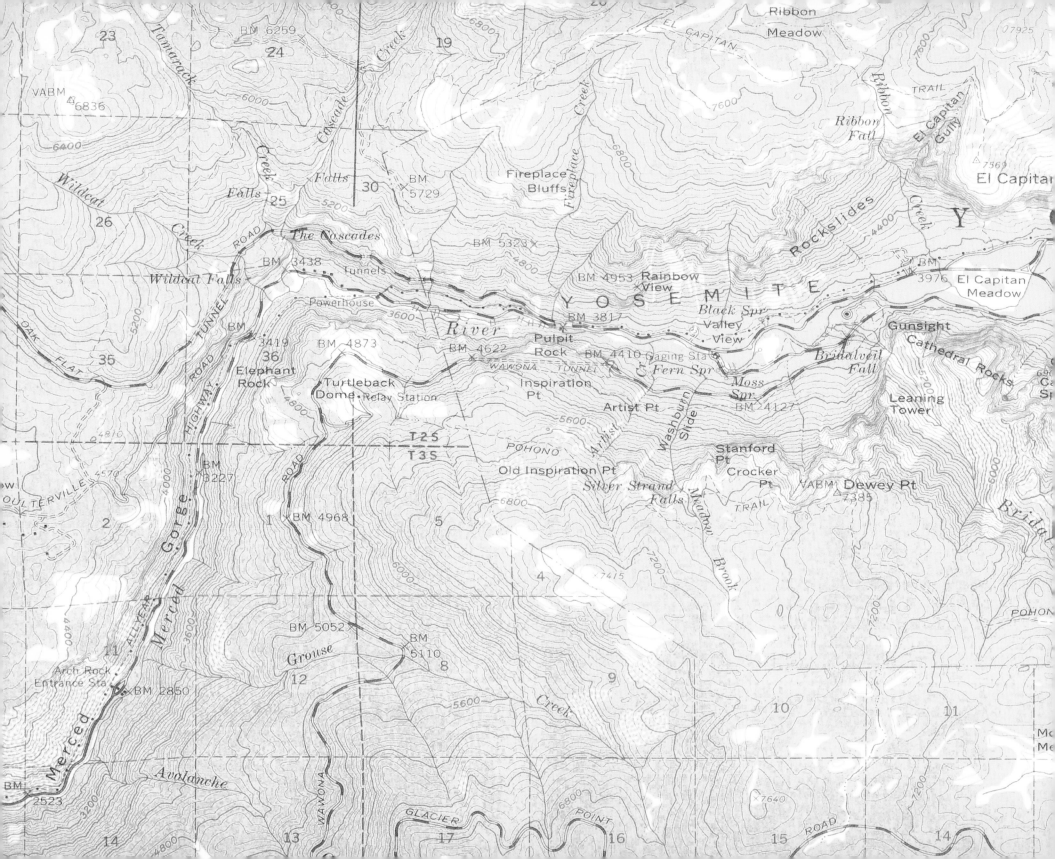

YOSEMITE NATIONAL PARK

"No Temple made by hands can compare with Yosemite." –John Muir

"Yosemite" was originally a Miwok word meaning "they are killers." The Miwok, who lived in the low foothills west of Yosemite, gave the name to a renegade band of mixed-tribe Indians who lived in the Yosemite Valley. This band briefly held out in the valley rather than accepting treaties and living on reservations. John Muir and others used "yosemite" as a generic geological term for the extra deep canyons that result from the confluence of multiple glacial canyons at several Sierra locations.

The Yosemite Valley and the Mariposa Grove of giant sequoias were originally preserved as a state park in 1864. For twenty years John Muir and others worked for federal protection of the surrounding area from excessive damage from grazing, mining, and logging, which resulted in the creation of the national park in 1890. In 1905, after Muir's famous backcountry camping trip with President Teddy Roosevelt, the Yosemite Valley and Mariposa Grove were consolidated into the national park to reduce state-allowed commercial development and grazing in the valley.

Cherry Creek Canyon

"There is no such sense of solitude
as that which we experience upon
the silent and vast elevations of
great mountains. Lifted high above
the level of human sounds and
habitations, among the wild
expanses and colossal features
of Nature, we are thrilled in our
loneliness with a strange fear and
elation." –Joseph Sheridan Le Fanu

From the top of Mercur Peak (8,200 ft), on the
northwestern boundary of Yosemite, looking across
Cherry Creek into the Emigrant Wilderness. Well below
treeline, glaciers so thoroughly scraped down to the
light-colored granite that vegetation is unable to grow
in most areas. My three days in this remote corner of
Yosemite is the only Sierra backpacking trip where
I never encountered any people.

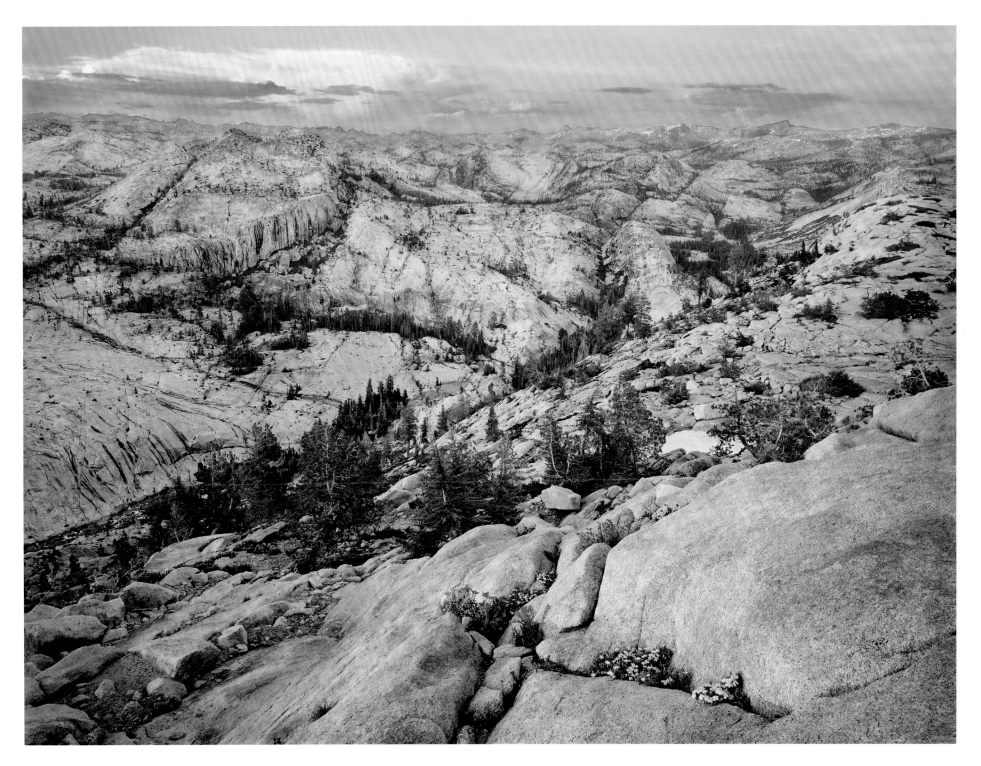

Cherry Creek Canyon

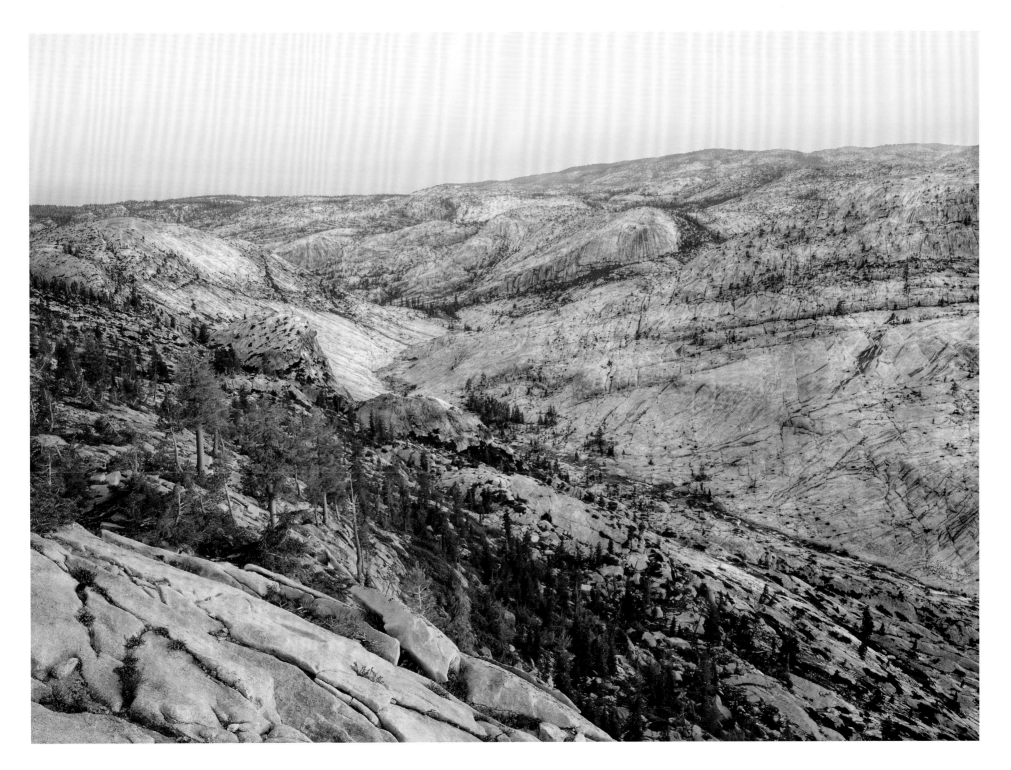

Mercur Peak Rock Garden

For this sunrise scene on Mt. Mercur it was especially
challenging to compose the multiple elements in a
pleasing arrangement. My general principle is that the
prominence of each element should be proportional to
its importance and attractiveness. This way the viewer's
eye is led around the image to what is important and is
not distracted by the less important. But there are always
compromises. The bunch of red flowers made a nice
off-center foreground and the central diagonal lines
of flowers, trees, and sunlit ridges lead nicely to the
background. However, the interesting tree on the far left
deserves more prominence and the central unremarkable
pine, less. It would also be nice if the lake on the far left
(Many Island Lake) were more prominent, but it illustrates
that in the Sierra there are scenic alpine lakes
hiding everywhere.

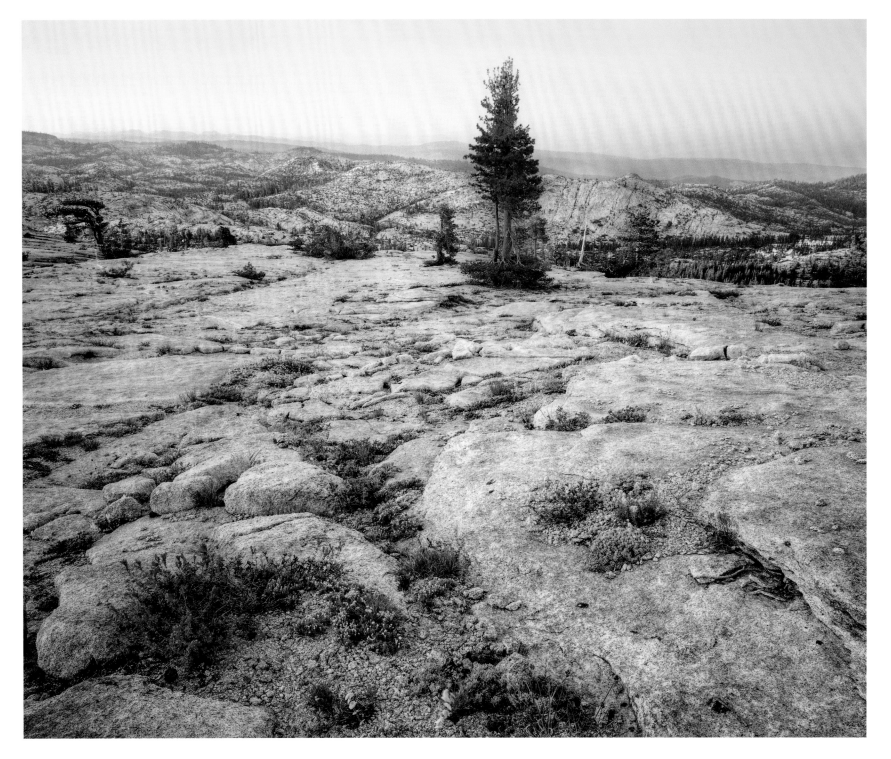

Boundary Lake

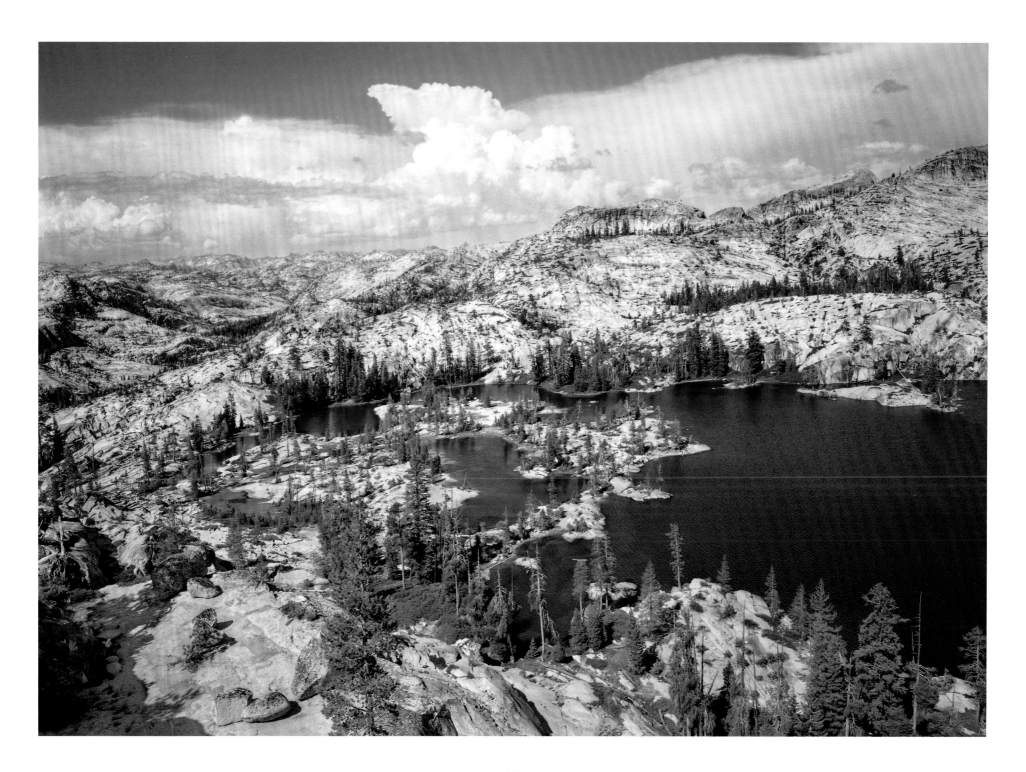

Tuolumne River

"The rivers flow not past, but through us, thrilling, tingling, vibrating every fiber and cell of the substance of our bodies, making them glide and sing." –John Muir

Not far from its origin on the northern slopes of Mt. Lyell, the Tuolumne starts a nine-mile quiet journey through Tuolumne Meadows. This long stretch in Lyell Canyon, paralleled by the John Muir/Pacific Crest Trail, is one of the most scenic and easy alpine meadow hikes in the Sierra. The mixture of warm and cool colors, vertical and horizontal depth, and the sweeping lines in this small pool capture its beauty and clarity, but not the numbing coldness.

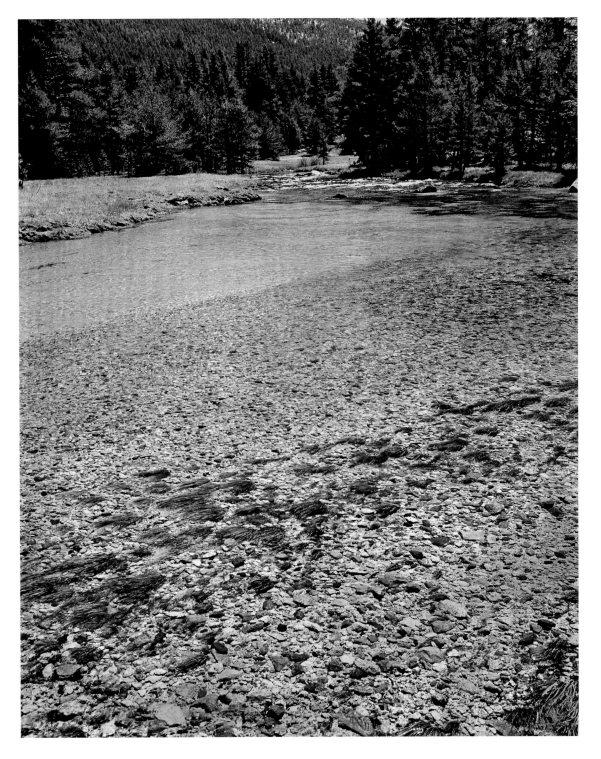

Tuolumne River and Cold Mountain

"Here, not peacefully, but
bounding over precipices, dashing,
and foaming in numerous cascades,
the stream threads its way through.
Now and then it glides quietly
through a diminutive meadow
or rests in a crystal pool, as if it
were accumulating energy for
a fresh run and plunge over
the rocks." –R. M. Price

By the time most Sierra rivers reach this size they are
secluded away into glacially carved canyons and shaded
by tall conifers, but in this unique stretch the Tuolumne
dances across bright granite slabs and through the sparse
open forest before entering the Grand Canyon of the
Tuolumne River to the left of Cold Mountain (10,301 ft.).

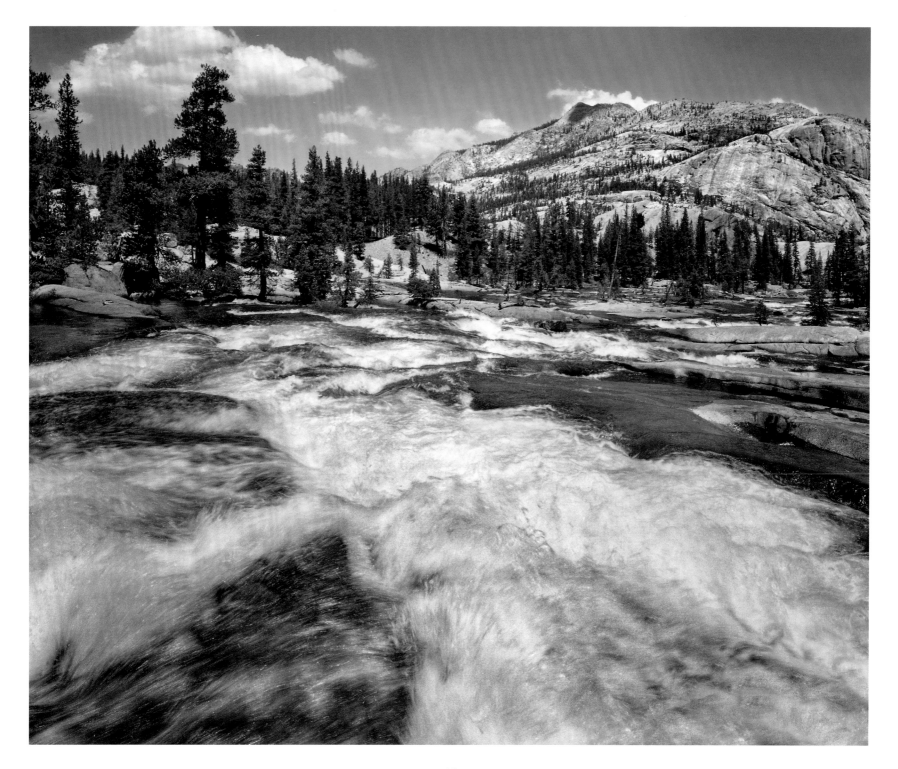

South from Cold Mountain

"...adorned along the top with a multitude of peaks that seem to have been nicked out in all kinds of fanciful forms for the sake of beauty." –John Muir

I don't usually take panoramas because it is like looking at a scene through a slit and doesn't give the viewer the full context of being there. However, sometimes I find some worthwhile but foreground-lacking subjects where a panorama is the only solution.

From Wildcat Point—a shoulder on the south side of Cold Mountain—the Tuolumne River (left) enters the top of the Grand Canyon of the Tuolumne in front of multi-domed Falls Ridge. In the distance, left to right: Donohue Peak (12,023 ft.), Amelia Earhart Peak (11,982 ft.), Banner Peak (12,936 ft.), Mt. Ritter (13,143 ft.), Mt. Lyell (13,114 ft.), Simmons Peak (12,503 ft.), Mt. McClure (12,960 ft.), Rafferty Peak (11,120 ft.), Fairview Dome (9,723 ft.), Unicorn Peak (10,880 ft.), Cockscomb (11,040 ft.), Cathedral Peak (10,940 ft., the highest from this angle), Echo Peaks (11,040 ft.), Medicott Dome (9,665 ft.), Tressider Peak (10,560 ft.), Mt. Clark (11,522 ft.), Tenaya Peak (10,301 ft.), Sunrise Mountain (9,928 ft.), Polly Dome (9,806 ft.), and Clouds Rest (9,926 ft.).

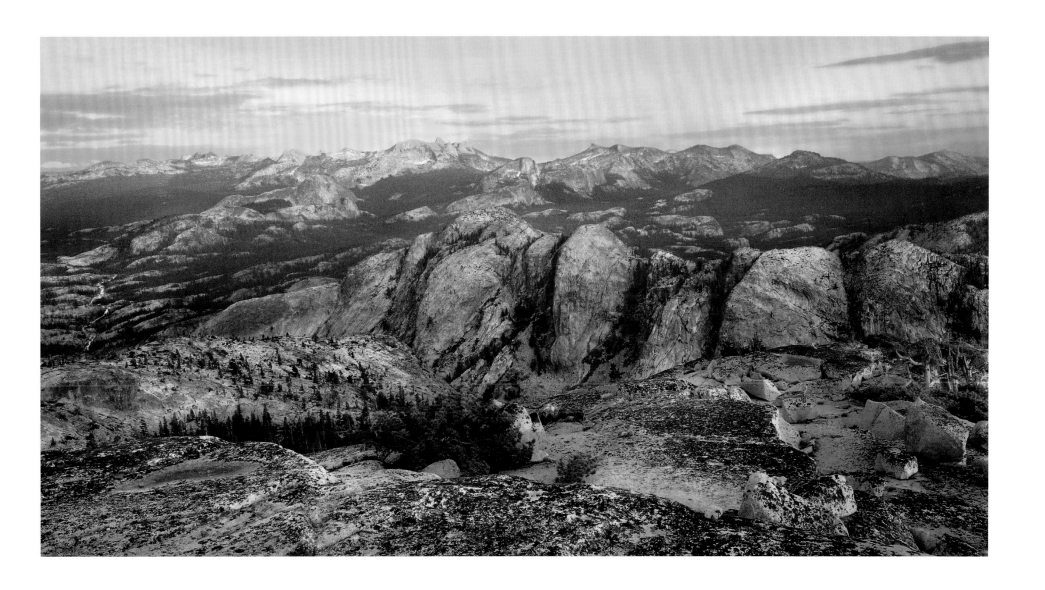

Mt. Conness Tarn

"Among the many unlooked-for treasures that are bound up and hidden away in the depths of Sierra solitudes, none more surely charm and surprise all kinds of travelers than the glacier lakes." –John Muir

There are about 1,000 named Sierra lakes, and many more are identified only by their altitude; there seems to be one around every corner. My most unanticipated Sierra lake was this small (about 150 yards in diameter) unmapped tarn, well on its way to becoming a meadow, on the south slope of Mt. Conness. This is by far the most distinct Sierra example of a string mire that I have ever seen. This is also the only photo in this book where I was too lazy to set up the tripod. I'm still kicking myself over its slight softness.

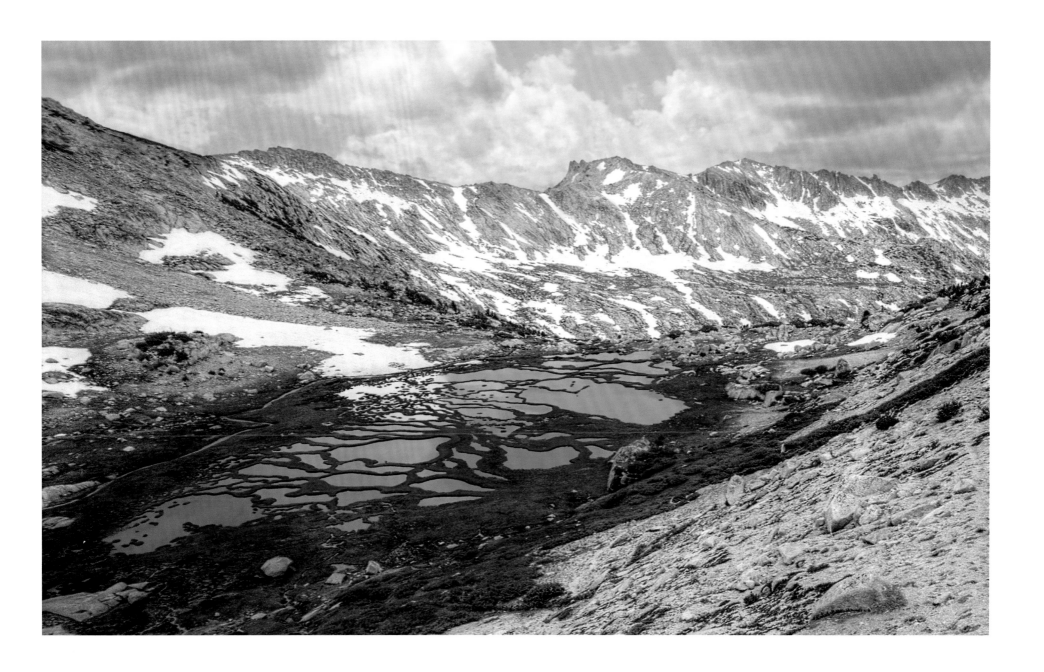

Mono Craters

"A country of wonderful contrasts.
Hot deserts bounded by snow-laden
mountains—cinders and ashes
scattered on glacier-polished
pavements—frost and fire
working together in the
making of beauty." –John Muir

South of Mono Lake and ten miles from Yosemite on
the dry eastern side of the Sierra are the recently formed
Mono Craters. Recent rains initiated a bloom of
paintbrush and other wildflowers on the lava scree.
In the distance, Mt. Gibbs (left, 12,764 ft.) and Mt.
Dana (right, 13,053 ft.) are the two peaks on
Yosemite's eastern boundary.

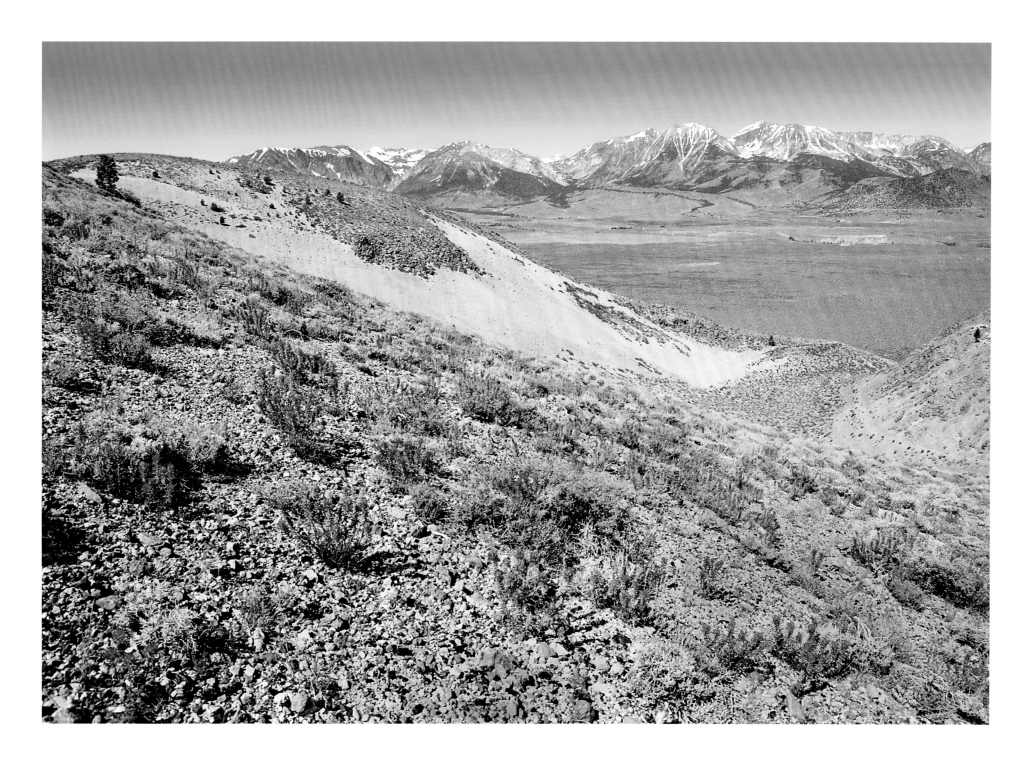

**Cathedral Peak
and Upper Cathedral Lake**
"Mountains are not stadiums
where I satisfy my ambition
to achieve, they are the cathedrals
where I practice my religion."
–Anatoli Boukreev

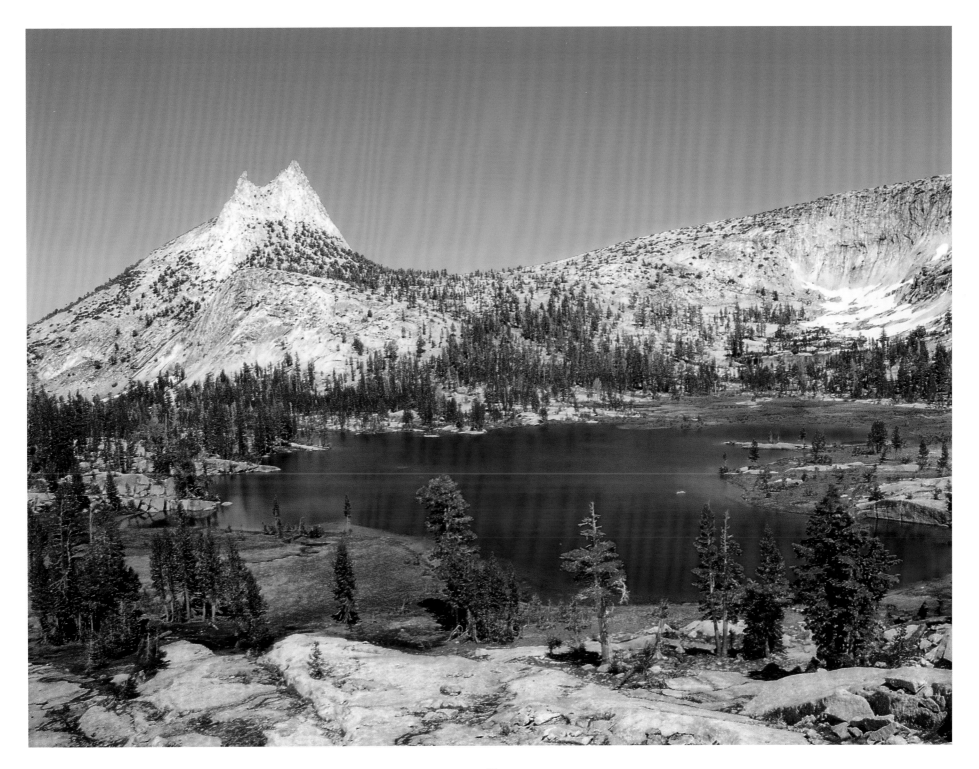

Pywiak Dome, Cathedral Peak

"No feature, however, of all the noble landscape as seen from here seems more wonderful than the Cathedral itself, a temple displaying Nature's best masonry and sermons in stones." –John Muir

The domes, spires, and knife-edge ridges of the Cathedral Range are a highlight of the drive on Tioga Road (middle left) as it winds through the Yosemite high country. With Pywiak Dome in the foreground, Mt. Dana (distant, center, 13,053 ft.), Cathedral Peak (center, 10,940 ft.), the Unicorn, and Echo Peaks (right) catch the last light. A portion of Tuolumne Meadows is visible on the far left.

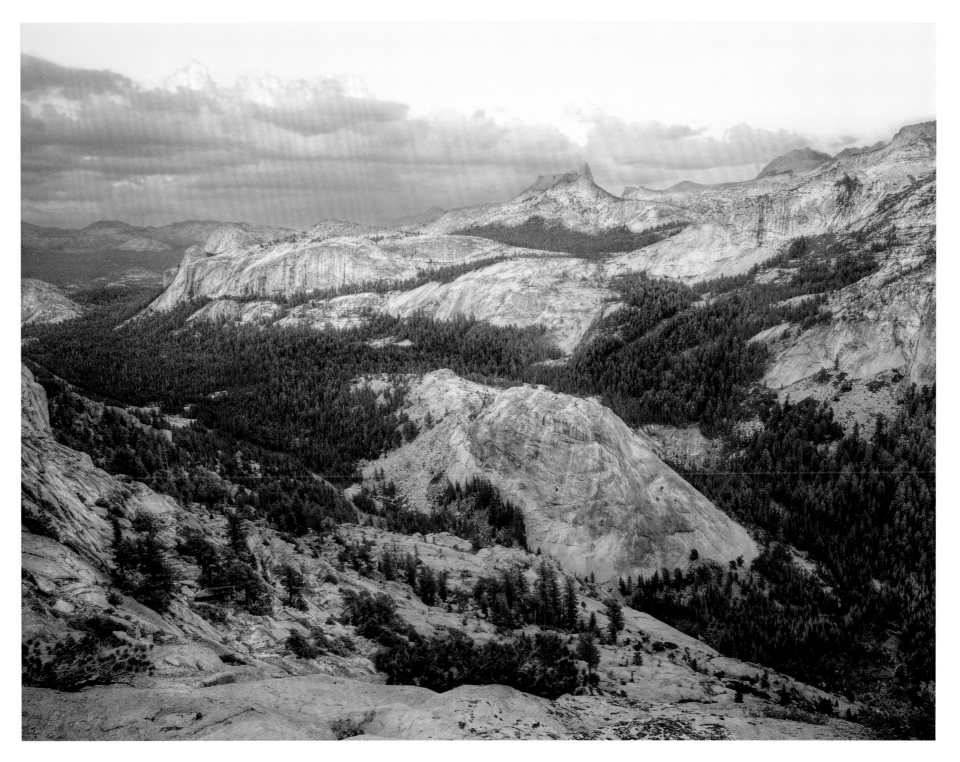

Tenaya Lake

"All is bare, shining granite, suggesting the Indian name of the lake, Pywiack, meaning shining rock. The basin seems to have been slowly excavated by the ancient glaciers, a marvelous work requiring countless thousands of years. On the south side an imposing mountain rises from the water's edge to a height of 3,000 feet or more, feathered with hemlock and pine." –John Muir

Tenaya Lake (8,150 ft.), on the Tioga Road east of Olmstead Point (distant right), is squeezed in among the exfoliating granite domes and glacial carvings. In the distance are Mt. Clark (left 11,522 ft.), Clouds Rest (center, 9,926 ft.), and Half Dome (right, 8,836 ft.).

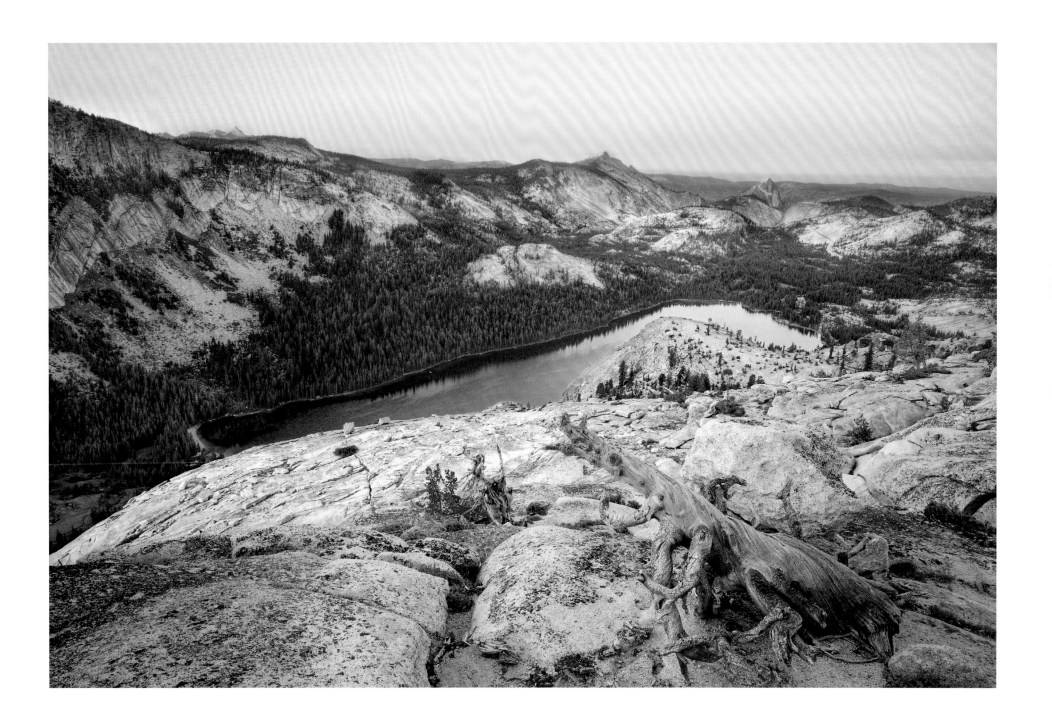

Matthes Crest and Matthes Lake

Matthes Lake (9,623 ft.) and its meandering inlet stream reflect Matthes Crest (10,918 ft.). Glacially sculpted Tressider Peak (left, 10,600 ft.) and the Cockscomb (right, 11,065 ft.) complete the morning scene in the Cathedral Range. Because there are higher peaks a few miles to the east, the morning alpenglow was later and not quite as dramatic as other places. Erosion resistant phenocrysts (climbers call them chicken heads) on the foreground rocks are characteristic of the Cathedral Range.

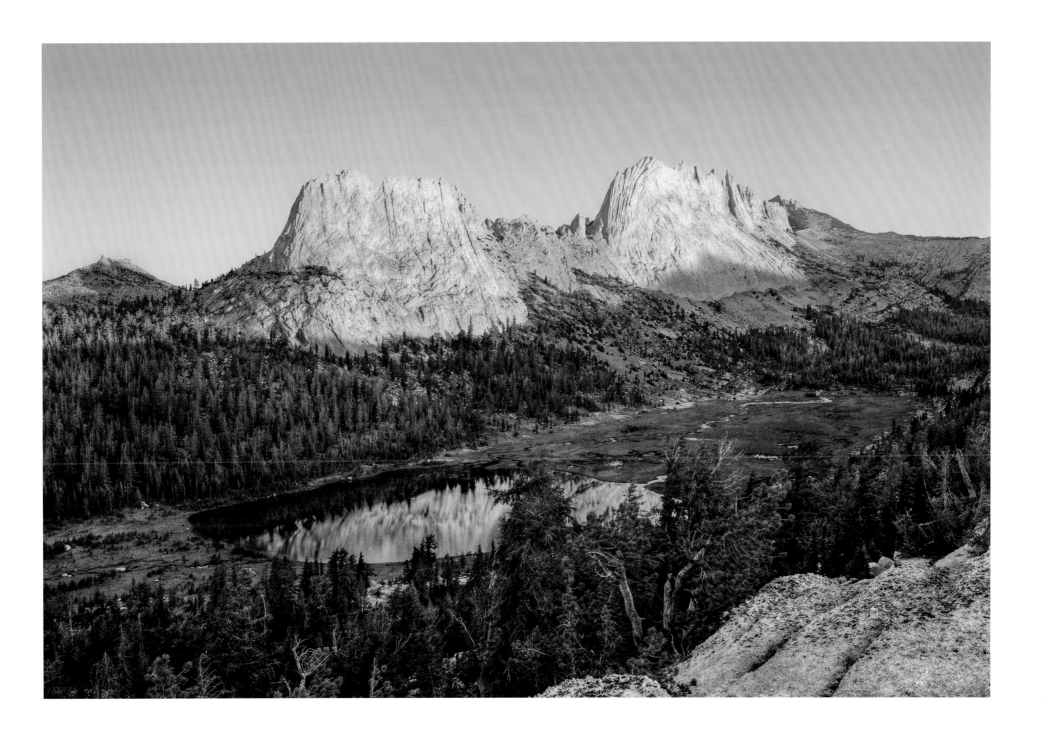

Yosemite Falls and Half Dome

"The climb speaks to our character,
but the view, I think, to our souls."
–Lori Lansens

A half hour of difficult bushwacking got me to this vista,
only to find that it was just twenty easy feet off the trail.
I was ready to leave when a cloud of mist from the falls
created a brief rainbow at my feet; I realized that in an
hour or so the rainbow would be in the mist at the base
of the falls. Patience was rewarded, and a nice
composition of these two landmarks was improved.
A few moments later the sun passed behind cliffs,
shading the entire scene.

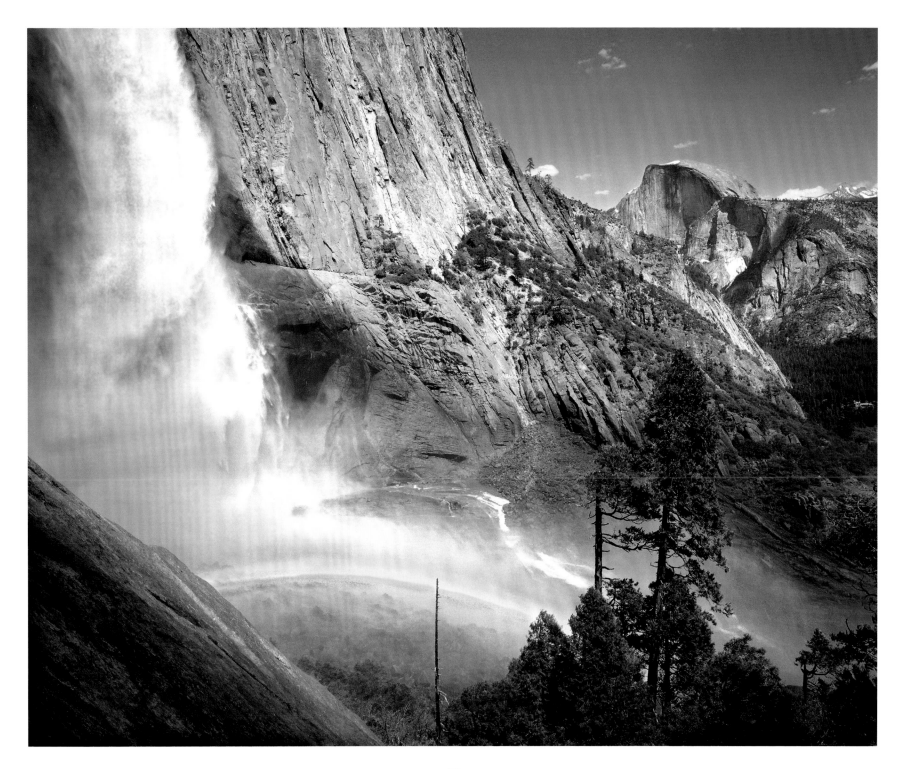

Quarter Domes and Half Dome

"The real act of discovery
consists not in finding new lands,
but in seeing it with new eyes."
–Marcel Proust

Heading south from Tioga Road to Mt. Watkins, I was
hoping for good sunset views of Cloud's Rest, Tenaya
Canyon, and Half Dome. An unexpected element was
the pattern of white avalanche chutes on the darker rocks.
There were some less obstructed views that showed more
of the bottom of the canyon, but I included the
foreground row of trees because it added some diagonal
foreground depth, blocked some less distinct portions of
the avalanche chutes, and balanced the line of side-lit
forest around Mt. Star King. A polarizing filter was used
to cut the haze, making this the only photo in this book
made with a filter.

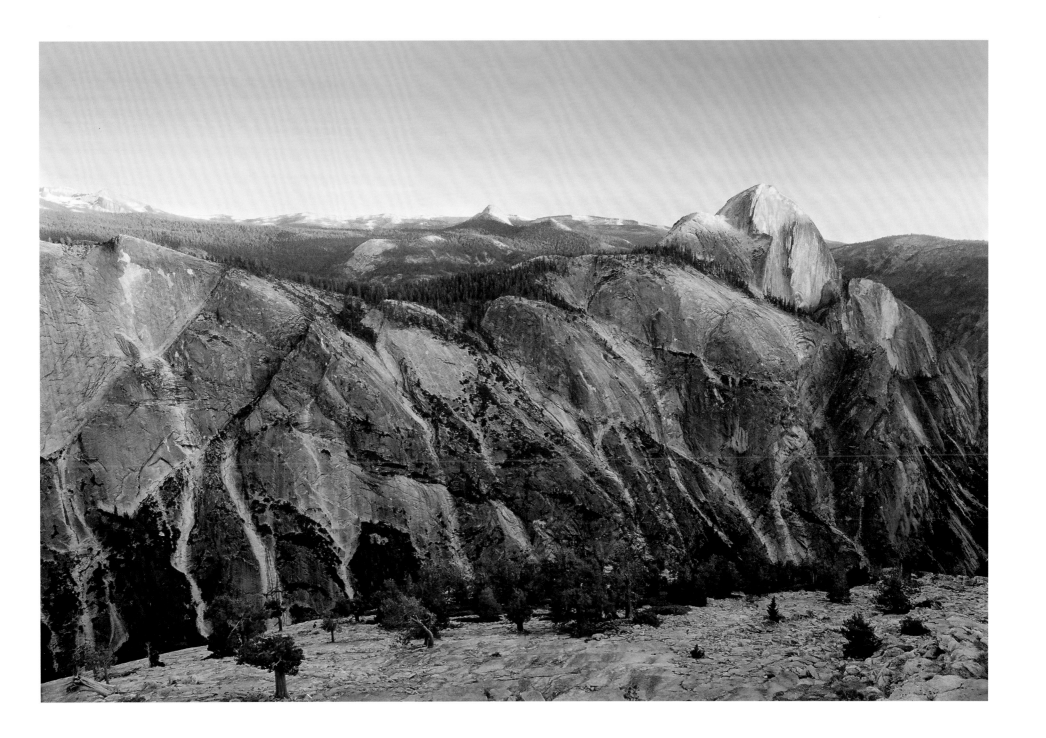

Mt. Watkins

This vast uniform pattern of backlit yellow flowers among exfoliating granite slabs is on the east slope of Mt. Watkins, across Tenaya Canyon from Half Dome. I settled on this composition because it had a good distribution of flowers in the front and mid-ground, no distracting elements, and enough trees to show depth without interrupting the floral pattern.

El Capitan

More than ½ mile high, the granite face of El Capitan is the world's standard for big wall climbing. The first ascent in 1958 took forty-seven days. The current record, set in 2012, is 2 hours, 23 minutes, 46 seconds.

When this band of thin clouds quickly floated by, my tripod was fortunately already set up on a talus slope with a clear view of much of El Capitan's south face, including a strong flow in Horsetail Falls (right).

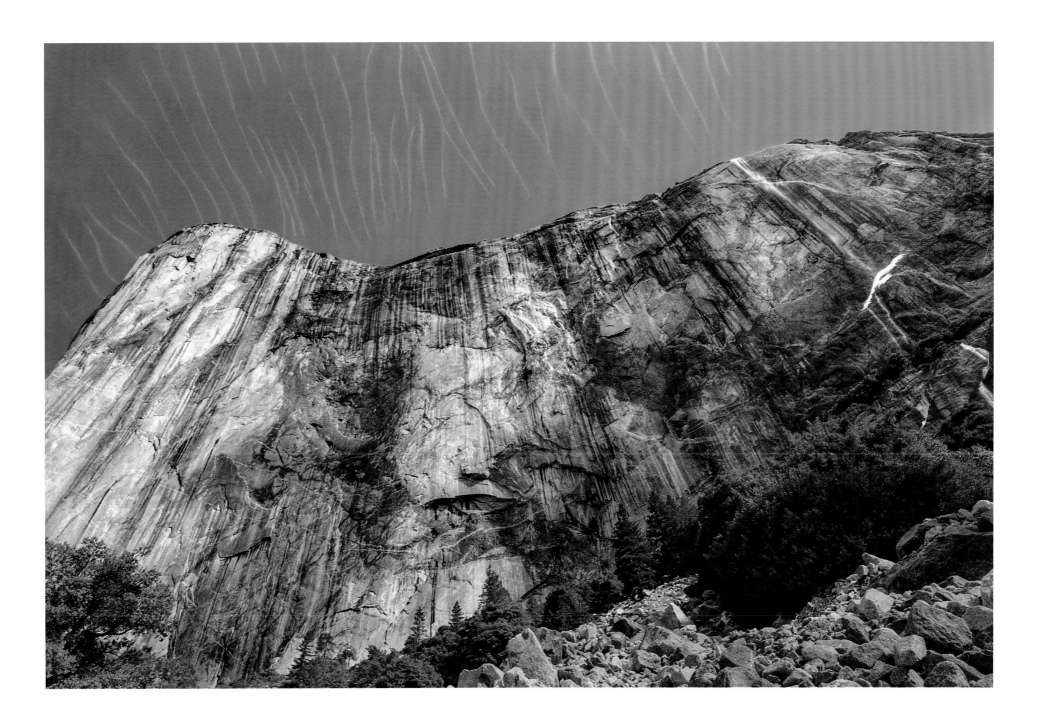

Clearing Storm from Glacier Point

Although the worst of this storm had cleared about an hour ago, I was uneasy standing at Glacier Point, as dark clouds loomed overhead. But the ranger did not cancel her evening talk, and at sunset the clouds cleared enough to let some sunlight fall on the lingering showers. I have taken photos from all the popular viewpoints like this in and around Yosemite Valley, but this was the only one that was special enough to attract viewers' attention.

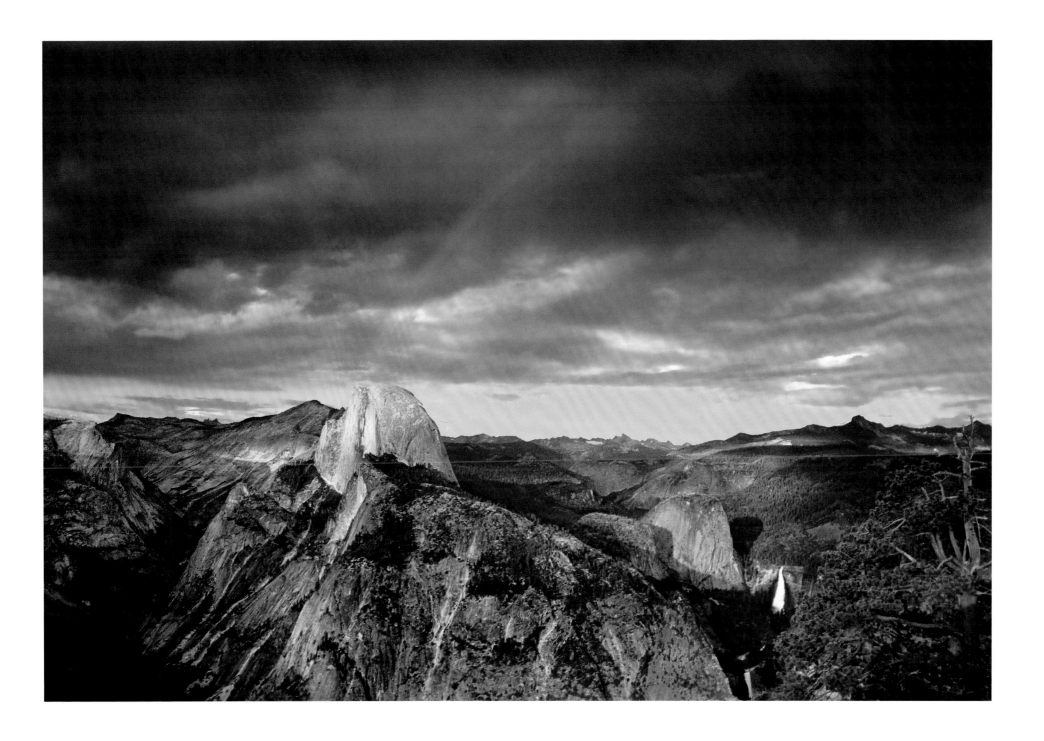

Yosemite Falls

Until the most recent glacial episode—the relatively minor Wisconsin Glaciation between 10 and 85 thousand years ago—Yosemite Creek cascaded into the valley via the large angled gulley just left of the falls where the current trail switch-backs up to the top of the canyon. During this period terminal moraines blocked the creek about one mile upstream and diverted it into its current channel.

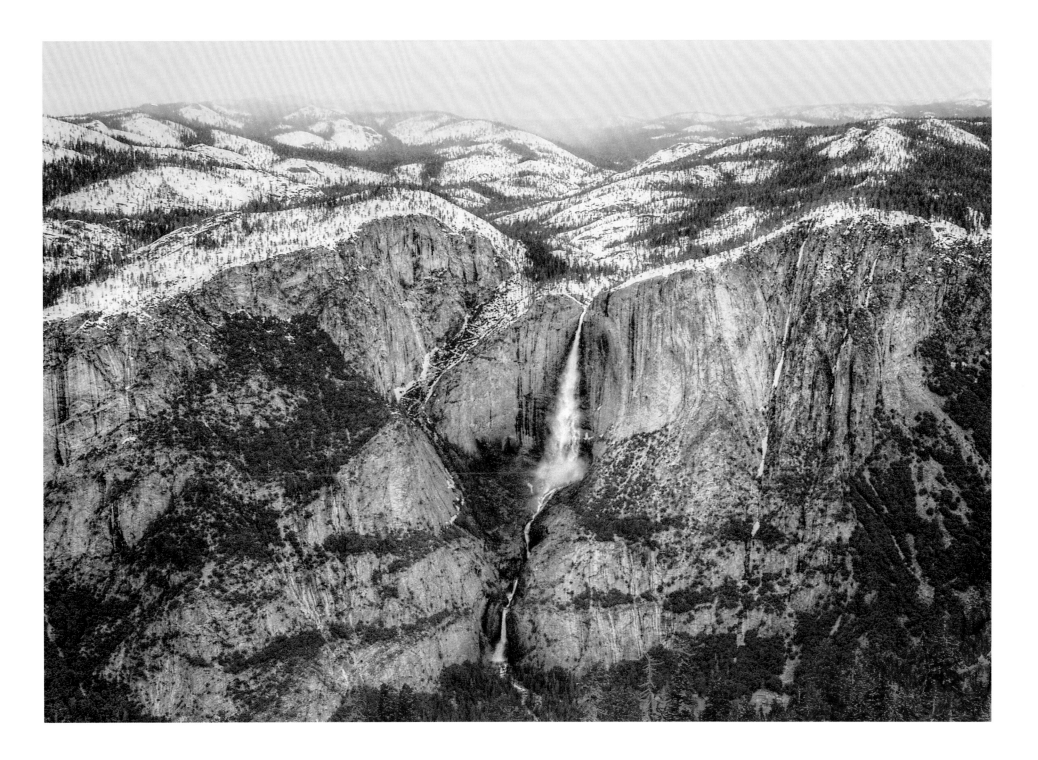

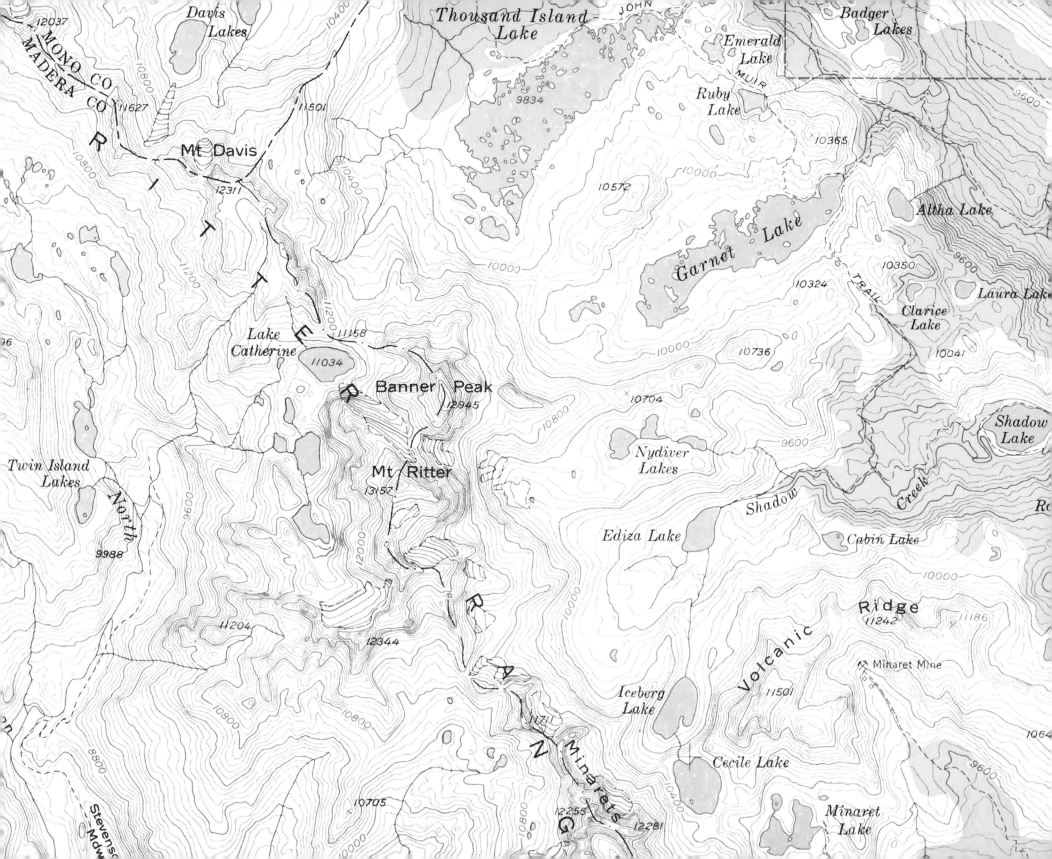

ANSEL ADAMS WILDERNESS

"In the evening we walked out on the trail... and sat for long under the gracious moon. The sense of detachment that comes upon you in the presence of moon-illuminated mountains augments the reality of experience. Space becomes intimate; the world of fixed dimensions fades into patterns of exquisite delicacy, and you mingle your being with the eternal quietude of stone." –Ansel Adams

Originally the Minarets Wilderness, in 1984, this area was enlarged and renamed to honor renowned photographer and wilderness preservationist Ansel Adams. The most distinctive feature of the Ansel Adams Wilderness is the Ritter Range, composed of Mt. Ritter, Banner Peak, and the Minarets. These dark peaks consist of magma that cooled about two miles deep in the throat of an ancient volcano. Since then more magma from below heated and metamorphosed the rock, and glacial erosion removed the overlying rocks, sculpted the peaks, and excavated the surrounding lakes.

One of the most scenic stretches of trail in the Sierra is the six-mile stretch of the John Muir Trail between Shadow Lake and Thousand Island Lake in the Ansel Adams Wilderness. The treeline trail follows mountain streams, traverses colorful rock outcrops, and passes large lakes with huge mountain backdrops, and some of the most unique smaller lakes in the Sierra.

Thousand Island Lake and Banner Peak

Thousand Island Lake (9,833 ft.), justifiably one of the
more popular backpacking destinations in the Sierra,
has earned the nickname "Thousand Person Lake."
In the morning light Banner Peak (12,936 ft.)
forms a huge colorful backdrop.

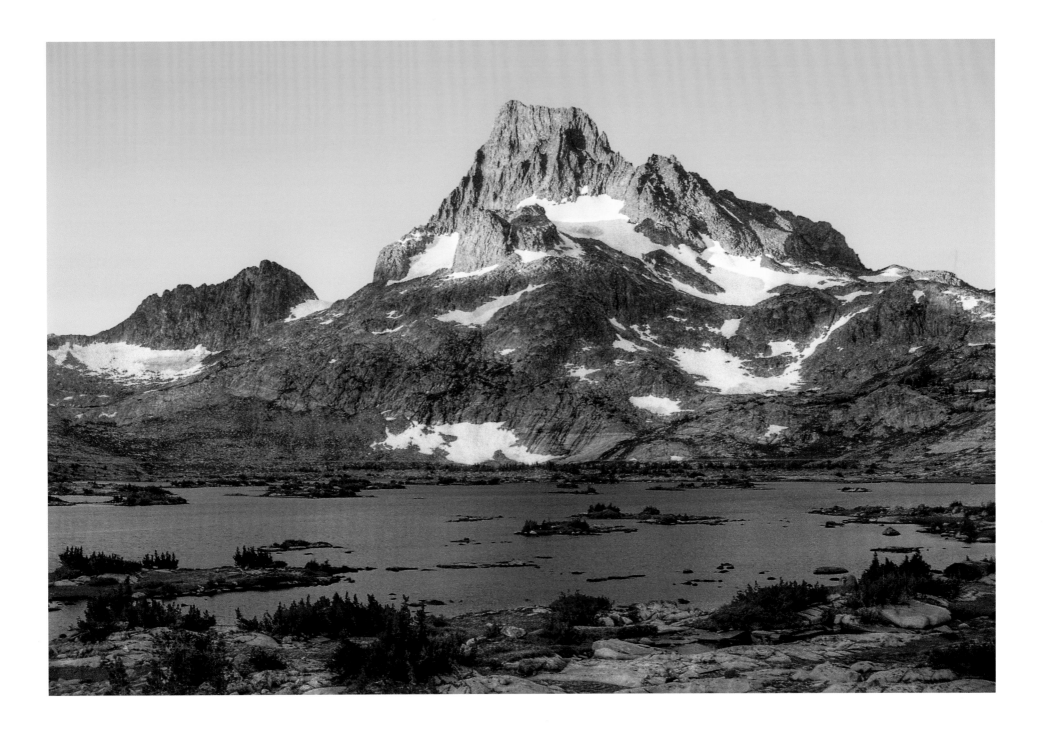

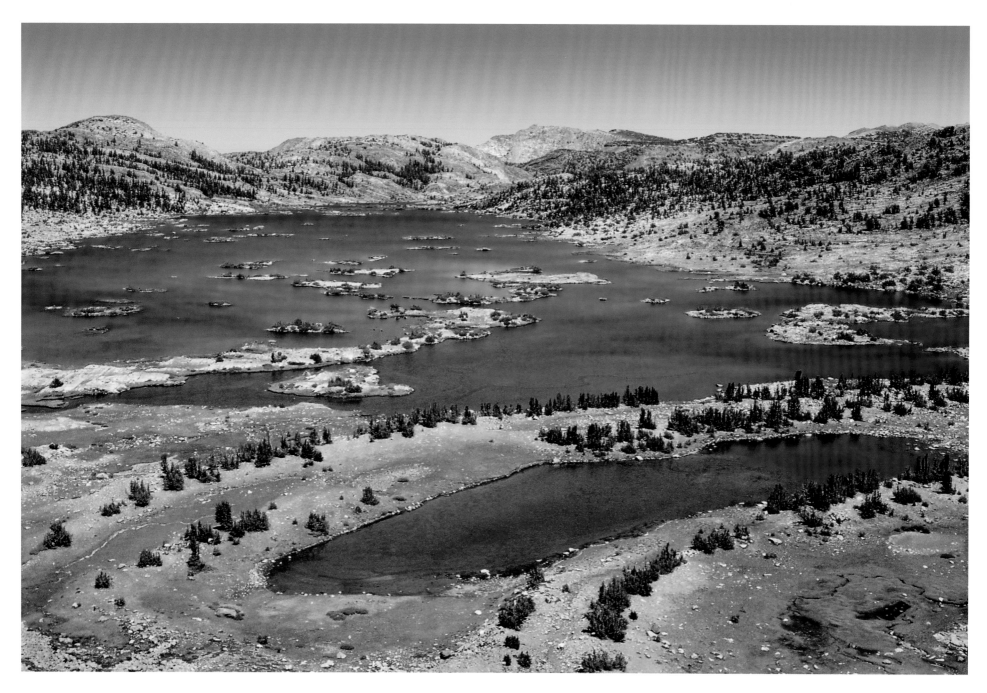

Thousand Island Lake

The two arching ridges in the foreground are either terminal or recessional moraines formed by the glacier originating from Banner Peak. Also remarkable are the underwater meanders of the inlet stream.

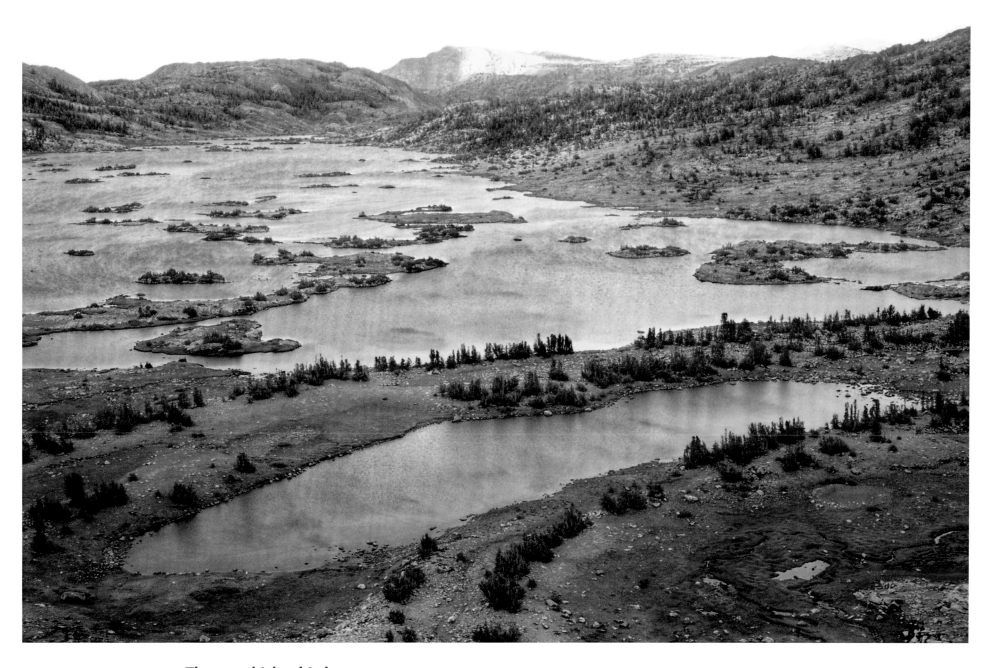

Thousand Island Lake
At sunset cool breezes and a different mood settle over the lake.

Emerald Lake

Emerald Lake is one of the smaller gems set in the rocky folds just east of Thousand Island Lake (left). The peaks on the far left are on the southeastern border of Yosemite National Park.

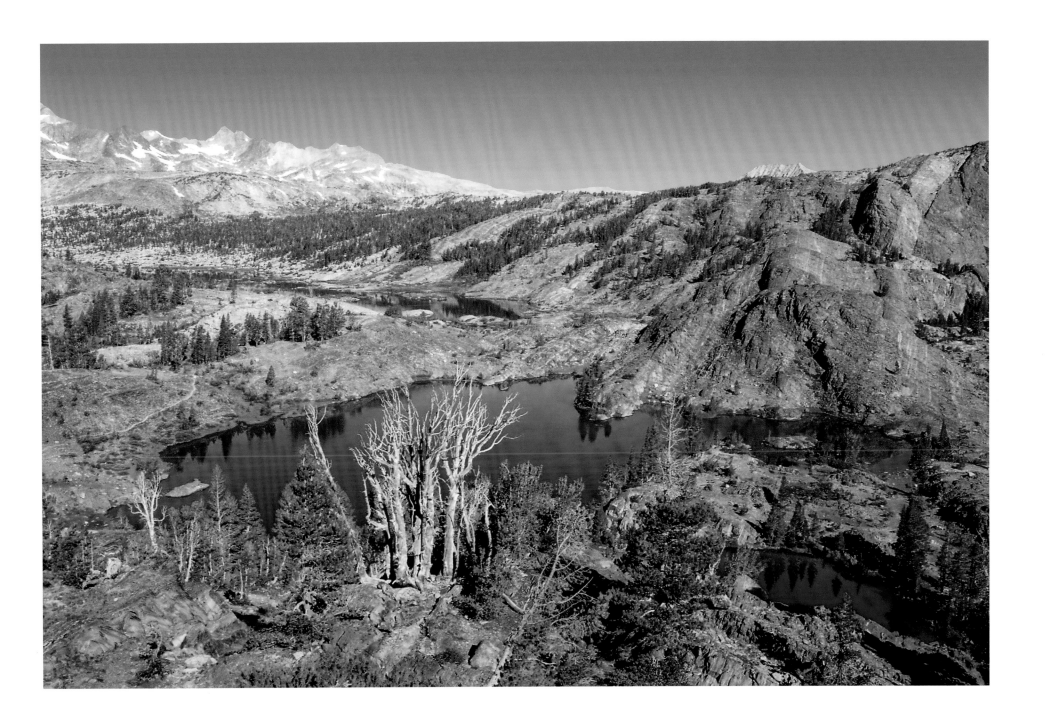

Garnet Lake

"No mountains I know of are so alluring. None so hospitable, kindly, tenderly inspiring. It seems strange that everybody does not come at their call." –John Muir

In a deeper glacial channel just south of Thousand Island Lake is the less accessible but equally striking Garnet Lake. Wind-blown dust in the Nevada deserts intensified the colors on Mt. Ritter and Banner Peak. A family of Common Mergansers made the only ripples on the still morning water.

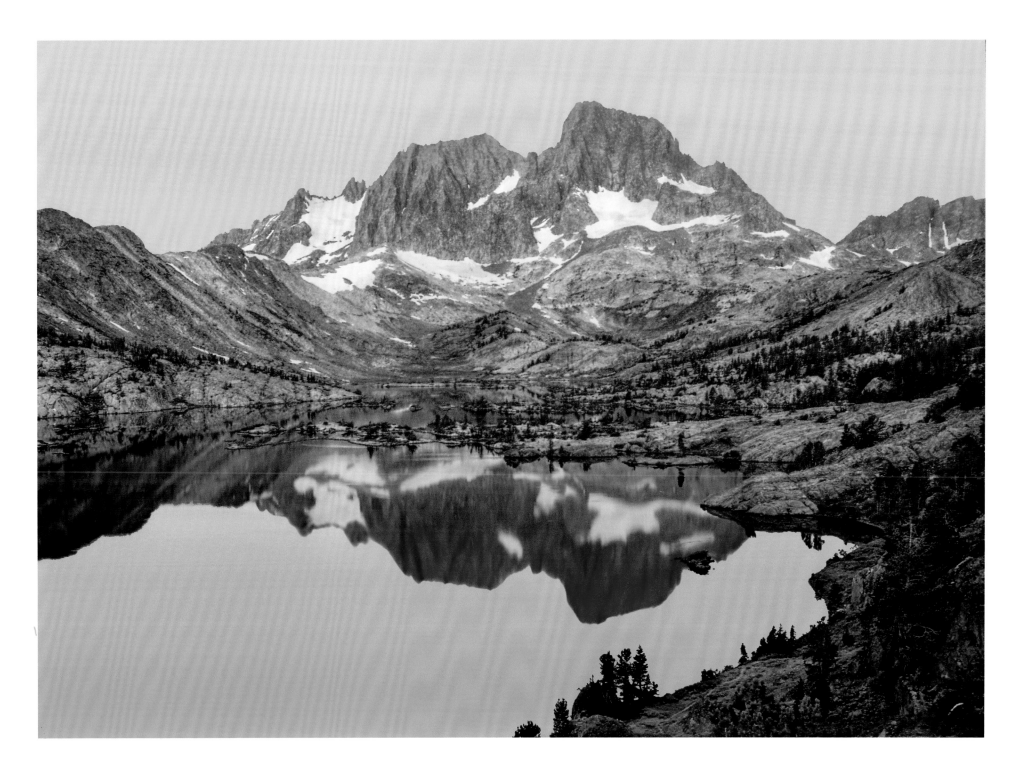

Garnet Lake

One of my favorite campsites just a few feet off
the John Muir Trail and overlooking Garnet Lake.

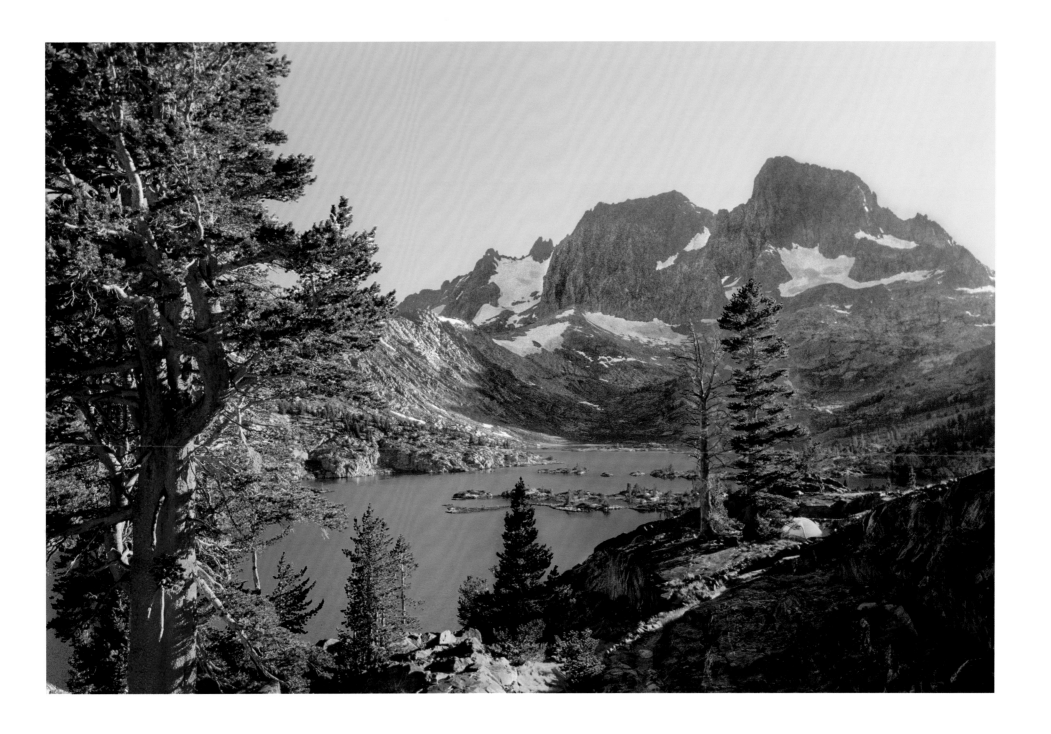

Minarets, Cecile, and Iceberg Lakes

"It is easy, therefore, to find the bright lake-eyes in the roughest and most ungovernable-looking topography of any landscape countenance" –John Muir

This is the photo that taught me that good views of dramatic peaks are often obtained by scrambling up the immediately adjacent, unscenic, ankle-breaking pile of rocks. Although the foreground spur showed up on the topo map, I did not realize it would have to be a major part of the composition. If I ever return to this area I'll camp up here and catch the sunrise.

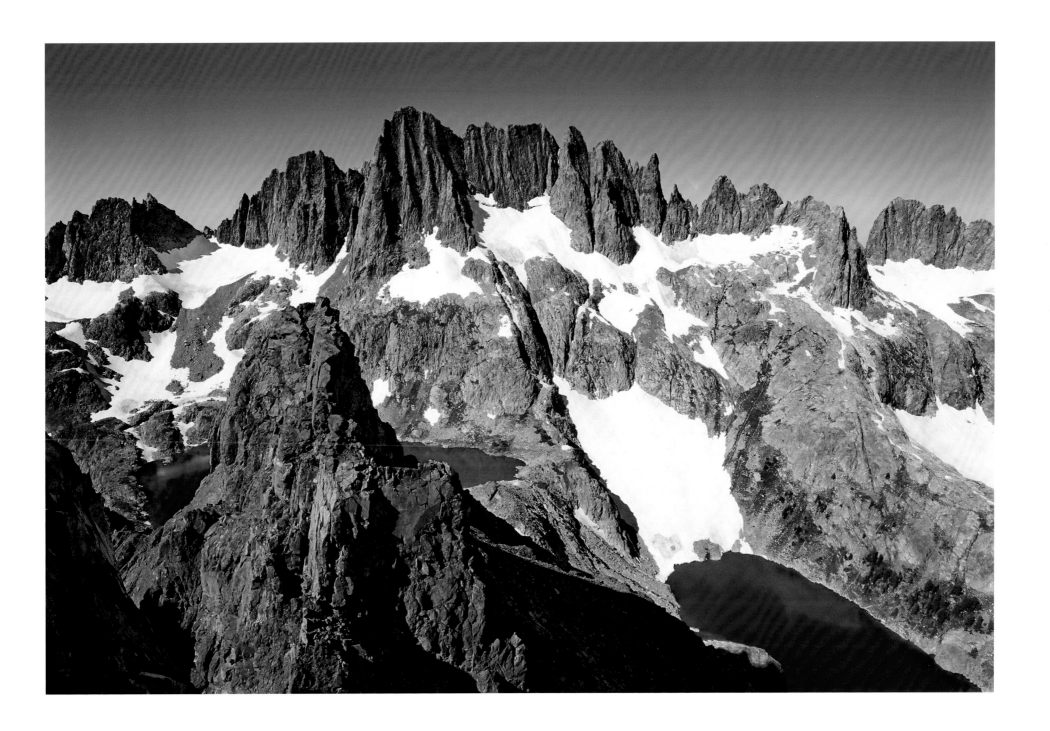

Iceberg Lake

At the foot of the Minarets (12,281 ft.) Iceberg Lake
(9,774 ft.) lives up to its name. Even when people are
present (at the beginning of the outlet stream) it is
difficult to judge the scale in the rest of the scene.

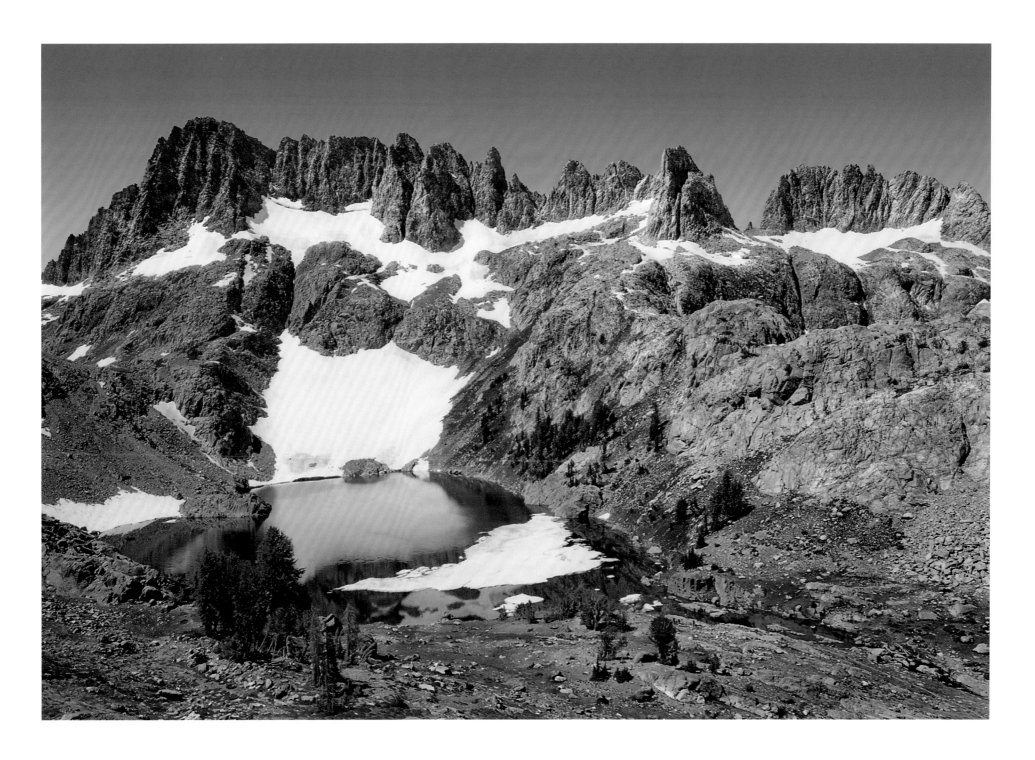

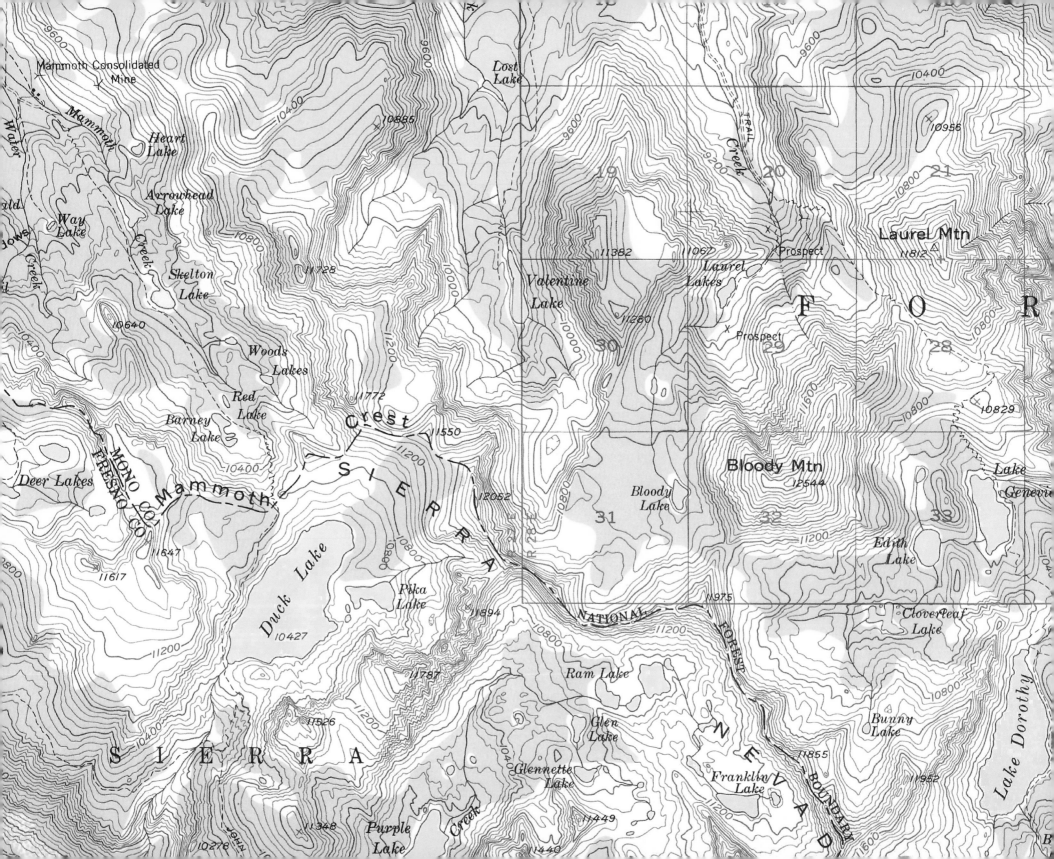

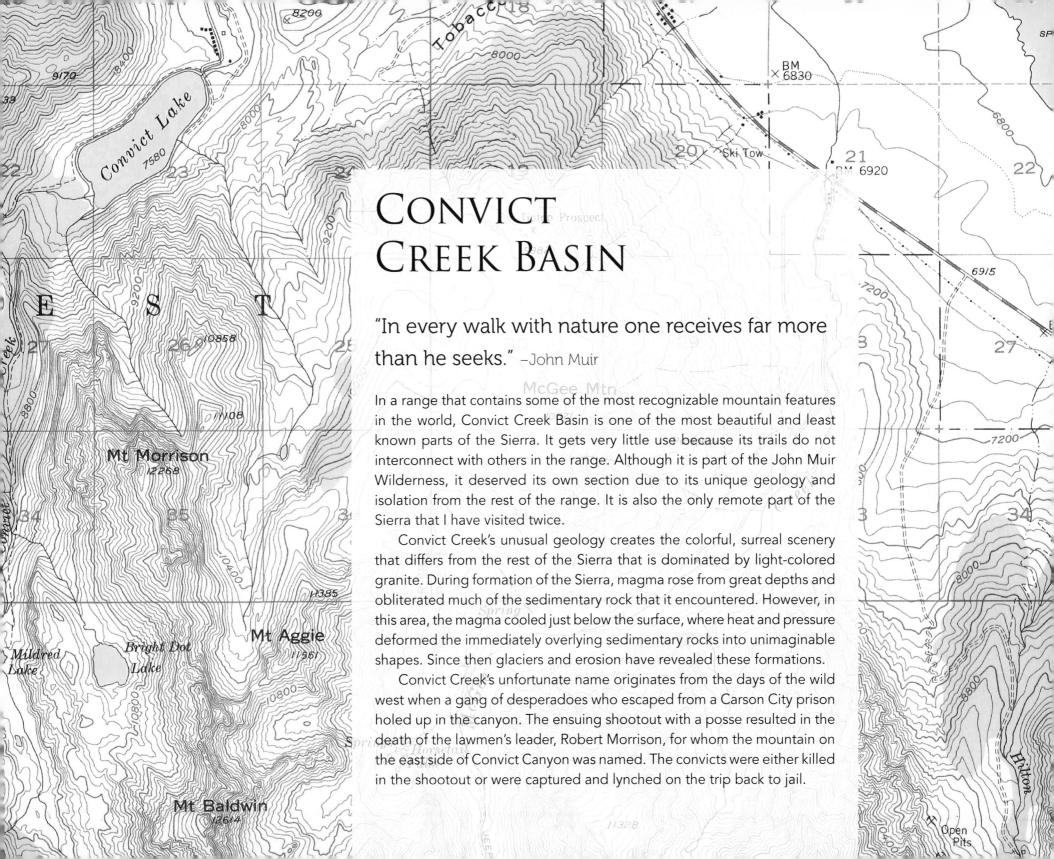

CONVICT CREEK BASIN

"In every walk with nature one receives far more than he seeks." –John Muir

In a range that contains some of the most recognizable mountain features in the world, Convict Creek Basin is one of the most beautiful and least known parts of the Sierra. It gets very little use because its trails do not interconnect with others in the range. Although it is part of the John Muir Wilderness, it deserved its own section due to its unique geology and isolation from the rest of the range. It is also the only remote part of the Sierra that I have visited twice.

Convict Creek's unusual geology creates the colorful, surreal scenery that differs from the rest of the Sierra that is dominated by light-colored granite. During formation of the Sierra, magma rose from great depths and obliterated much of the sedimentary rock that it encountered. However, in this area, the magma cooled just below the surface, where heat and pressure deformed the immediately overlying sedimentary rocks into unimaginable shapes. Since then glaciers and erosion have revealed these formations.

Convict Creek's unfortunate name originates from the days of the wild west when a gang of desperadoes who escaped from a Carson City prison holed up in the canyon. The ensuing shootout with a posse resulted in the death of the lawmen's leader, Robert Morrison, for whom the mountain on the east side of Convict Canyon was named. The convicts were either killed in the shootout or were captured and lynched on the trip back to jail.

Convict Lake and Laurel Mountain

Jeff Brown, a geologist friend, told me that the
mountains in the Convict Creek basin had the oldest
and most wonderfully colored rocks in the Sierra. Near
the Convict Creek trailhead Convict Lake (7,580 ft.) and
the Sevehah Cliffs on Laurel Mountain (11,800 ft.) are all
that most visitors ever see of this unique corner of the
Sierra. The dramatic Sevehah Cliffs have been used
as backdrops for automobile, beer,
and other advertisements.

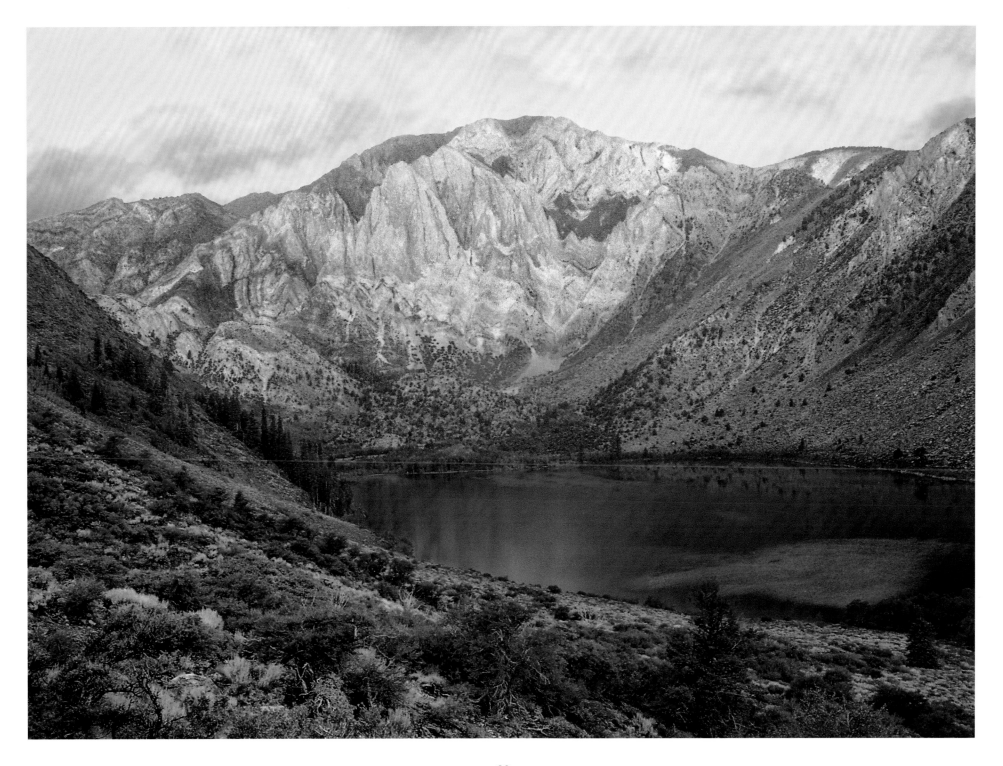

Mt. Morrison

Just south of Mammoth Lakes is one of the most remarkable views encountered on Highway 395: the menacing north face of Mt. Morrison (12,277 ft.). Unseen from the road, the western side of this peak has a much different character: a surreal mix of colors and contorted patterns, including this twisted marble "signature" of the Convict Creek Basin masterpiece.

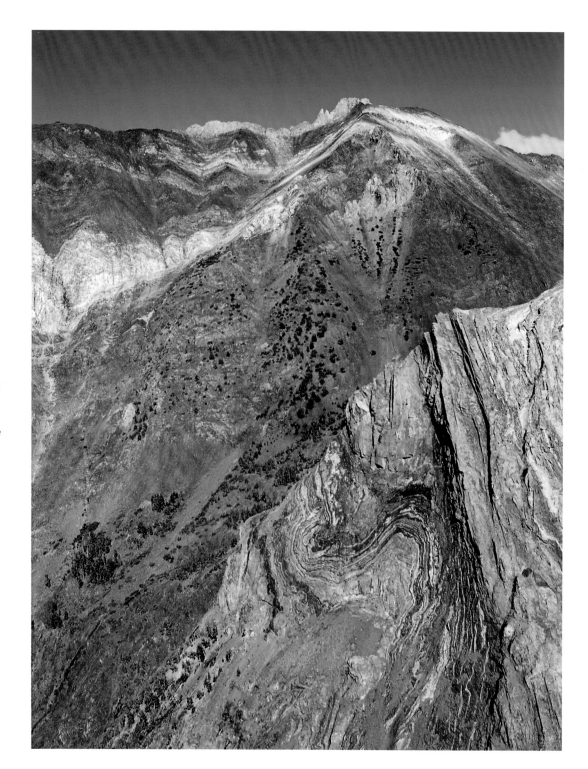

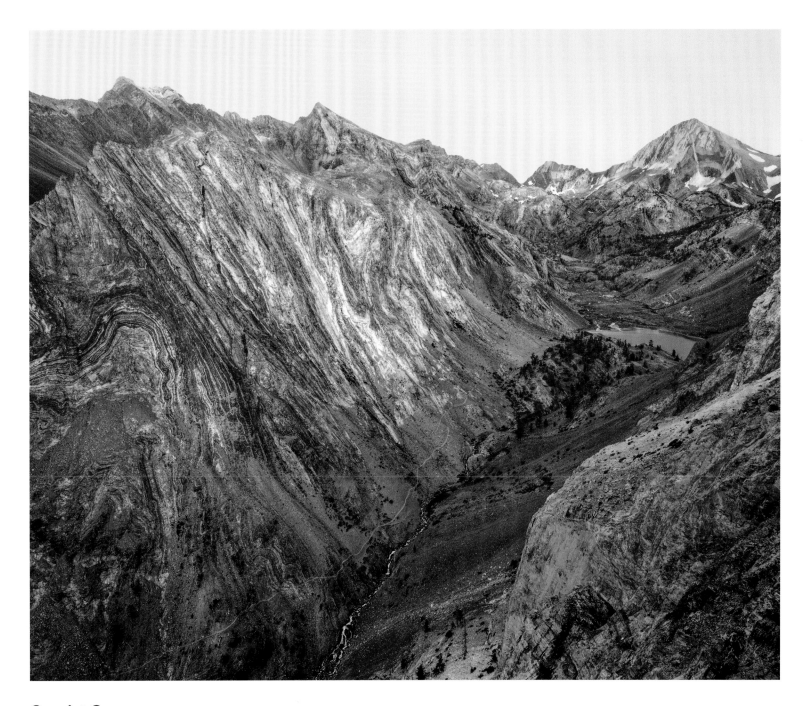

Convict Canyon

Far below, the final mile of the trail up Convict Canyon to Mildred Lake (9,800 ft.) does an upward traverse across colorful marble on the western flank of Mt. Morrison. Mt. Baldwin (center, 12,600 ft.) and Red Slate Mountain (right 13,100 ft.) form the horizon.

Mildred Lake

Mildred Lake, with its warped marble backdrop, is the first
lake on the scenic Convict Canyon trail, about six miles
and 2,200 vertical feet from the Convict Lake trailhead.

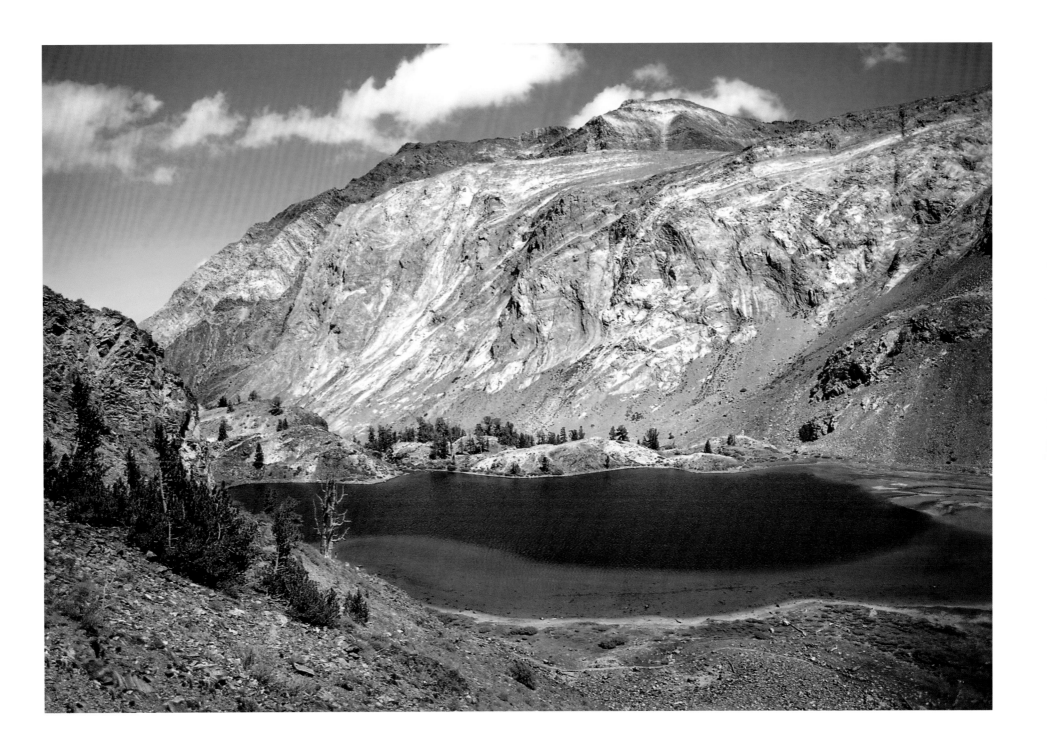

Mildred Lake

Sunset at Mildred Lake with Mt. Baldwin and Red Slate Mountain. Rabbit bush and early fall color on the aspen and willows enhanced this already colorful scene.

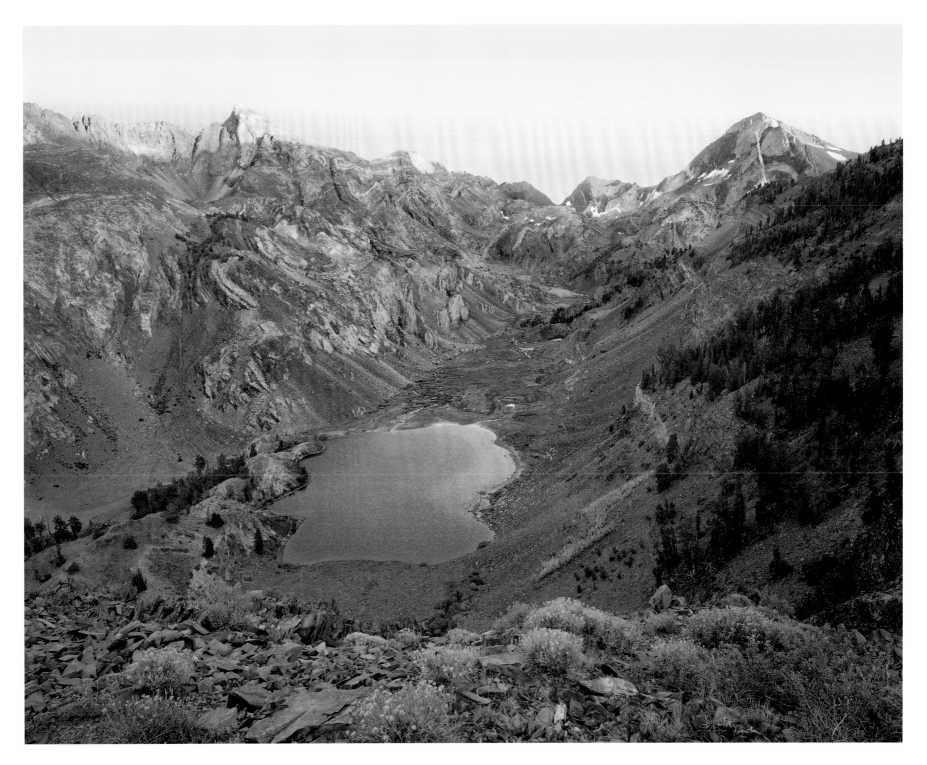

Lake Genevieve and Bloody Mountain

"Another of those charming exhilarating days that makes the blood dance and excites nerve currents that render one unweariable and well-nigh immortal. Had another view of the broad ice-ploughed divide, and gazed again and again at the Sierra temple and the great red mountains east of the meadows." –John Muir

There is an ideal campsite in the lakeside grove of pines on the left, immediately beneath the partially hidden Lake Edith.

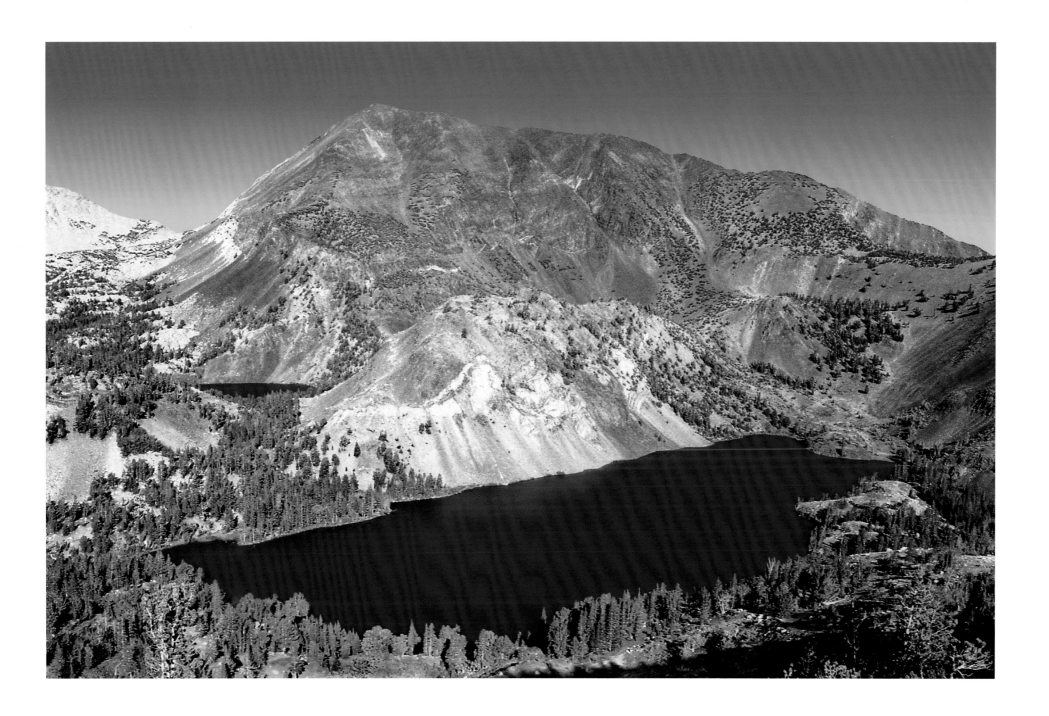

Lake Genevieve and Mt. Morrison

I scrambled up the small colorful ridge (see the previous image) between Lake Genevieve (10,000 ft.) and Bloody Mountain (12,552 ft.) in the late afternoon in hopes of getting a shadow-free, front-lit view of the colorful west side of Mt. Morrison. Several other elements made this scramble worth the effort, including contrasting warm and cold colors, the smooth curves of the lake contrasting with the angular rock patterns, and additional depth provided by some foreground snags and an unexpected distant view of the northern end of the White Mountains (14,000+ ft.).

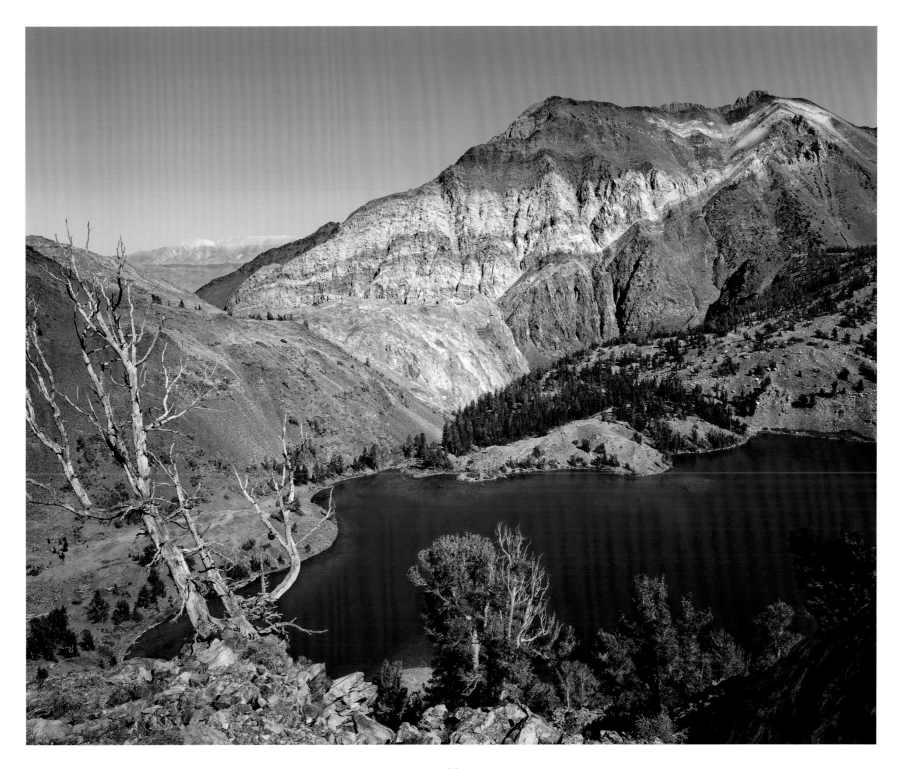

Lake Dorothy

"I only went out for a walk, and finally concluded to stay out till sundown, for going out, I found, was really going in." –John Muir

On my first visit to the Convict Creek basin a constant strong cold wind forced me to strap rocks to the tripod at this location, and of course waves prevented a clear reflection. This scene was one of the main reasons for a return trip several years later. This time calm conditions allowed Lake Dorothy (10,275 ft.) to reflect the sunrise on Red Slate Mountain. An added bonus was the recent rains that greened up the vegetation, including this patch of rabbit bush. No mere words ever come to mind when experiencing a scene like this and many others in the Sierra, and to assign some in retrospect is inadequate. I prefer to let each viewer have their own genuine and unprompted reaction.

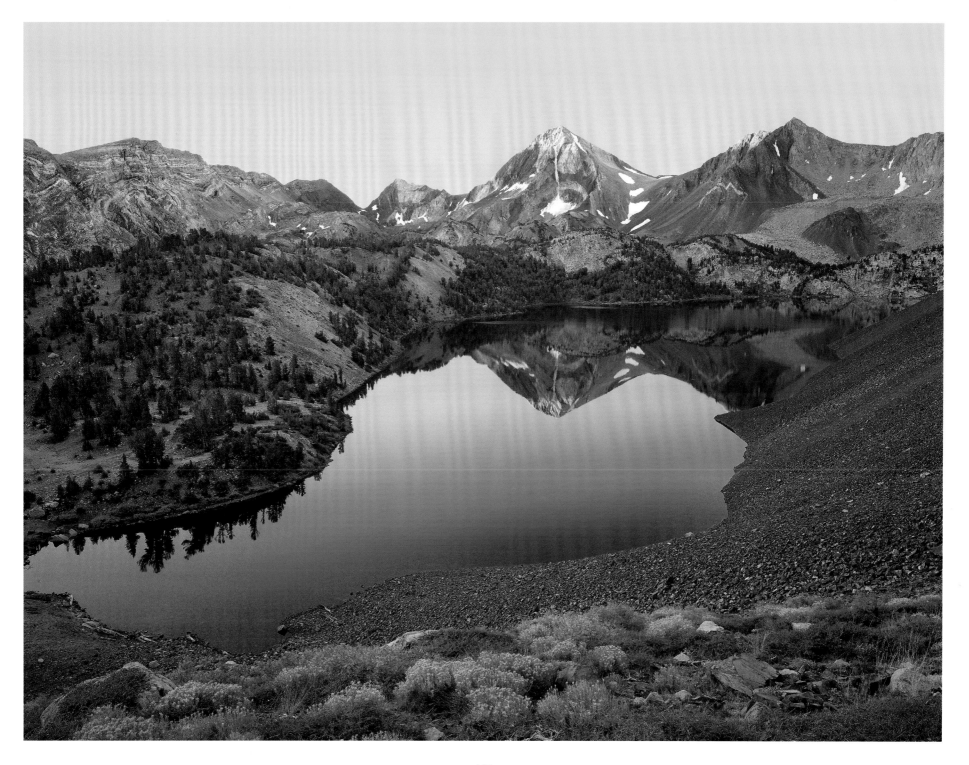

Bright Dot Lake
Bright Dot Lake (10,535), named after Dorothy Bright,
wife of the former owner of Convict Lake Resort,
is perched on the colorful southwestern flank
of Mt. Morrison.

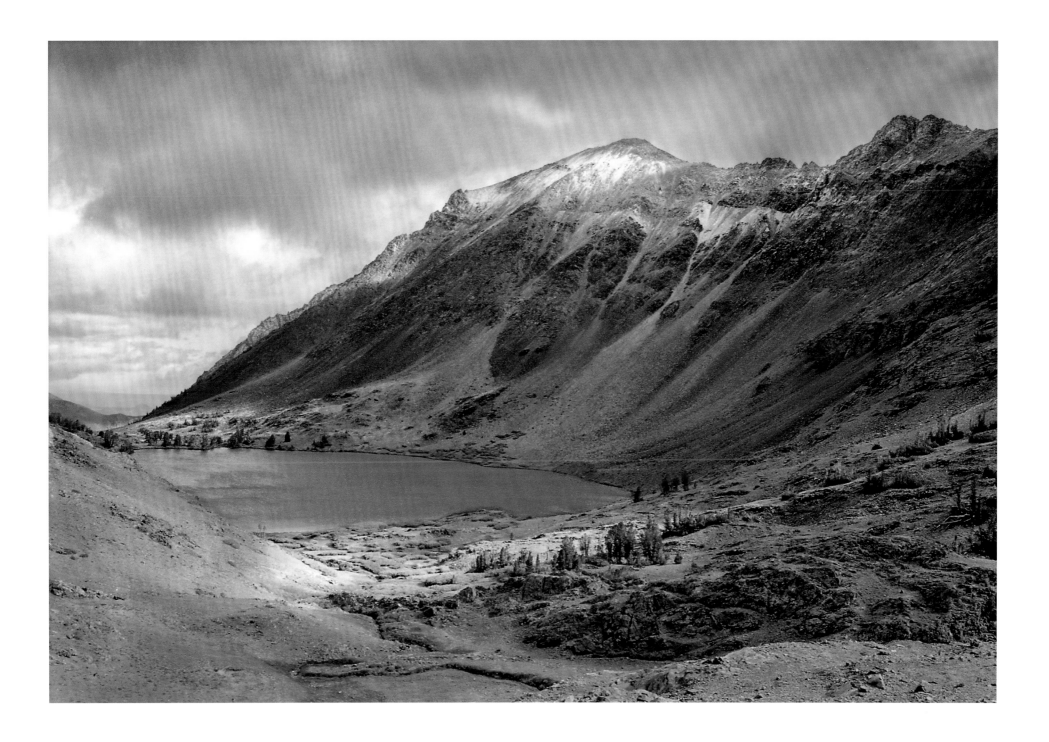

Cloverleaf Lake and Bloody Mountain

I anticipated multi-lobed Cloverleaf Lake (10,400 ft.) adjacent to colorful Bloody Mountain would provide good photo opportunities. Here at the lake's outlet stream, the seam between the overlying red, iron-rich metamorphic rocks and the underlying light granitic rocks is clearly visible.

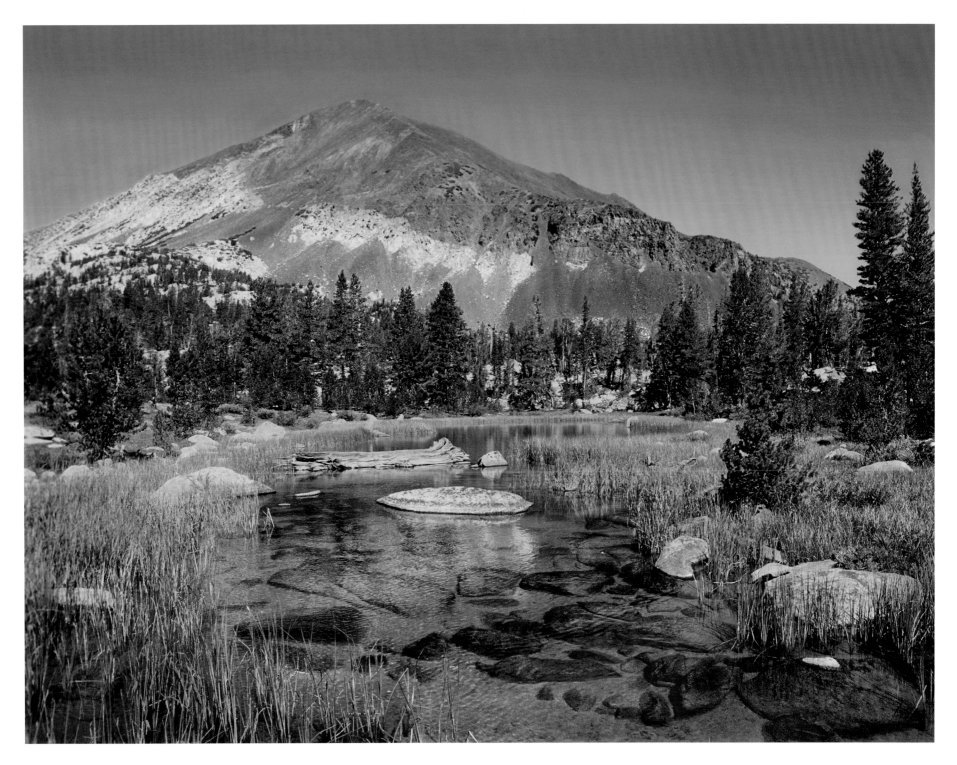

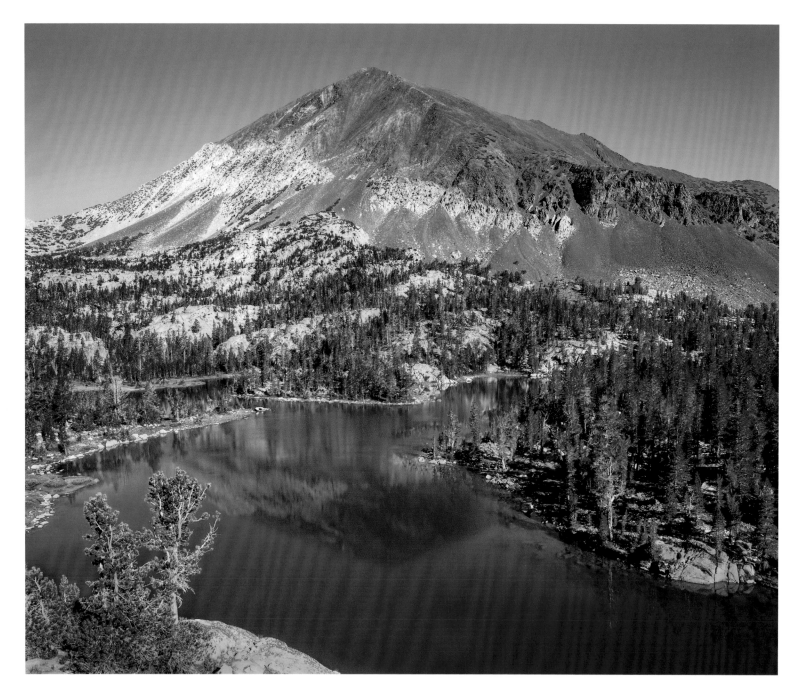

Cloverleaf Lake and Bloody Mountain

The view of Bloody Mountain across Cloverleaf Lake was nice from the shoreline, but once again, a good scene was improved by turning around and looking for an elevated position. In this case depth was added and the shape of the lake was revealed.

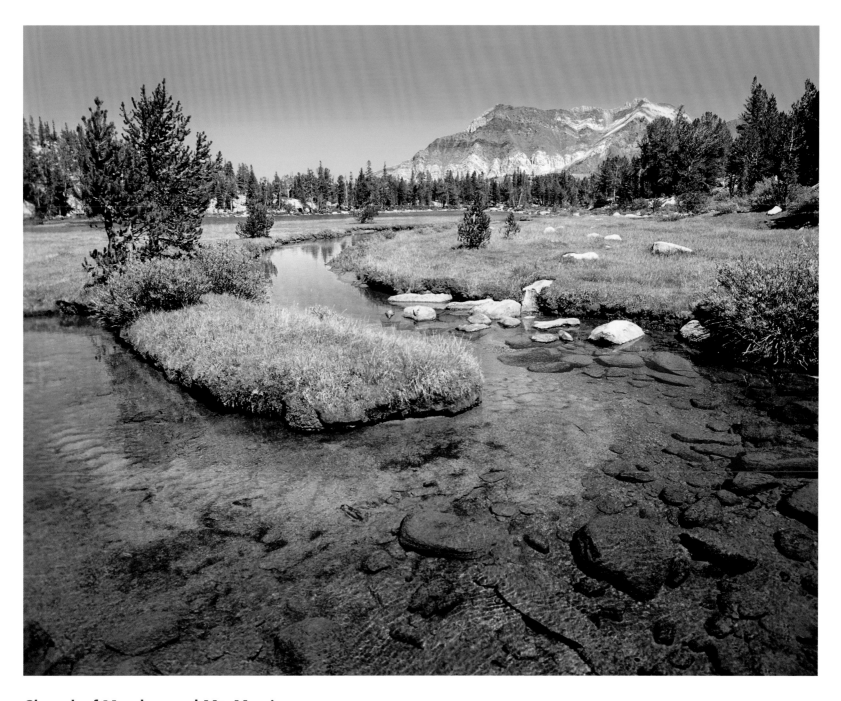

Cloverleaf Meadow and Mt. Morrison

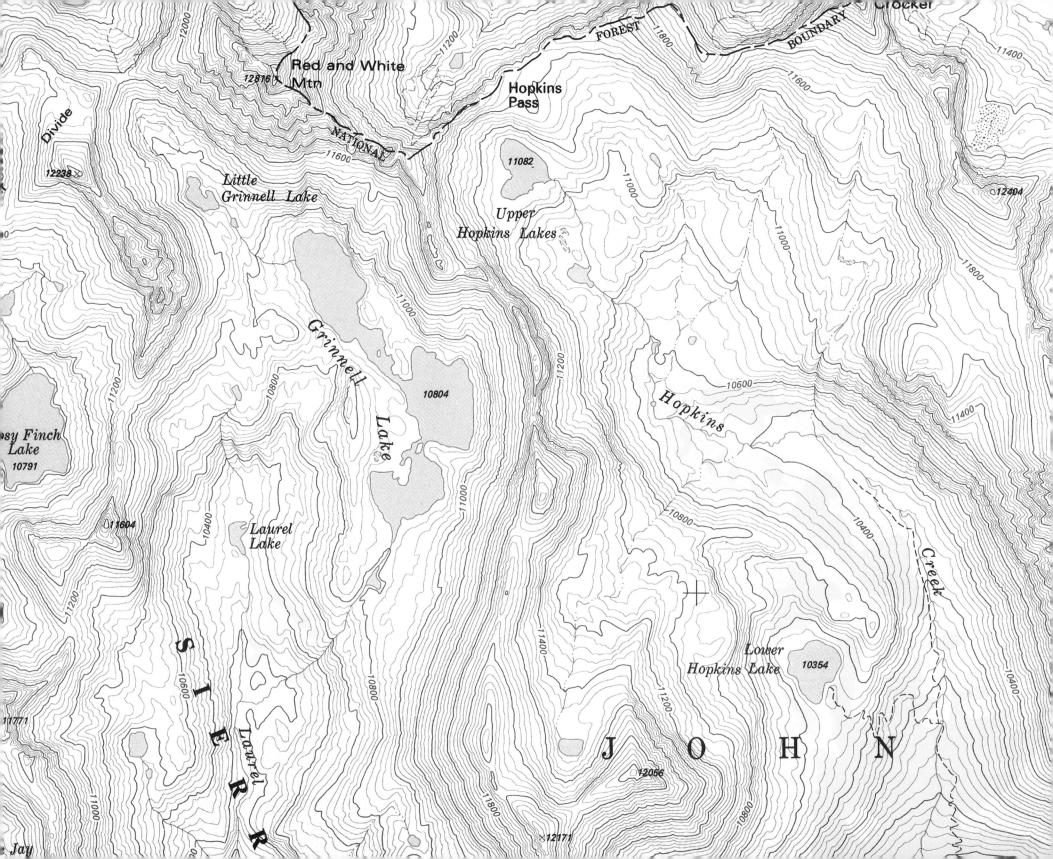

John Muir Wilderness

"...a territory of solid granite and darker hued metamorphic rock, the surface of which was rent, upheaved, and disheveled into a bewildering confusion of peaks, walls, detritus piles, pinnacles, and cliffs, massed and fairly crowding upon the view; and among them, like jewels, were patches of snow and cold lakes, like black-blue eyes, and here and there a little gnarled tree, which was almost painful in the landscape, because of its suggestion of a nether world of things that live."

–early Sierra explorer Theodore Solomons, 1895

The initial preservation of the Sierra south of Yosemite National Park occurred in 1893, when logging, grazing, and mining were prohibited under the Forest Reserve Act. However, this was overturned by the Forest Management Act of 1897, which repurposed the Forest Reserves to "furnish a continuous supply of timber" and allowed mining and grazing.

When Kings Canyon and Sequoia National Parks were established in 1890 and 1940, respectively, the eastern boundary of both parks was the crest of the Sierra and did not include the eastern half of the highest peaks in the range. In 1964, the creation of the John Muir Wilderness by the Wilderness Act preserved this eastern escarpment, along with much of the mountainous region between Kings Canyon and Yosemite National Parks.

The John Muir Wilderness contains the typical Sierra assortment of numerous high peaks and glacial lakes, but its unique feature is the largest contiguous area of land above 11,000 feet in the continental US, the relatively flat subalpine tundra in Humphreys Basin and the upper French Creek drainage.

Sierra Nevada Sunrise

"How glorious a greeting the sun gives the mountains." –John Muir

Viewed from the White Mountains, the steep eastern escarpment of Sierra Nevada rises 10,000 feet above the Owens Valley and Bishop (the darker area on the right). The previous evening I surveyed several miles of potential foregrounds for this image before settling on these bristlecone pine snags and leading lines of Silver Canyon.

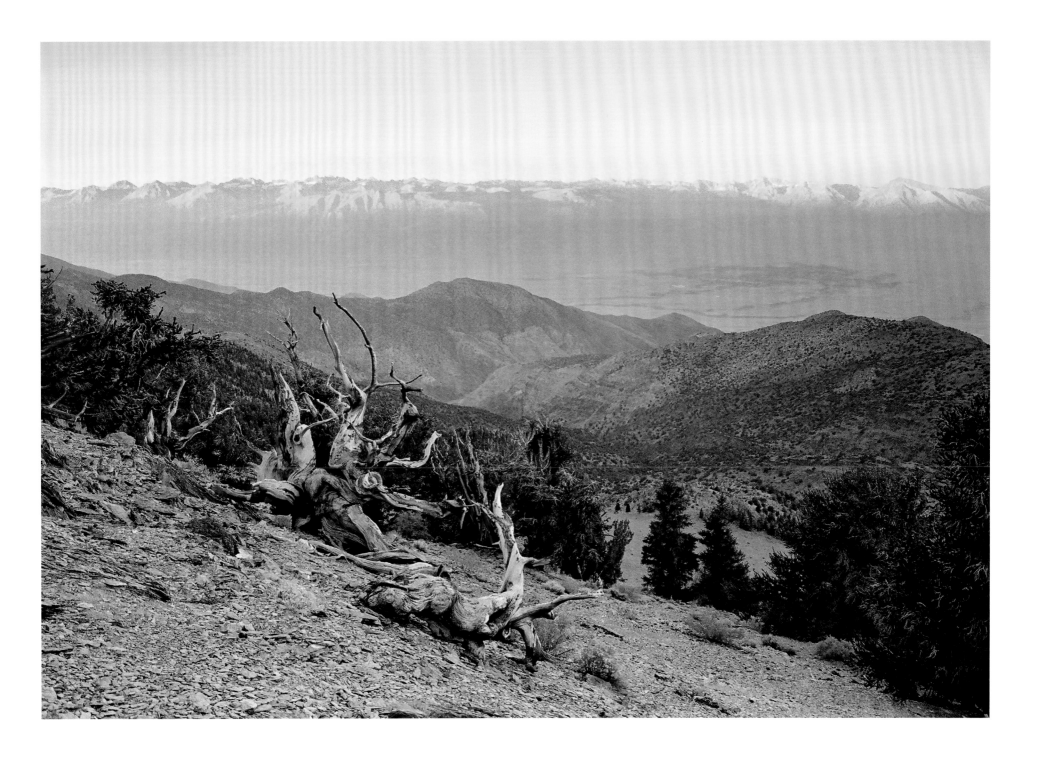

Red Mountains

Red and White Mountain (left, 12,816 ft.) and Red Slate Mountain (right) are part of a colorful ridge of metamorphic rock that continues north to Mt. Baldwin and ends at Mt. Morrison and Convict Lake. Crocker Lake, Big McGee Lake (~10,500 ft.), and Little McGee Lake (front to back) are visible in this view across upper McGee Canyon from the shoulder of Mt. Crocker.

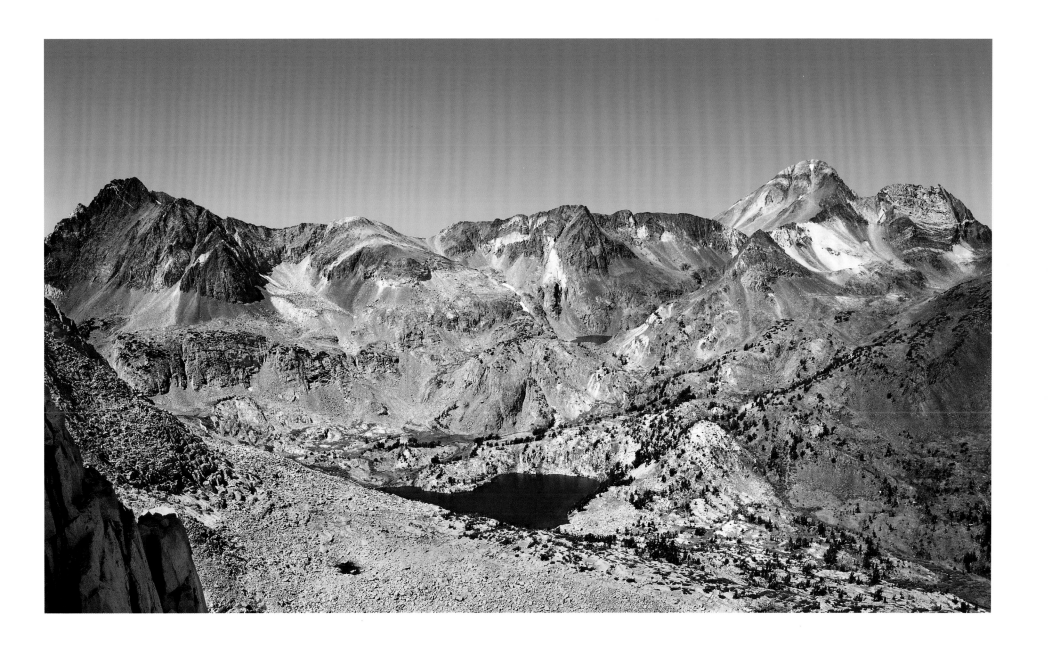

Pioneer Basin

One of the easier hikes over the Sierra crest from
the east side is from the highest trailhead in the Sierra,
Mosquito Flat (10, 440 ft.). It is a three and one-half mile
hike with 1,800 feet of climb to Mono Pass (upper left).
On the west side of the pass are the upper tributaries and
lake basins of Mono Creek, including Pioneer Basin
(foreground), Fourth Recess (left, midground), and Third
Recess (right). Mt. Abbot (13,704 ft.) is the highest visible
peak. Next time I will avoid the blue mid-day light by
camping near this ridge that overlooks McGee Canyon
(previous image) in the other direction.

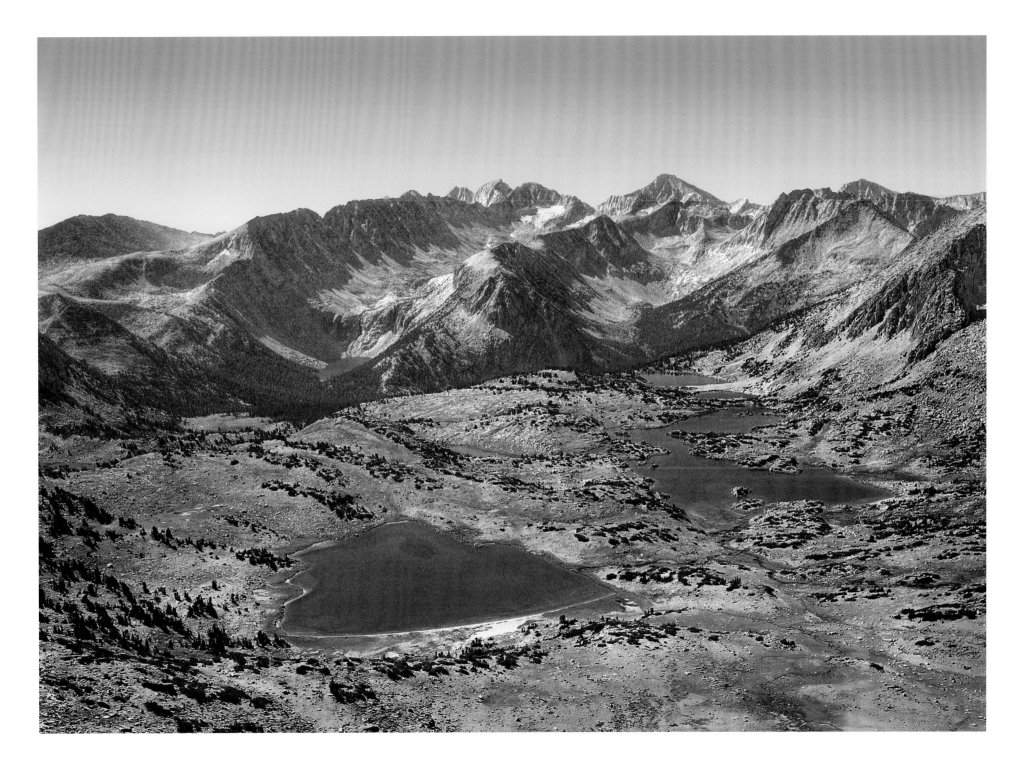

Mud Lake

From the time we left the parking lot at Mosquito Flat my
friend's cell phone was not able to get a connection until,
a day and a half later, we arrived at the first (10,800 ft.)
of the Pioneer Basin lakes in the John Muir Wilderness.
"Hello Dad, I've found heaven on earth!" were his first
words to describe this view from the campsite that we
shared with a pair of uncommon White-tailed ptarmigan.
The numerous ripples on the lake are from the largest
display of jumping trout I have ever seen. From the left:
Mt. Star (12,835 ft.); Mono Pass (12,200 ft.)—our route
in and out; Mt. Mills (13,451 ft.) at the far end of the
alpenglowed ridgeline; and Mono Rock (11,554 ft.),
the peak just right of center. I found out later in a
Sierra fishing guidebook that this heavenly lake
had already been named Mud Lake.

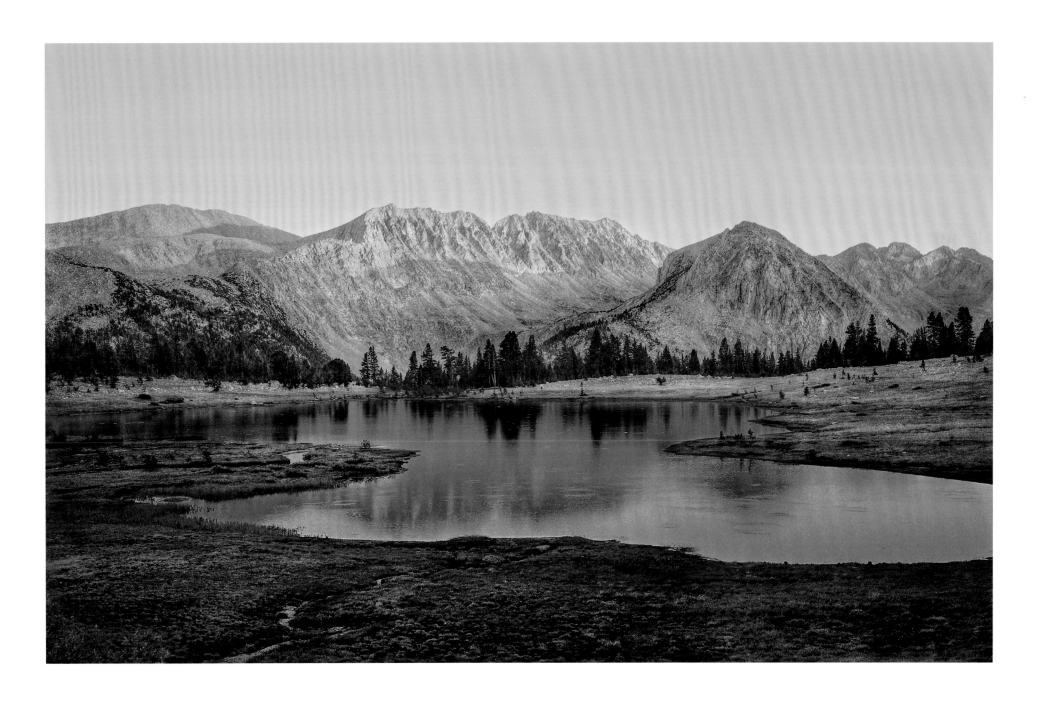

Mud Lake

"If this were the Alps there would be a hotel over here, a gas station over there..." –a German backpacker

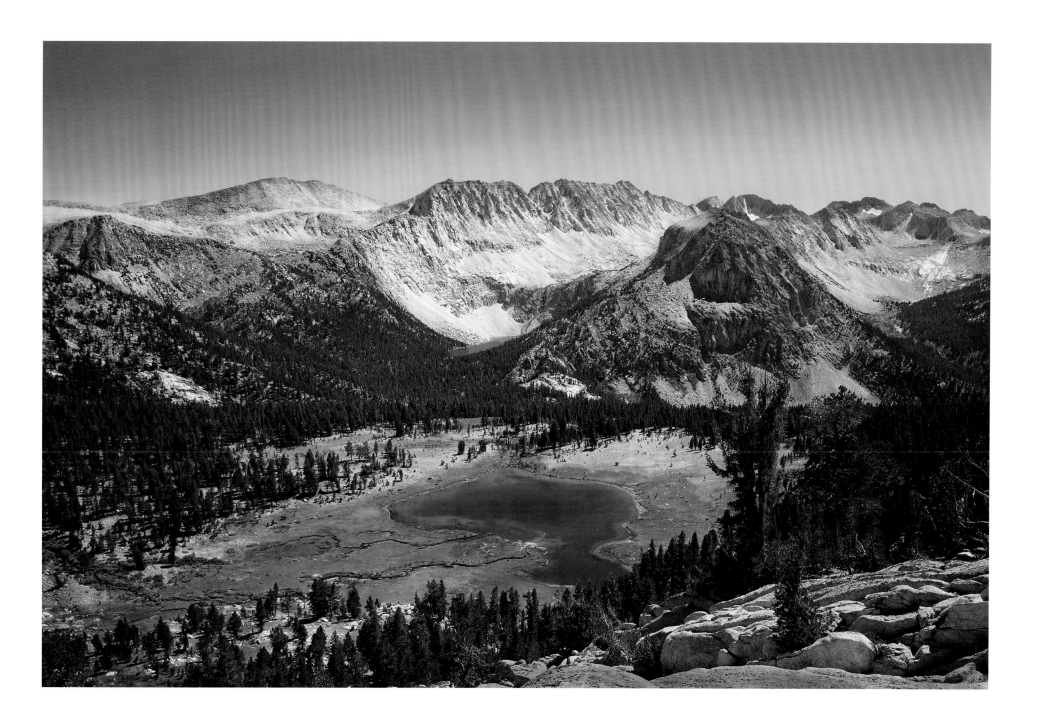

Cockscomb and Big Margaret Lake

Less renown but more impressive than the Cockscomb near Tuolumne Meadows in Yosemite, this one is at Big Margaret Lake in the remote northwestern corner of the John Muir Wilderness.

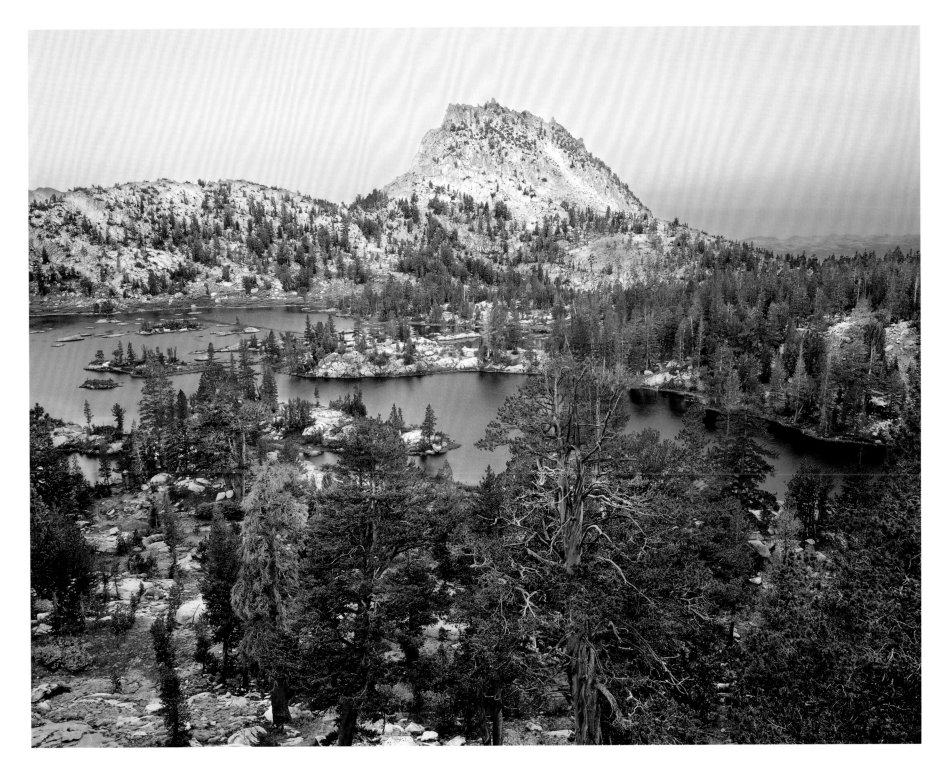

Sublime and Awful

"Words are puny things, and the language of description quite as impotent as the painter's brush. Roughly speaking, one might say that the sight was sublime and awful." –Theodore Solomons, 1895, the first ascender of Seven Gables, describing the view from the top.

This gnarled terrain around Ursa and Big Bear Lake (11,300 ft.) and Seven Gables (13,080 ft) was at least partially responsible for Solomons' description. Although there are unmaintained use trails at several places, this remote area is about as far from a maintained trail as you can be in the Sierra.

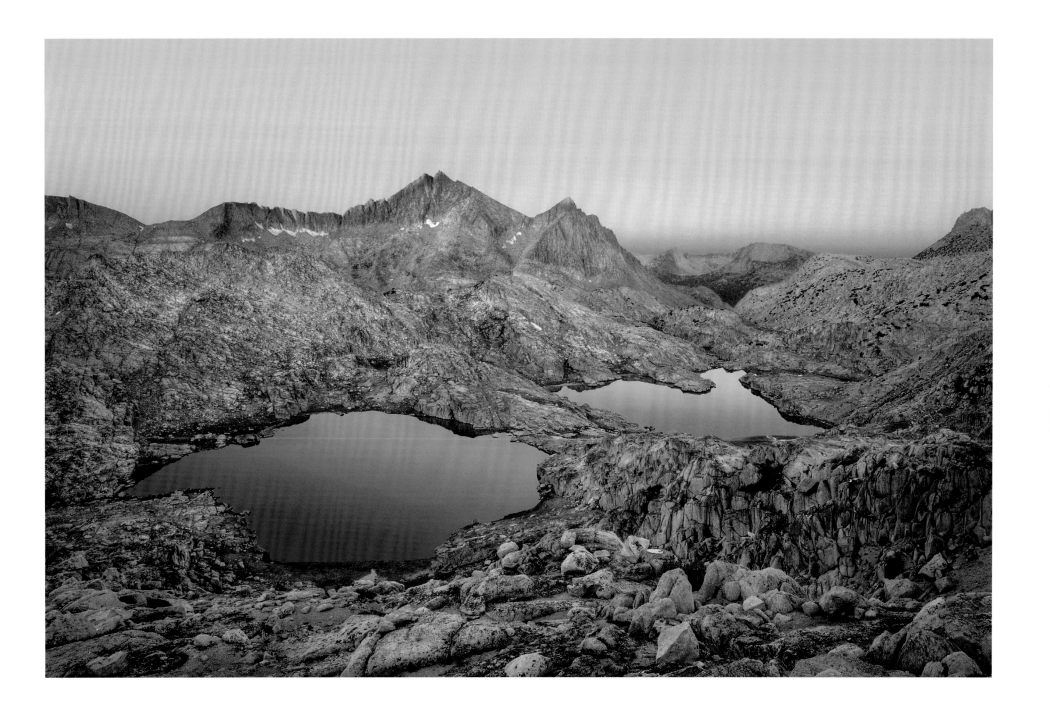

Granite Park

With Mt. Humphries (13,986 ft.) in the distance, an
unnamed lake in the heart of the Granite Park basin
is in the final stage of the lake-to-meadow transition.
The reddish hues among the golden grasses are
the backlit leaves of the Sierra bilberry.

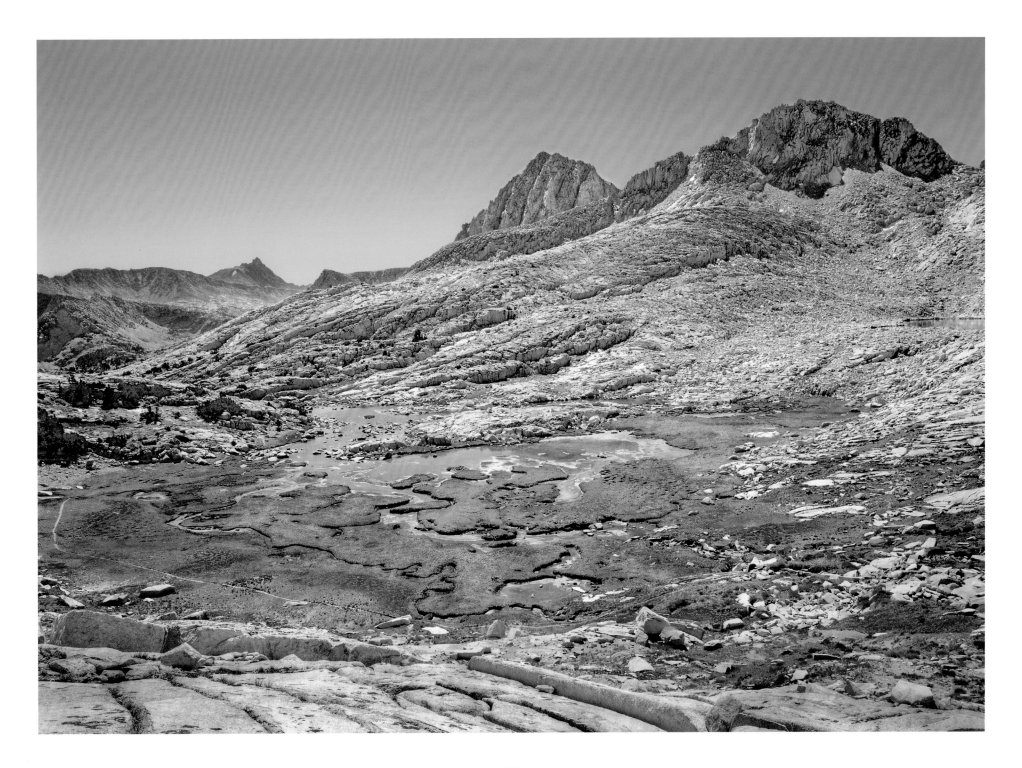

Pine Creek Basin

"Though the eastern flank of the range is excessively steep, we find lakes pretty regularly distributed throughout even the most precipitous portions. They are mostly found in the upper branches of the cañons, and in the glacial amphitheaters around the peaks."

–John Muir

Notable features in the Pine Creek basin include: Lakes (l–r) Golden, Honeymoon, unnamed, Upper Pine, and Lower Pine. Peaks (l–r) Peppermint Peak (12,680 ft., the striped east ridge of Bear Creek Spire), Mt. Morgan (far left, 13,748 ft.), Broken Finger Peak (13,086 ft.), and the distant White Mountains.

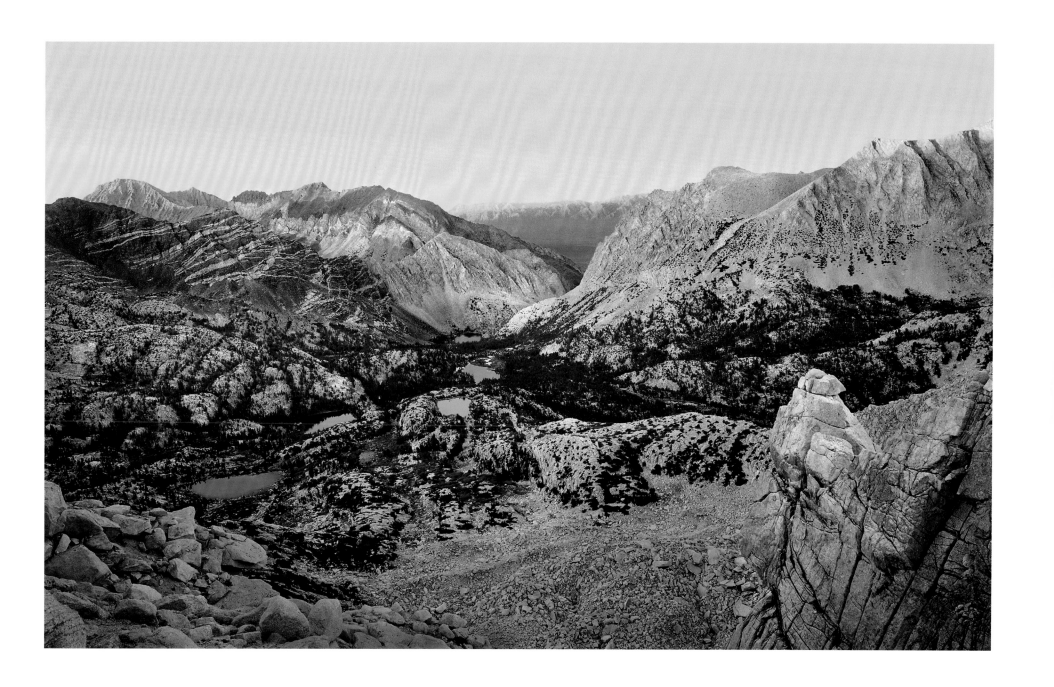

Royce Lakes and Merriam Peak

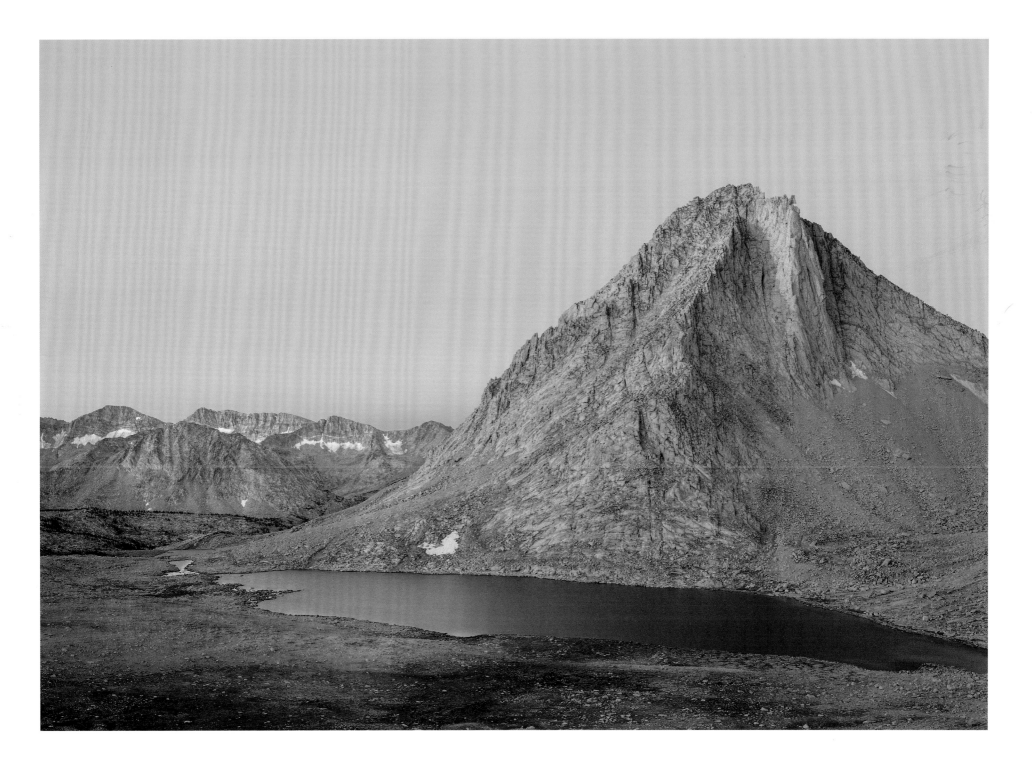

French Lake
Subtle colors and terrain at French Lake (11,265 ft.).
Merriam Peak (left 13,103 ft.) and Royce Peak catch
the hazy morning sun.

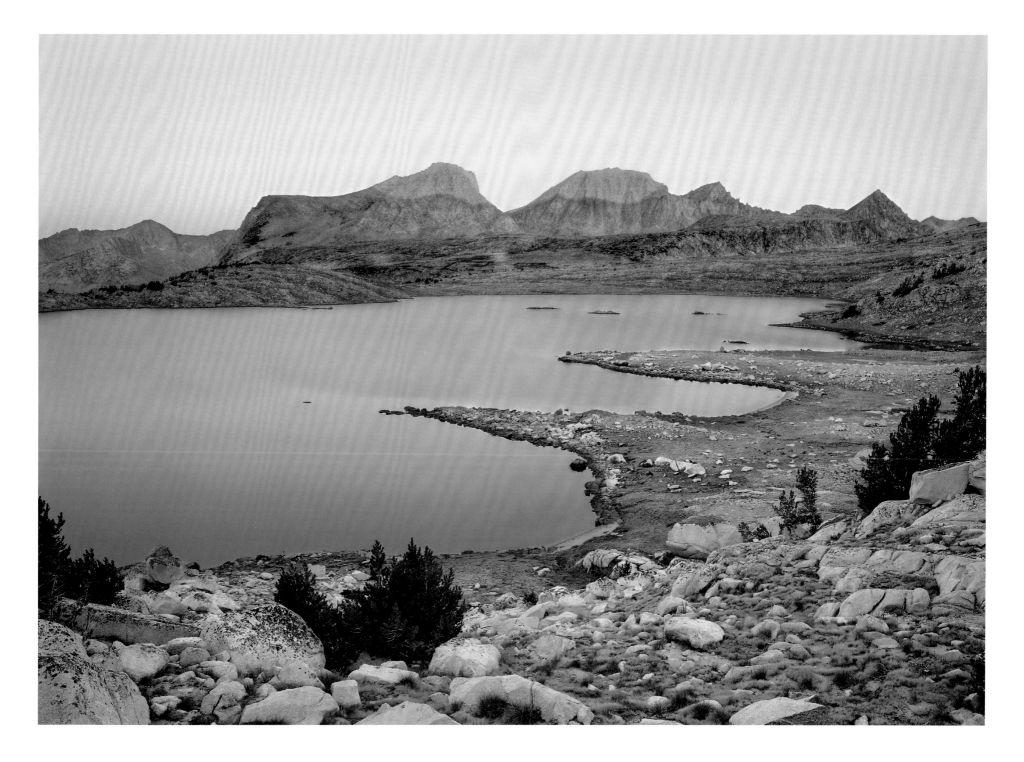

French Meadows and Mt. Humphries
"How pleasingly this basin contrasts with the severity of the Kings-Kern Divide—its long inclines, its broad hollows filled with lakes and meadows, its somber distant aspect of ridges and forests, all blending in soothing tranquility with the late afternoon diffusion of sunlight!" –David Brower, 1935

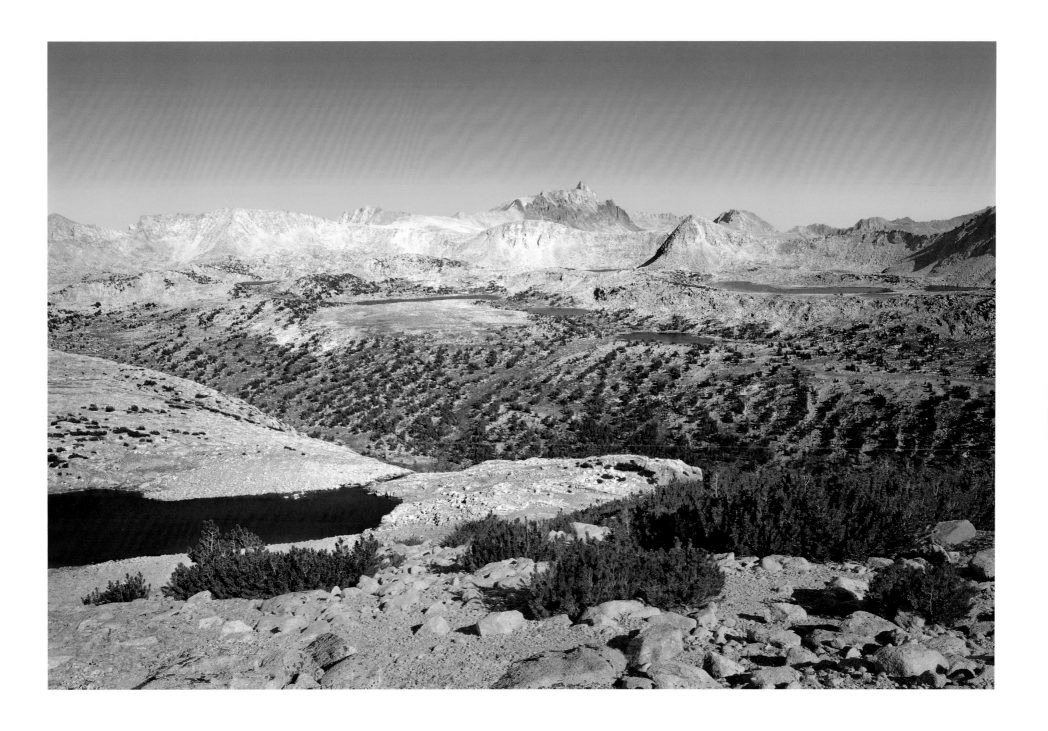

French Meadows from Pilot Knob

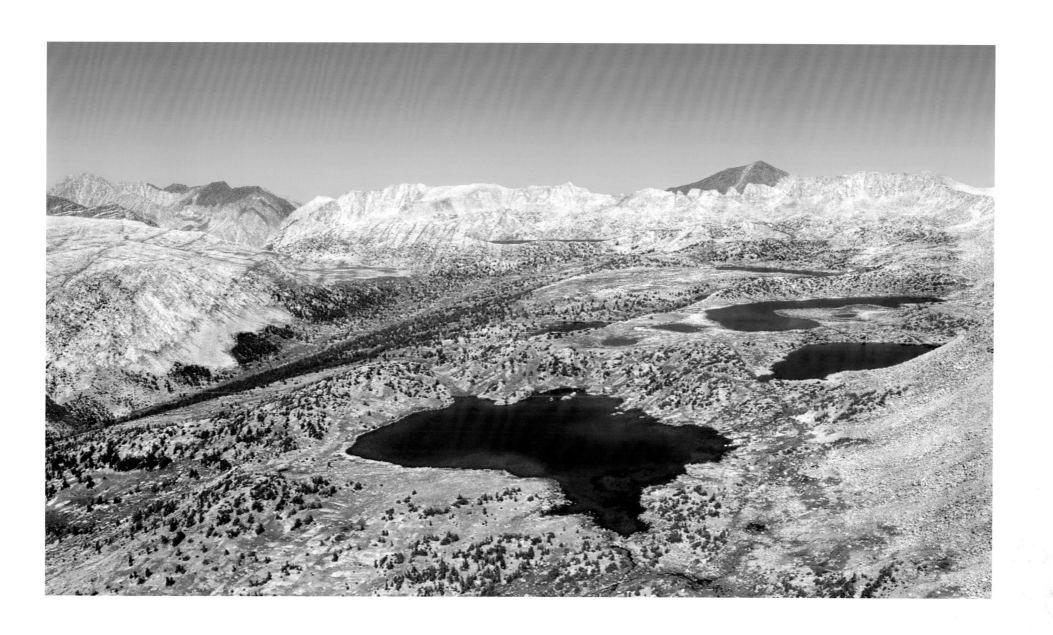

Bilberry at Knob Lake

The finest patches of Sierra bilberry that I have ever
seen in the Sierra are in Humphreys Basin in the vicinity
of Knob Lake, Square Lake, and Mesa Lake (11,300 ft.).
This low growing shrub turns a rich red color in fall
that is quite bright when backlit by the sun.

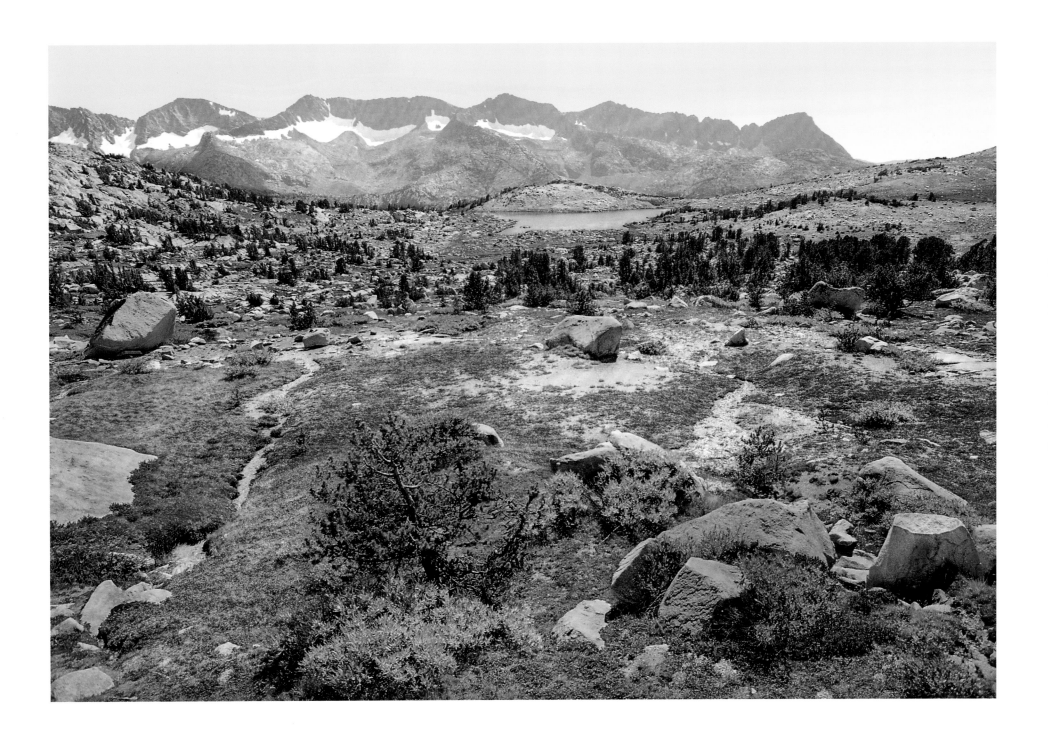

Tundra at Mesa Lake

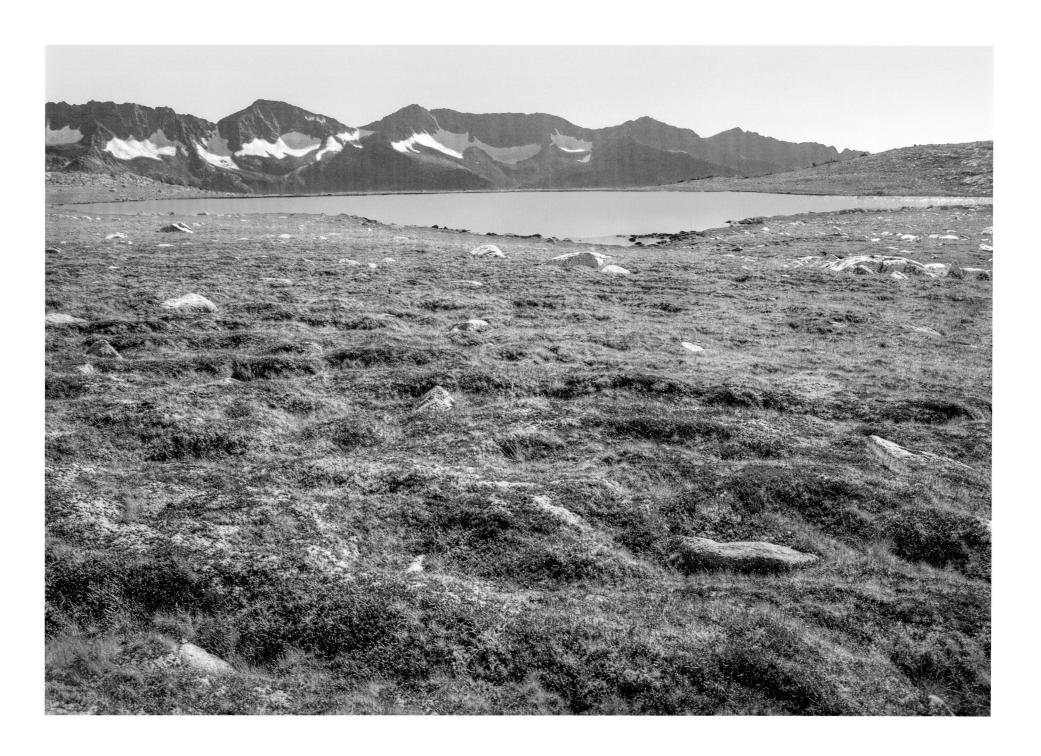

Humphries Lake and Mt. Humphries

"The remoteness of these lovely places—the leisure of toil behind us as the even greater beauty to come as we approach the climax of the great range and the spirit of comradeship and sympathy of ideals among the members of this party—the simple food and the glorious pagan activity—it is all a delicious procession of unearthly experiences discounting civilization and chronological time."
–Ansel Adams

At the base of the western face of Mt. Humphries, in the remote eastern edge of Humphreys Basin, is the largest of Humphries Lakes (11,600 ft.). Although it is best to camp farther from lakes, there weren't many flat options.

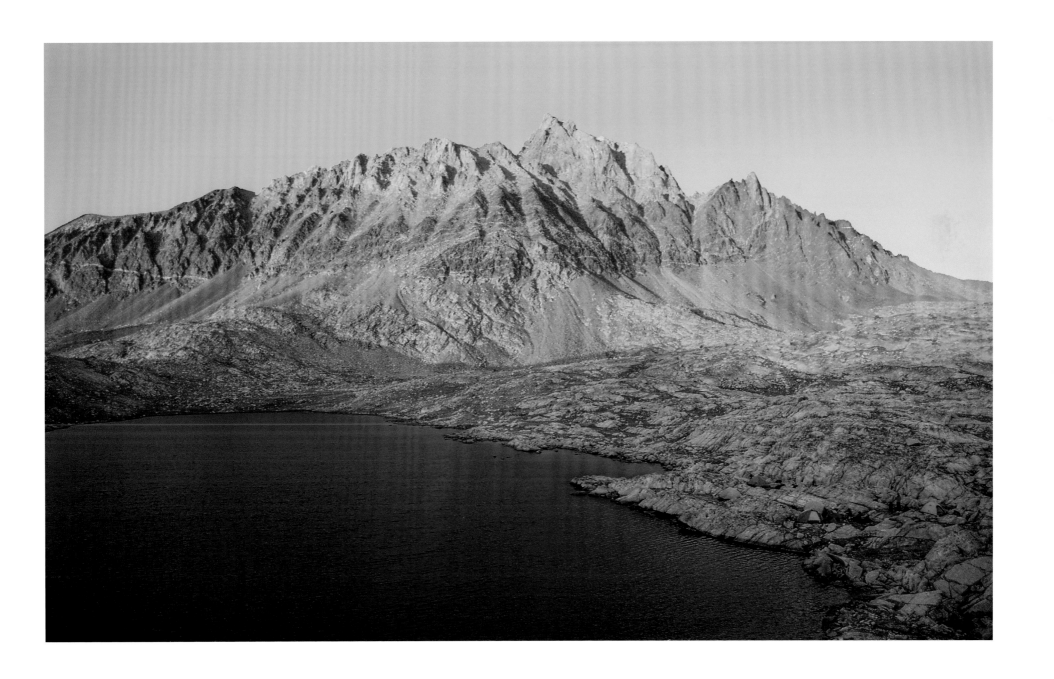

Muriel Lake

Almost one mile long and curiously symmetric, Muriel
Lake sits in the southeastern corner of the tundra flats.
Mt. Humphries dominates the eastern horizon.

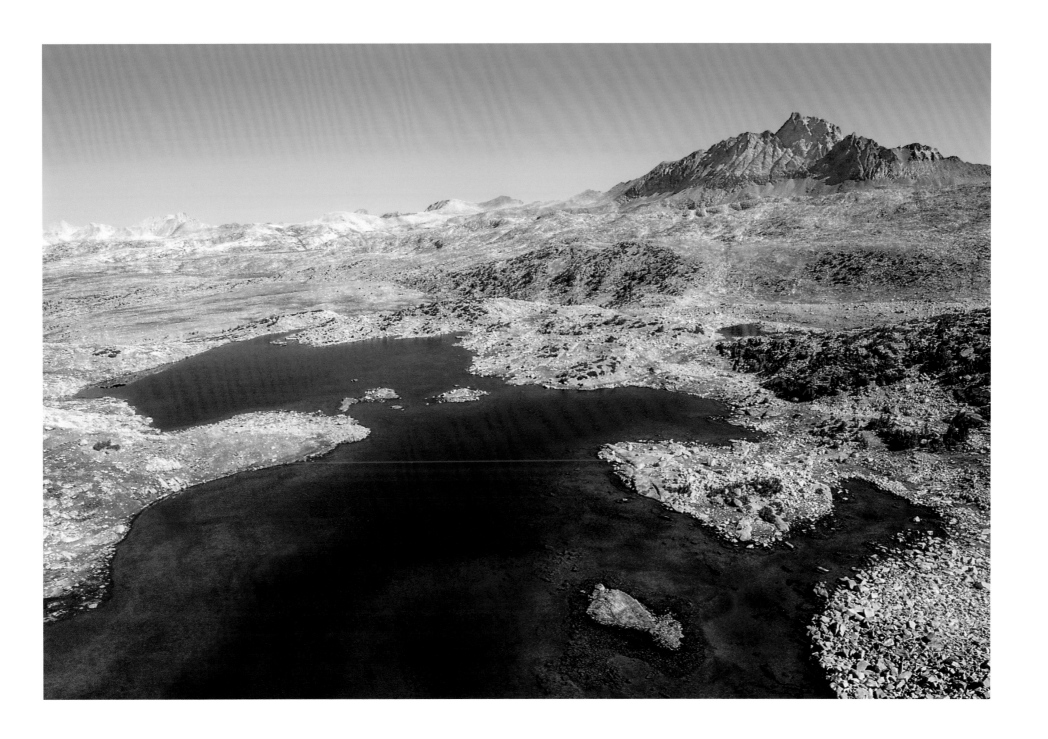

Bishop Creek

"You're off to great places!
Today is your day!
Your mountain is waiting.
So get on your way." –Dr. Seuss

A stream crossing on Middle Fork Bishop Creek near Dingleberry Lake.

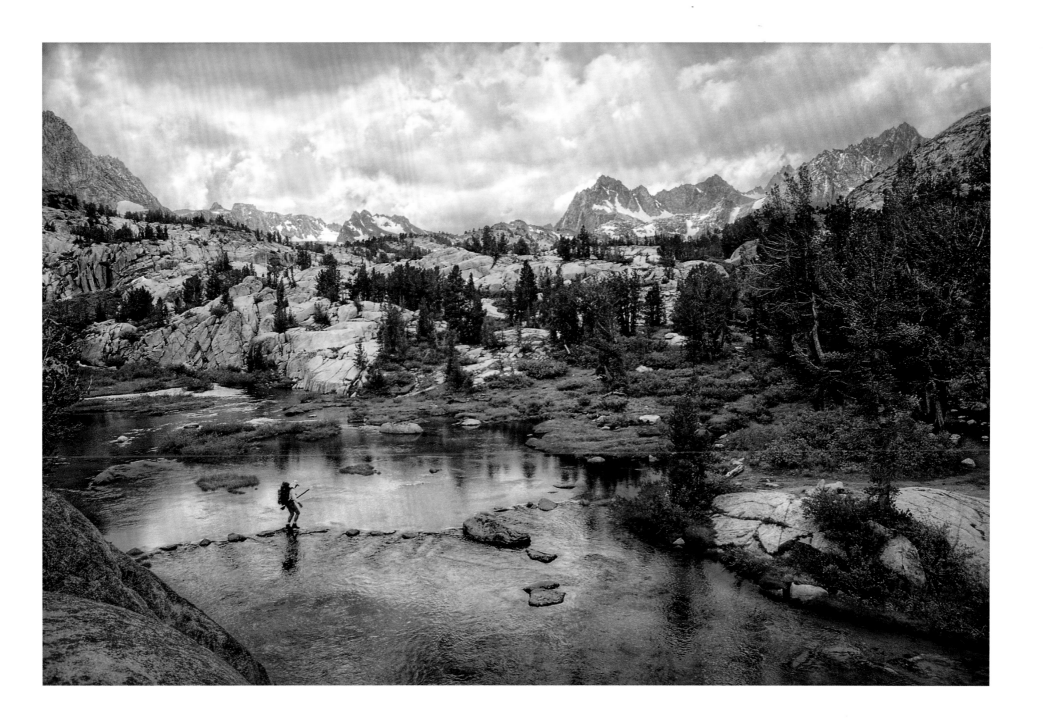

Topsy Turvy Lake

The name alone merited taking the short cross-country detour to Topsy Turvy Lake (~10,800 ft.). I rock hopped to the far side to get the reflections of Mt. Powell (left 13,364 ft.) and Picture Peak (right-center, 13,120 ft.). Mt. Haeckel (13,418 ft.) is on the far right. I was thankful for the high clouds that produced warm, shadowless light without the mid-day blue tinge of a sunny day.

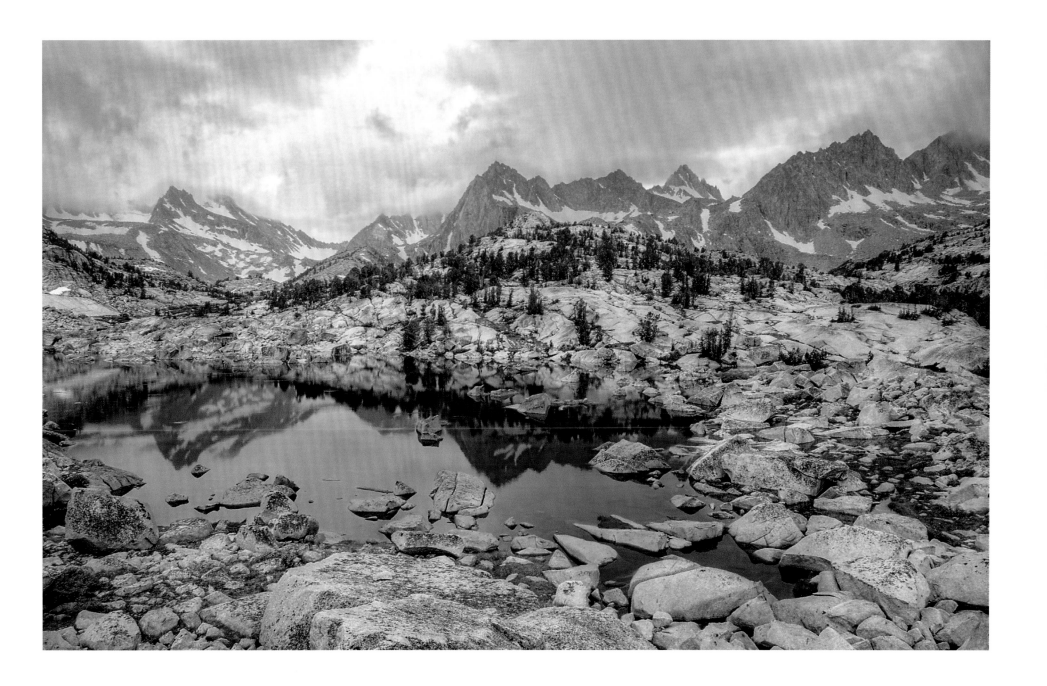

Columbines

"Who could imagine beauty so fine in so savage a place? Gardens are blooming in all sorts of nooks and hollows." –John Muir

Despite John Muir's observation that "...every attempt to appreciate any one feature is beaten down by the overwhelming influence of all the others," I could not resist a portrait of this Columbine nestled in a large boulder field near Topsy Turvy Lake.

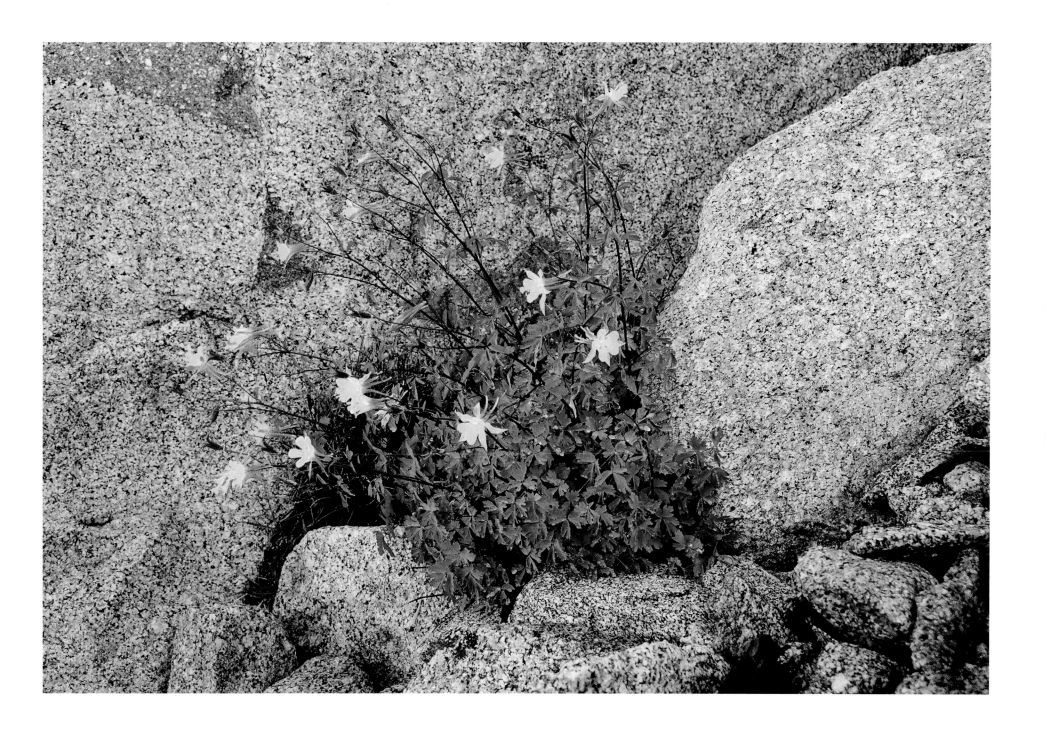

Sailor Lake

Along the Middle Fork Bishop Creek cascading streams, pools, and waterfalls are scattered among the larger lakes. Originally named Drunken Sailor Lake after such an individual was found recovering there, the open terrain made cross-country travel much easier than trying to find an indistinct trail.

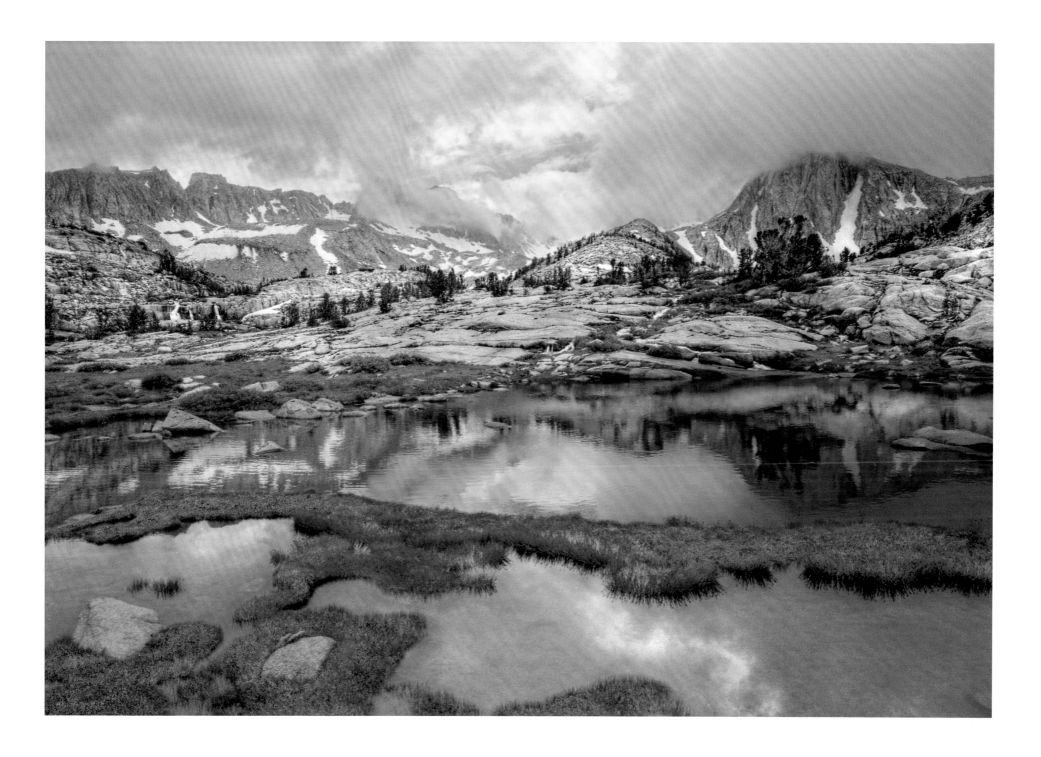

Echo Lake

"The violets in the mountains have broken the rocks." –Tennessee Williams

Adventure photographer Galen Rowell said that days spent in the Sierra's rugged isolation could produce "spiritual rewards," but backpacking with photographic and essential gear, "…rarely passes the gumption factor of being worth the effort." Even my worst Sierra trip was easily worth the effort. Persistent summer rain— uncommon in the Sierra—from the remnants of a Pacific hurricane blew in and kept us tent bound at Echo Lake (11,602 ft.) for much of Labor Day weekend. Finally the rain eased and the fog lifted enough behind this colorful alpine rock garden to reveal most of Clyde Spires (13,267 ft.) and distant Echo Pass.

 Although it was tempting in this instance, a lower viewpoint emphasizing the flowers might have made a more creatively expressive image, but it would have conveyed a less realistic, dog's-eye-level experience to the viewer.

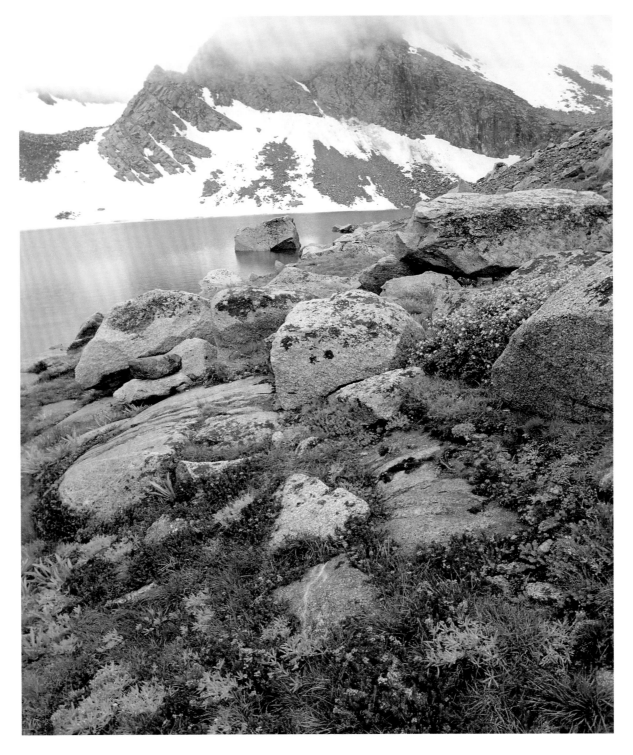

Lamarck Col

Although considered a cross country route due to
the lack of a maintained trail, heavy use of Lamarck
Col (foreground 12,960 ft.) to cross the Sierra crest has
created a well worn trail on most of the route. On the far
left Mt. Agassiz (13,893 ft.) and North Palisade (14,242 ft.)
are the two most prominent peaks in this view looking
southeast down the Sierra crest from the top of Mt.
Lamarck (13,417 ft.).

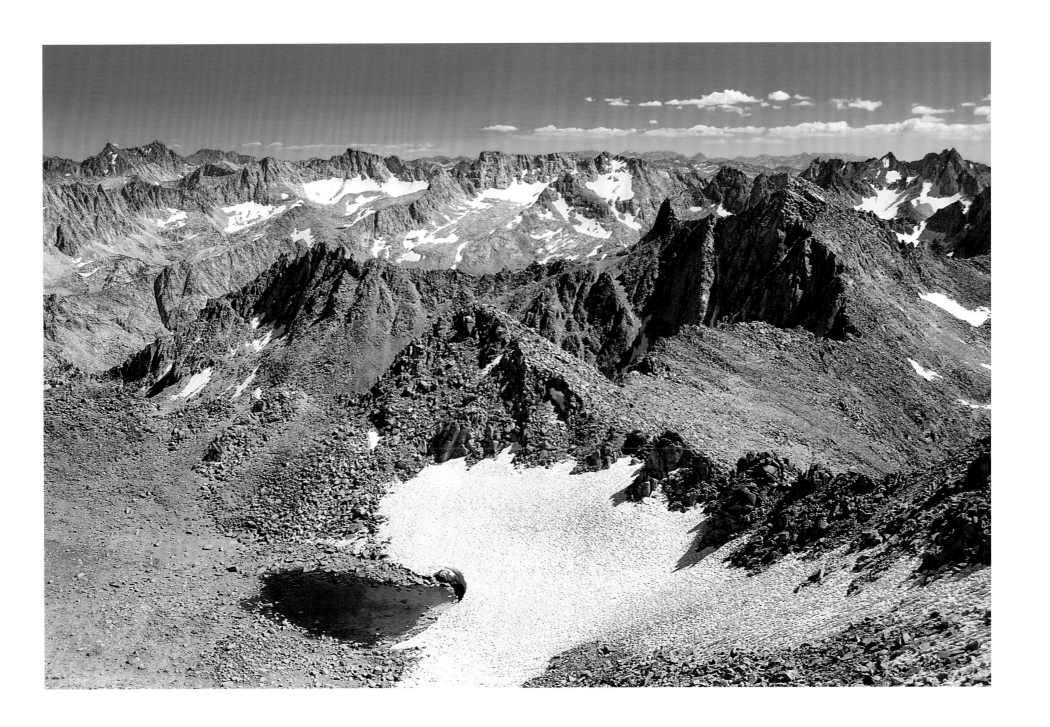

Chocolate Peak from Cloudripper

"All the upper branches of the rivers are fairly laden with lakes, like orchard trees with fruit. They lie embosomed in the deep woods, down in the grovy bottoms of cañons, high on bald table-lands, and around the feet of the icy peaks, mirroring back their wild beauty over and over again." –John Muir

I expected a good view of Bishop Creek Basin, but it wasn't until I gained Cloudripper's north ridge (~13,000 ft.) that I realized how Chocolate Peak (11,682 ft.) got its name. There in the middle of a lake-filled, gleaming granite basin was what geologists call a "roof pendant" of metamorphic rock; a remnant of the dark metamorphic rocks, most of which were pushed aside and eroded away during formation of the Sierra. Also visible on the far left, with its characteristic arching ridges, is a good-sized rock glacier. These are moving glaciers that are covered with rocks. They can exist at lower elevations because the rocks serve as insulation from warm air and the sun's rays. The highest peak on the far right is Mt. Darwin (13,830 ft.).

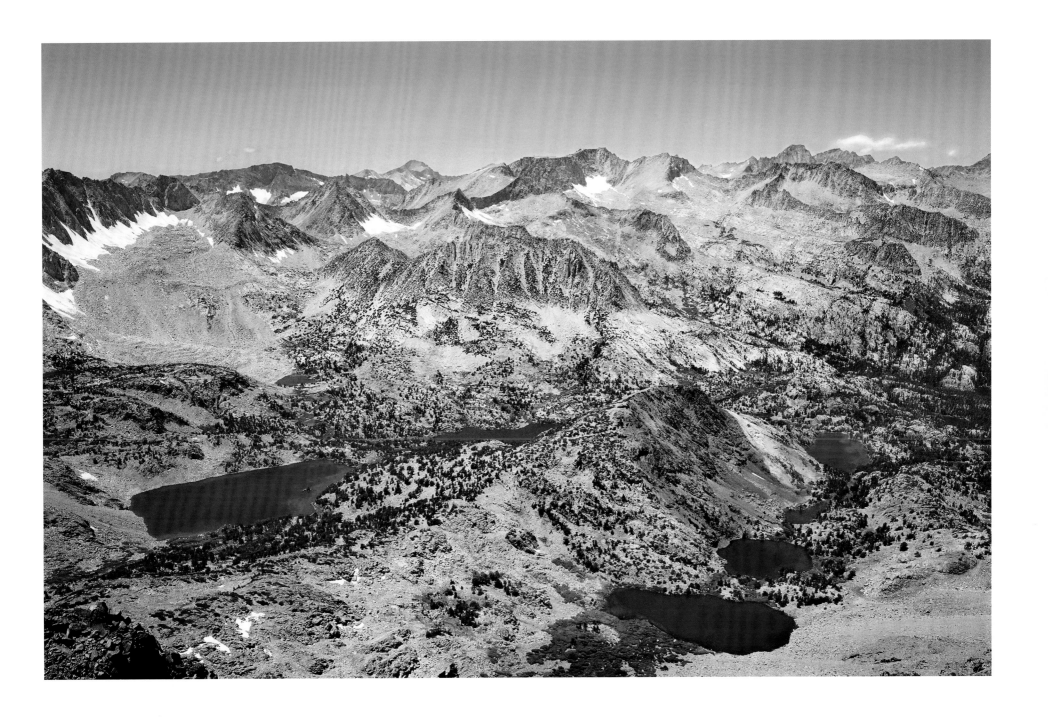

Thunder and Lightning Lake

The names suggested doom when camped at 13,000 feet in the Inconsolable Range between Cloudripper Peak and Thunder and Lightning Lake.

When hiking, I typically spend the day looking for a good evening and morning scene and then camp nearby. Conveniently, this evening location was just a few feet from my camp site and the following morning scene of the Palisades. The distant ridge is the White Mountains on the far side of Owens Valley. Alpine sunflowers provide some relief from the barren, rocky foregrounds that are tough to avoid above treeline.

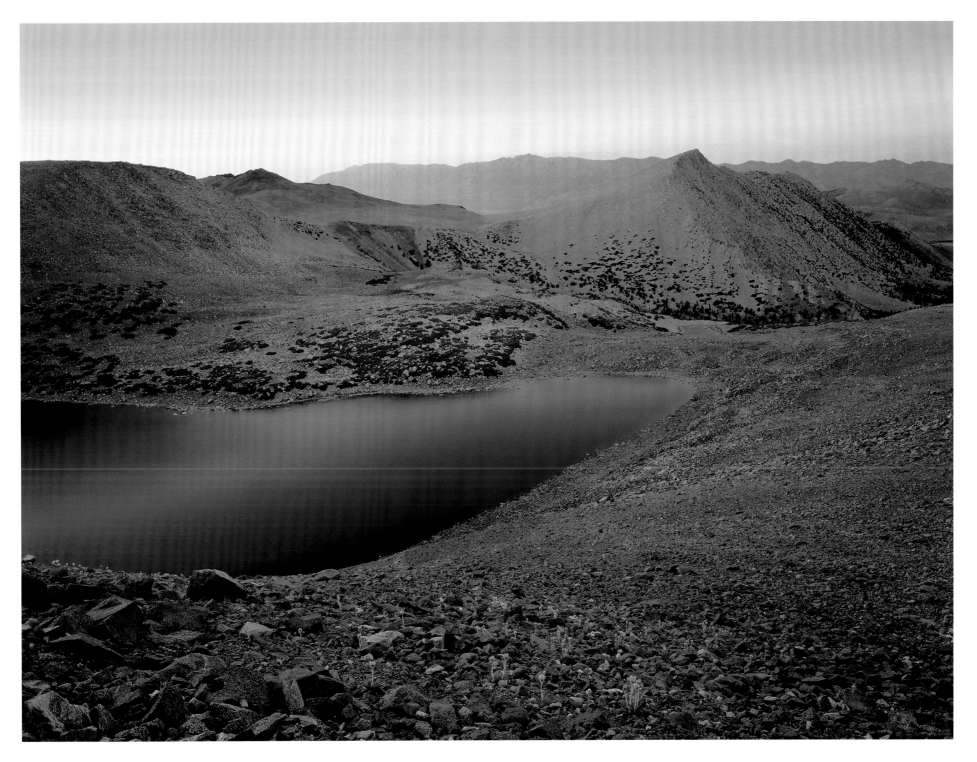

Palisades

"The Palisades country, I have reason to believe, is the acme of alpine sublimity on the American continent. There is here a very chaos of gorges of appalling depth and savage aspect, separating and throwing into fearful relief a great mass of peaks, precipices, and cliffs amongst which glitter frozen lakes, cascades, snowfields, and it is said, glaciers. Over this Titan's pandemonium tower the Palisades or Sawteeth, flinging aloft their pinnacled crests a thousand feet clear of the surrounding mountains."
–Theodore Solomons, 1896

I had this location circled on the map for several years, knowing that the morning alpenglow should nicely highlight the Palisades ridge, and the lakes in the basin would be in a diagonal arrangement. However, it took a while to find a foreground that minimized the large talus field in front of the lakes without being too dominating.

The Palisades, on the northeastern boundary of Kings Canyon National Park, contain almost one-third of California's peaks over 14,000 feet and the largest glacier (partially visible) in the Sierra. A very popular mountaineering area, there are at least twelve named peaks in this photo. The interesting names must have been taken when they named this chain of lakes along Big Pine Creek: Seventh (11,100 ft.), Sixth, and Fifth Lakes are visible, with parts of Fourth and Third Lakes in the distance.

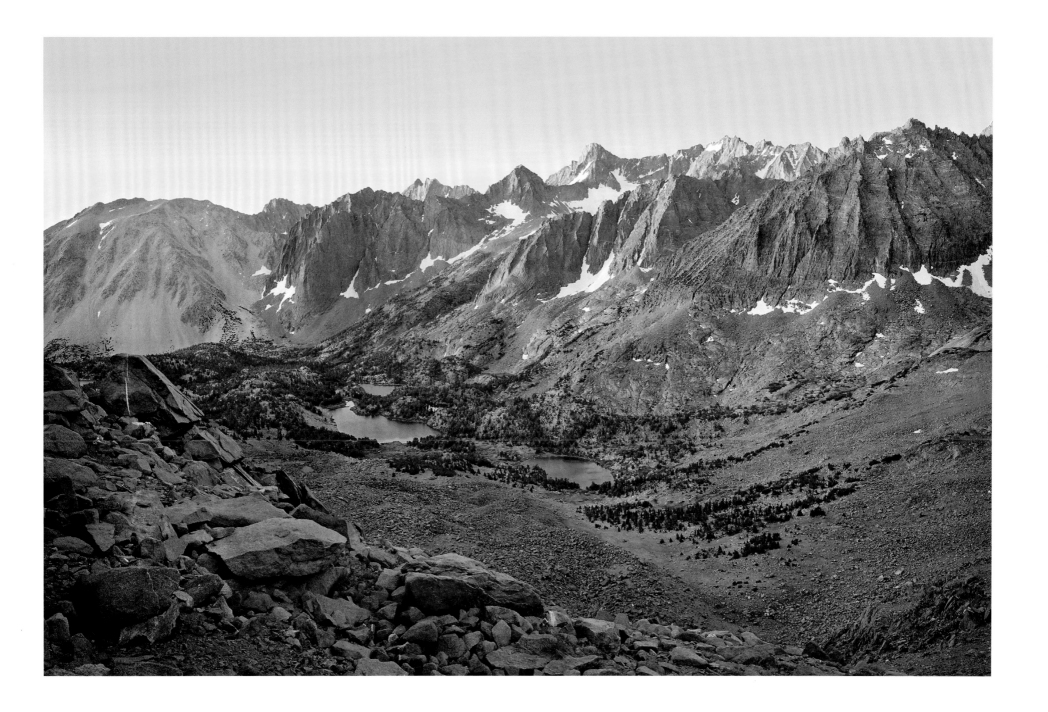

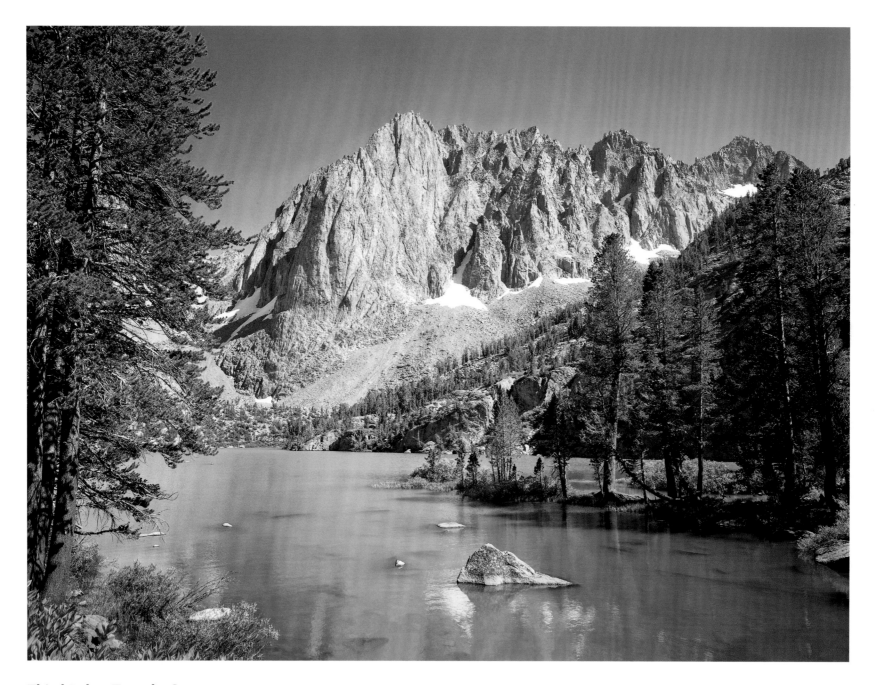

Third Lake, Temple Crags

Immediately downstream from the Sierra's largest active glacier, Third Lake (~10,200 ft.) is one of the few Sierra lakes with a milky turquoise color. The glacier pulverizes rocks so fine that some of the particles do not settle even in the still water of the lake. Many lakes in Glacier National Park have this characteristic color.

Third Lake, Temple Crags

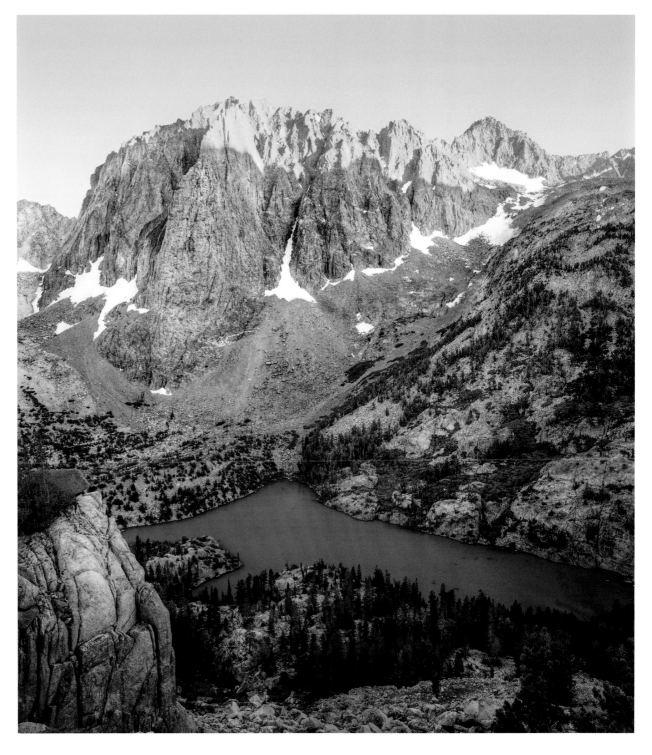

Mt. Williamson

"The mountains loomed over the valley like a psychical presence, a source and mirror of nervous influences, emotions, subtle and unlabeled aspirations; no man could ignore that presence. The emanations of mountain and sky imprinted some analogue of their nature on the evolution and shape of every soul." –Edward Abbey

Many eastern Sierra trailheads are on the low elevation flats of the dry Owens Valley where daunting, steep-angled views of the next morning's route shorten your sleep and make you reconsider your route choice. This is the scene near the Shepherds Pass trailhead (6,300 ft.), where the trail climbs more than 6,000 feet before reaching the pass just north of Mt. Williamson (right, 14,375 ft.), the second highest peak in the Sierra.

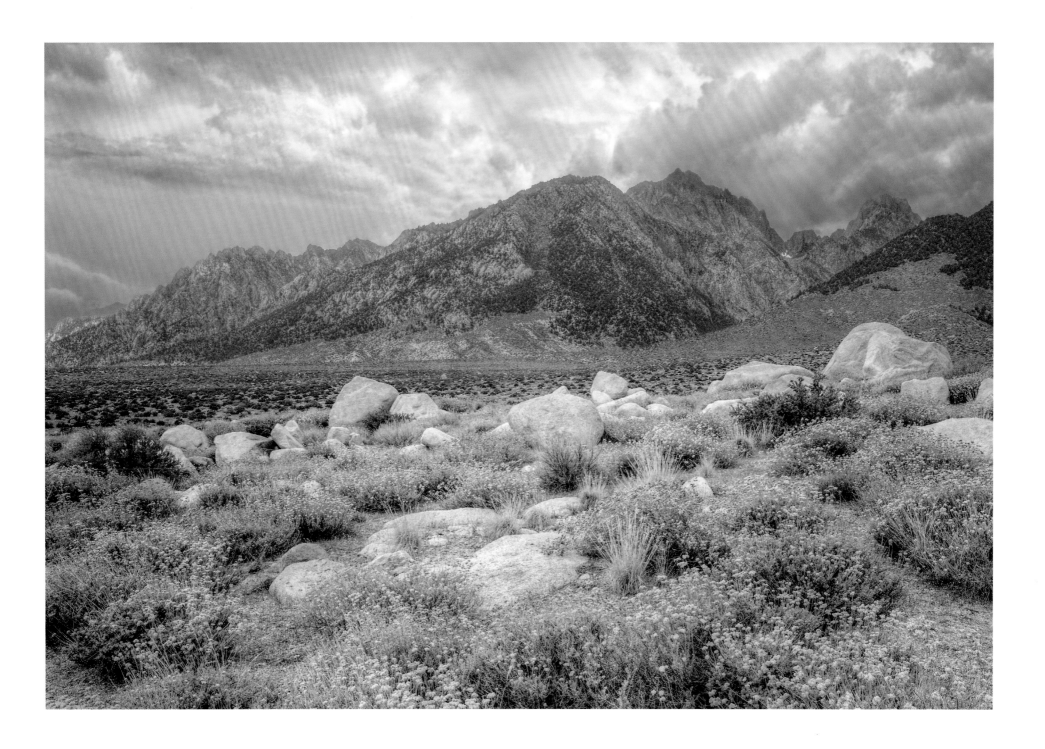

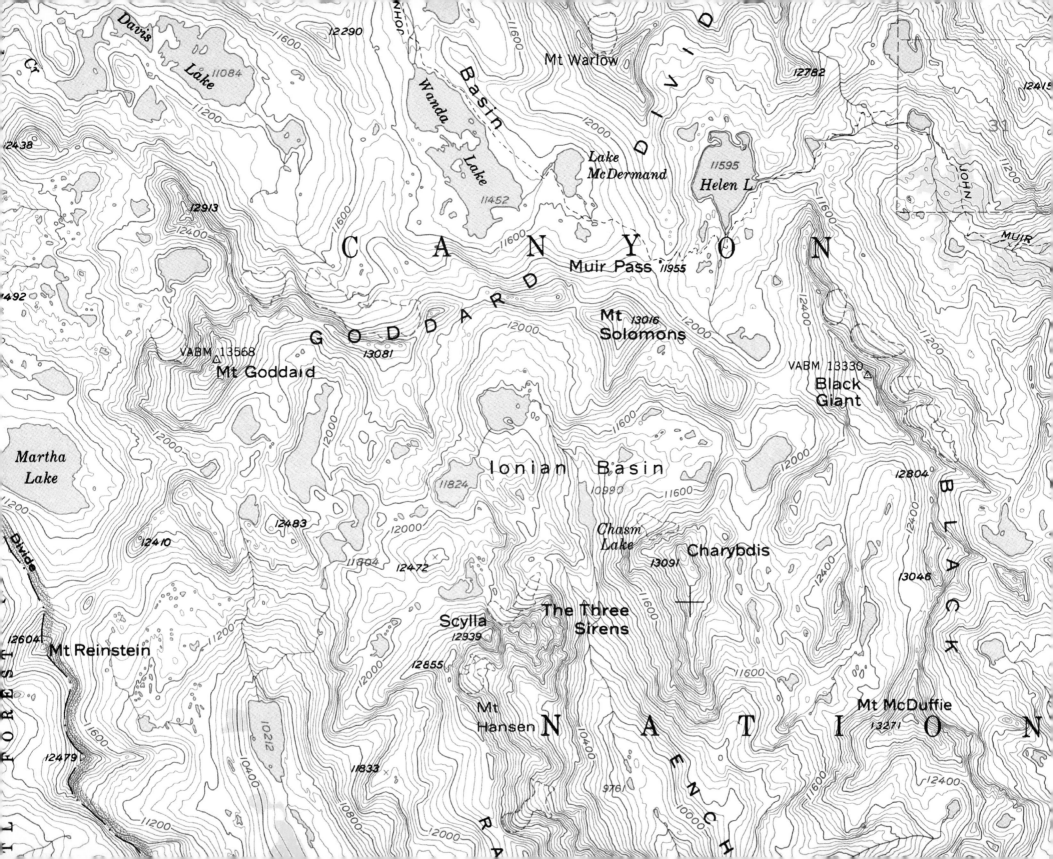

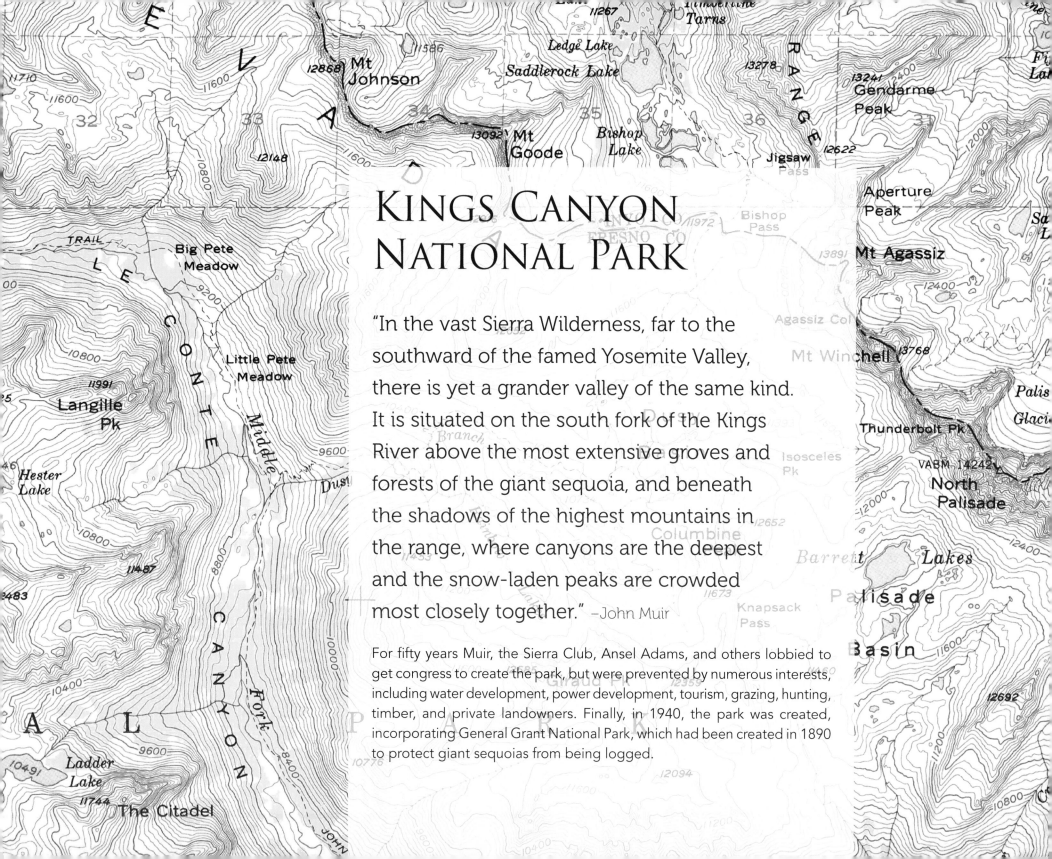

KINGS CANYON NATIONAL PARK

"In the vast Sierra Wilderness, far to the southward of the famed Yosemite Valley, there is yet a grander valley of the same kind. It is situated on the south fork of the Kings River above the most extensive groves and forests of the giant sequoia, and beneath the shadows of the highest mountains in the range, where canyons are the deepest and the snow-laden peaks are crowded most closely together." –John Muir

For fifty years Muir, the Sierra Club, Ansel Adams, and others lobbied to get congress to create the park, but were prevented by numerous interests, including water development, power development, tourism, grazing, hunting, timber, and private landowners. Finally, in 1940, the park was created, incorporating General Grant National Park, which had been created in 1890 to protect giant sequoias from being logged.

Darwin Canyon

This chain of unnamed lakes in Darwin Canyon is literally a textbook example of paternoster lakes—named after their similarity to rosary beads.

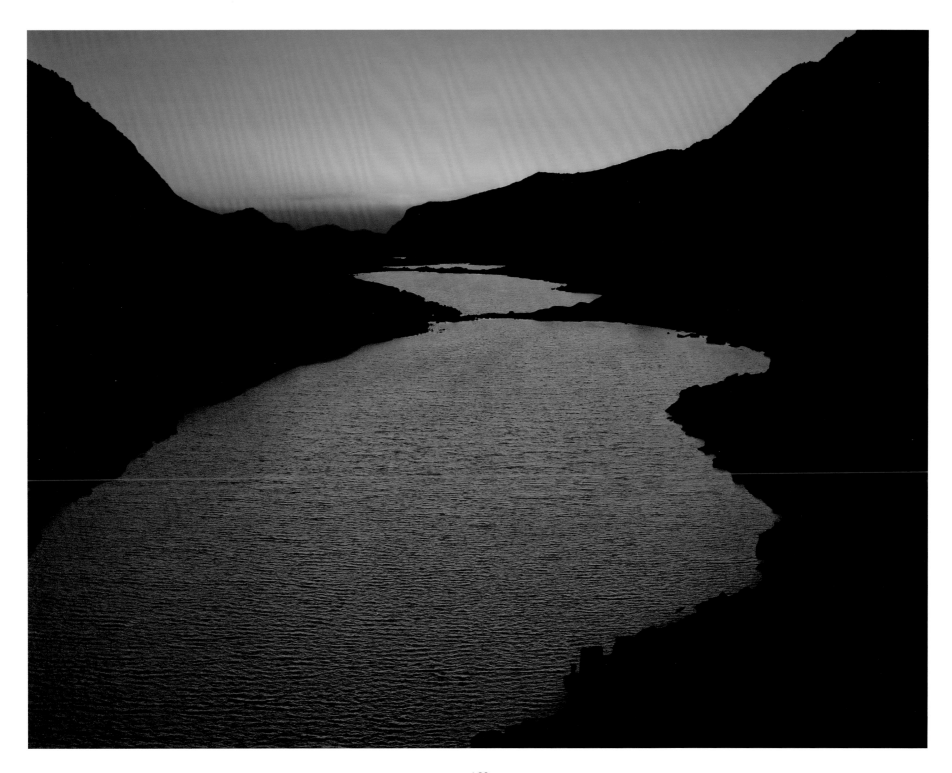

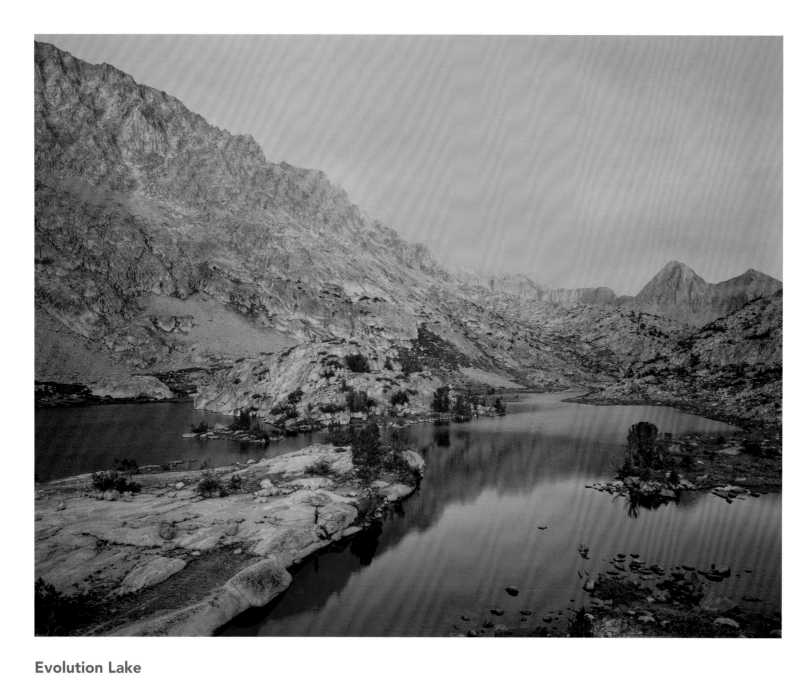

Evolution Lake

"Evolution Valley took us for a ride
Climbing Darwin's Mountain, to the sky
I feel alive, I'm up so high" –Hot Buttered Rum String Band

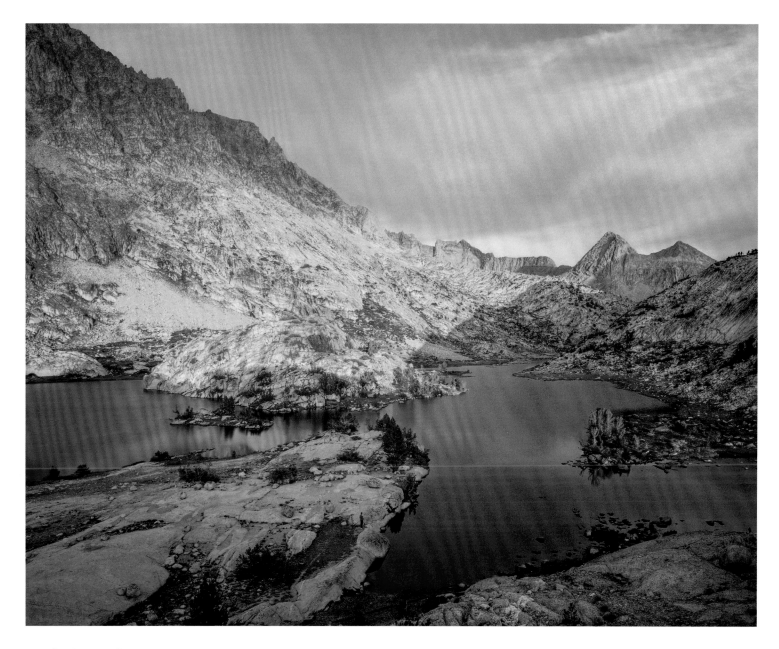

Evolution Lake

In the 1890s Theodore Solomons, a geologist, explorer, and prolific namer of Sierra peaks and lakes, named six peaks in this area after scientists who were early proponents of evolutionary theory: Darwin, Fiske, Haeckel, Huxley, Spencer, and Wallace. Since then other scientists from the same era were similarly honored: Mendel, Lamarck, and Agassiz.

Evolution Lake (10,850 ft.) has a well-deserved reputation as one of the most desirable backcountry destinations in the Sierra. I was rewarded with a few scattered clouds at sunset that cast a shadow on Mt. Darwin (13,830 ft., upper left).

Evolution Cascade

The light colored granite in the "Range of Light" changes color during the day depending on the ambient colors. Here, near the outlet of Evolution Lake, Evolution Creek's cascade was lit by warm morning sunlight reflected off the flank of the Hermit, a large peak immediately behind me.

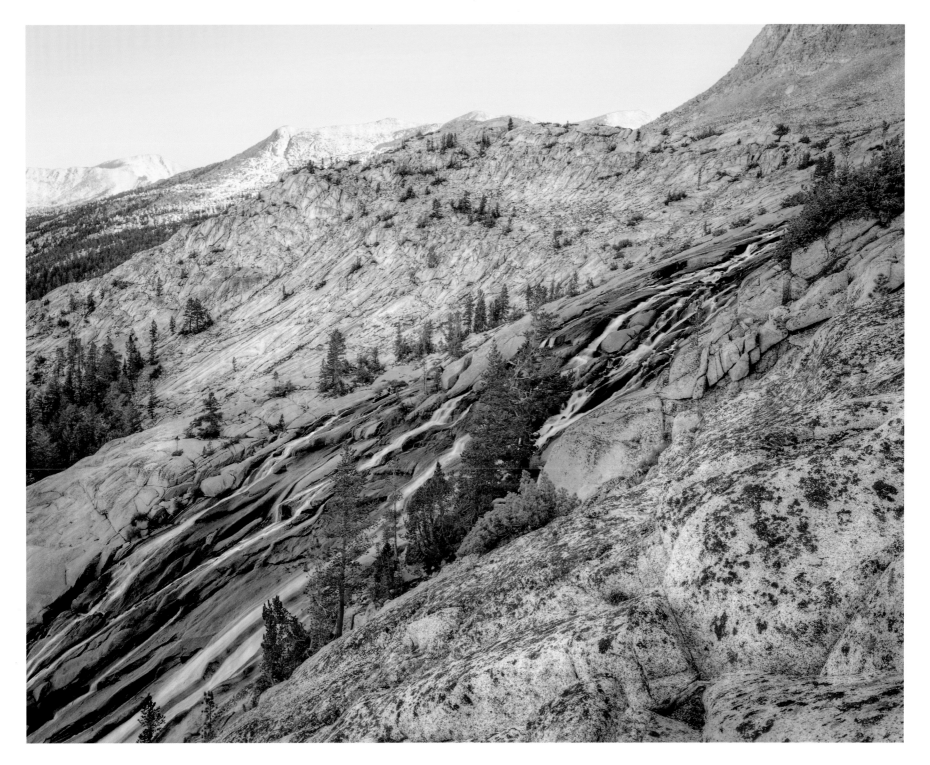

Evolution Cascade and Evolution Valley

"Even horses and dogs gaze wonderingly at the strange brightness of the ground, and smell the polished spaces and place their feet cautiously on them when they come to them for the first time, as if afraid of sinking."

–John Muir, on glacial polish

Overlooking Evolution Valley wet, glacially polished granite at the top of Evolution Creek's cascade reflects the sunset colors.

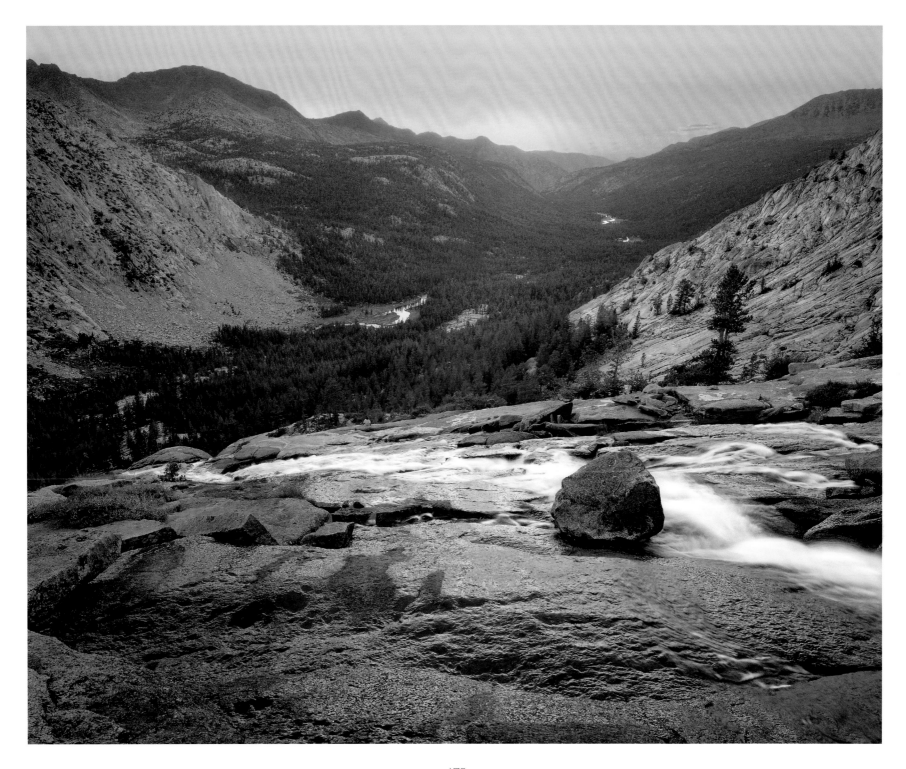

Sapphire Lake

"Nature's poems carved on tables of stone—the simplest and most emphatic of her glacial compositions." –John Muir

The next lake upstream from Evolution Lake on the John Muir/ Pacific Crest Trail in a glacially carved granite bowl at the foot Mt. Huxley (13,086 ft.) is Sapphire Lake, with its chain of outlet pools.

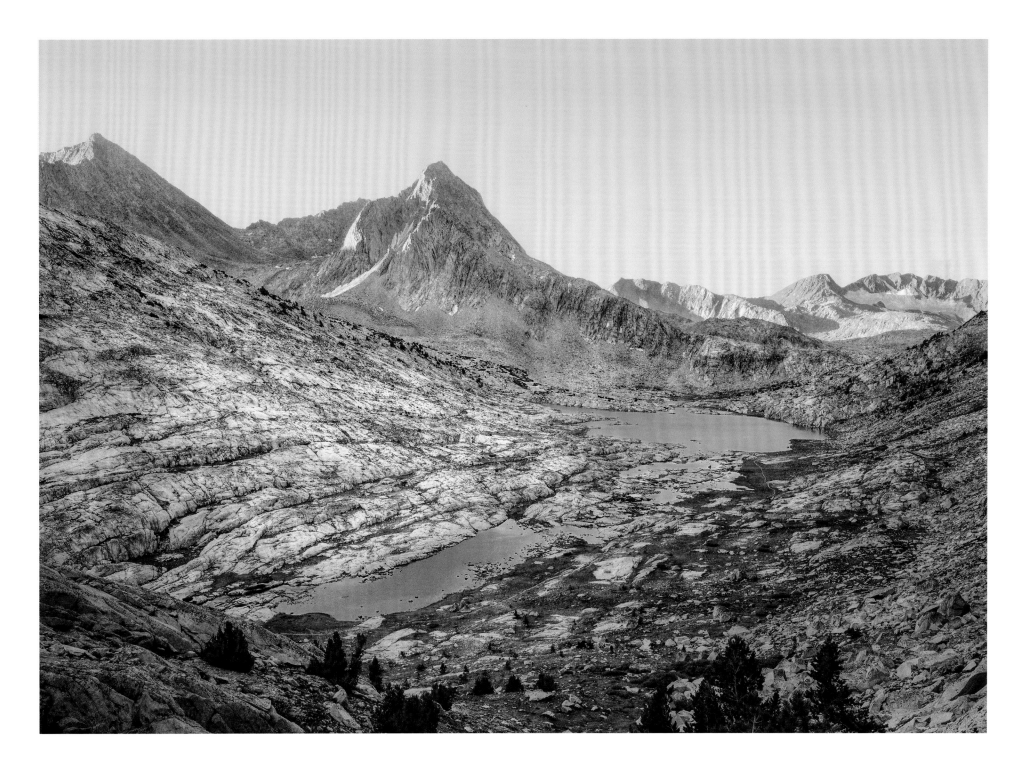

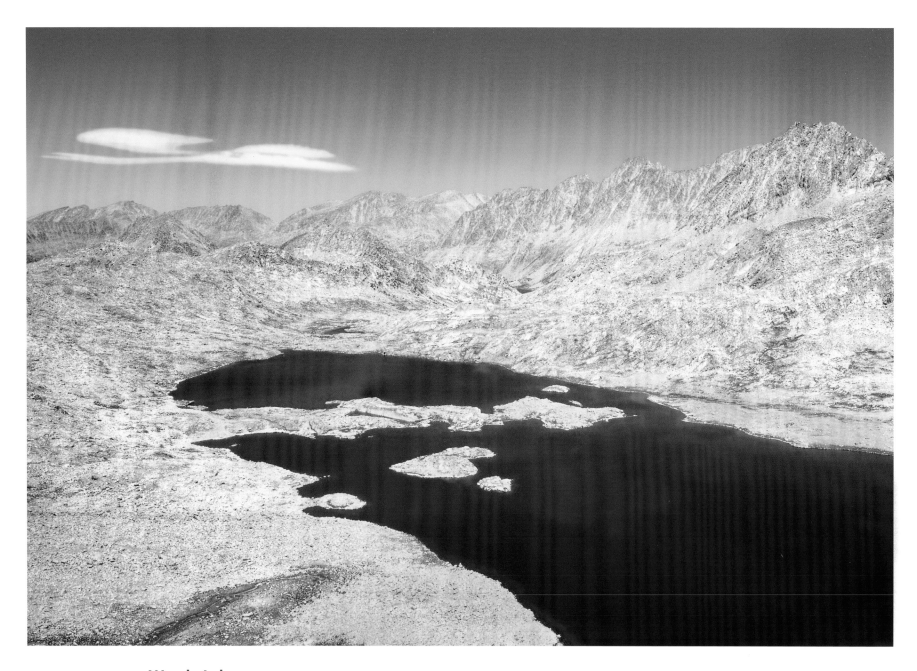

Wanda Lake

Glacial lakes above treeline have a more desolate, inhospitable character than those surrounded by trees and meadows. Over one-half mile wide, Wanda Lake (11,425 ft.) sits in the former glacier's route down Evolution Canyon to Evolution Lake (barely visible in the distance). The ridge on the right, including flat-topped Mt. Darwin, has some of the lightest granite in the range.

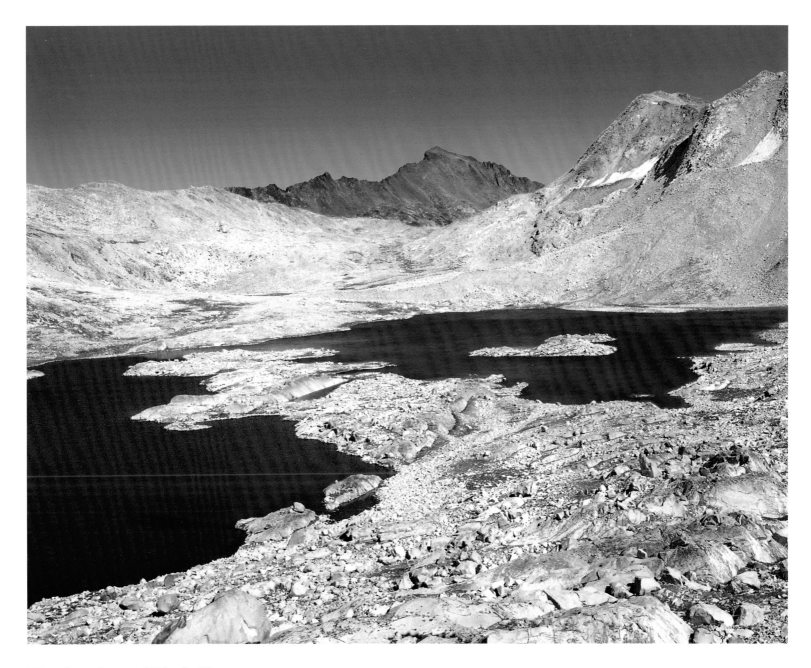

Wanda Lake and Black Giant

Immediately adjacent to the south and west of the light granites in the Evolution Basin is a region of very dark metamorphic rock. These rocks originally erupted from explosive volcanoes and were later metamorphosed from below by magma that never reached the surface.

Enchanted Gorge and Ionian Basin

"...this gorge was guarded by a nearly frozen lake (Chasm Lake), whose shear ice-smoothed walls arose on either side, up and up, seemingly into the very sky, their crowns two sharp black pearls of majestic form. A Scylla and Charybdis they seemed to us as we stood at the margin of the lake and wondered how we might pass the dangerous portal." –Theodore Solomons, 1896

In 1885, caught in a "blinding storm," Solomons sought lower elevations by descending through what he later named the Enchanted Gorge "because of the many remarkable features it possesses and the weirdness of its scenery."

On either side of tiny Chasm Lake are Scyla (far right, 12,956 ft.) and Charybdis (left, 13,096 ft.), named after the mythical unavoidable sea monsters from Homer's Odyssey. In the foreground is an unnamed lake in the Ionian Basin.

Fifteen miles in the smoke-obscured distance is the Monarch Divide. I've canceled several trips and one entire season due to wildfires and their lingering smoke. Fortunately this smoke was limited to the Kings River Canyon and did not effect my visit to neighboring Evolution Basin.

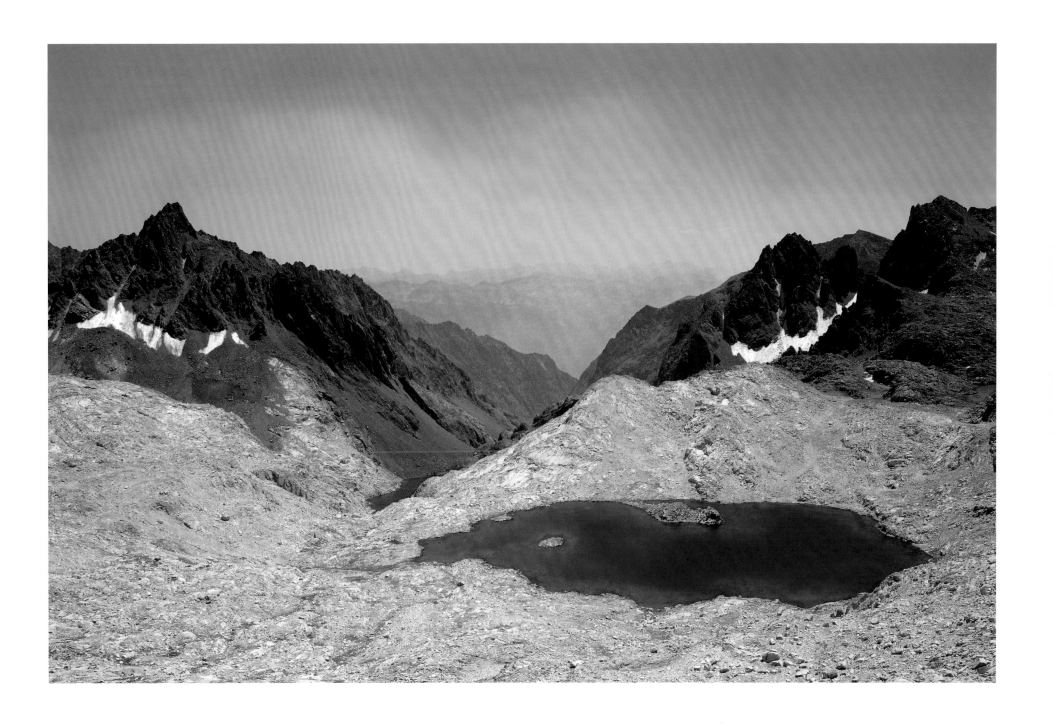

Striped Mountain

This mountain's name encouraged a short side trip on the way from Taboose Pass to Bench Lake. Lake 11,607, at the base of Stripped Mountain (13,179 ft.), is one of the uncountable number of unnamed glacial lakes in the Sierra that are identified by their elevation. A small rock glacier—the downward arching structure—sits in the scree on the far side of the lake.

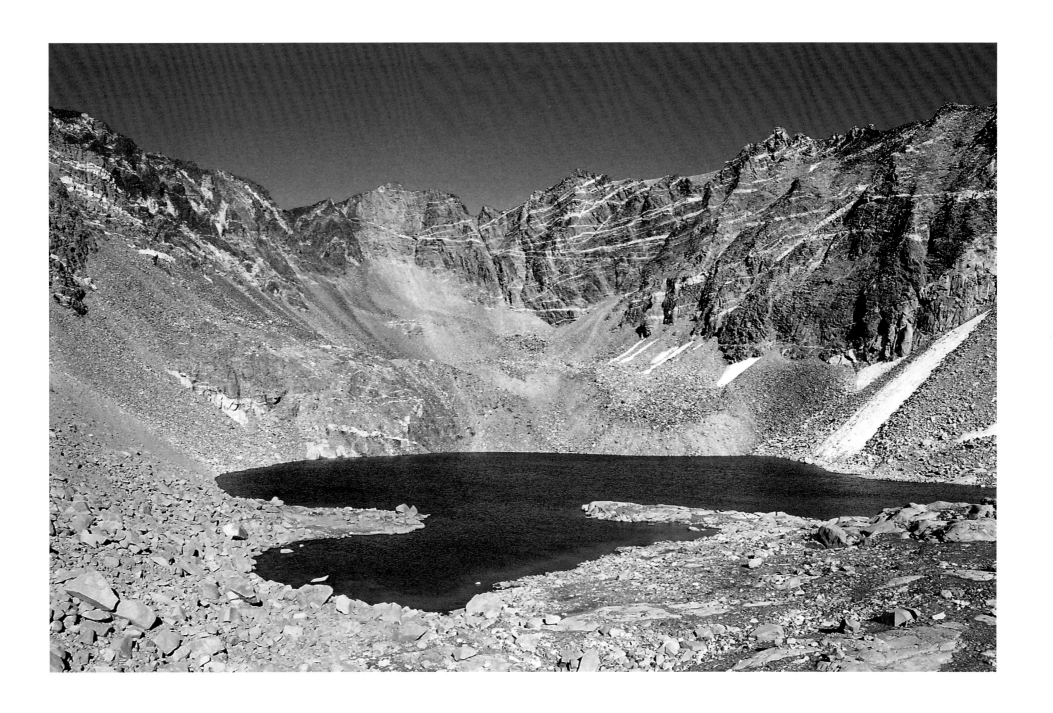

Bench Lake

The hike over Taboose Pass (11,352 ft., upper right) is one of the tougher east side ascents due to its steeper-than-normal, under-maintained trail and low elevation (5,380 ft.) trailhead, but Bench Lake (10,558 ft.) made it worth the effort. Split Mountain (14,058 ft.) and reddish-topped Cardinal Mountain (13,397 ft.) are just north of the pass.

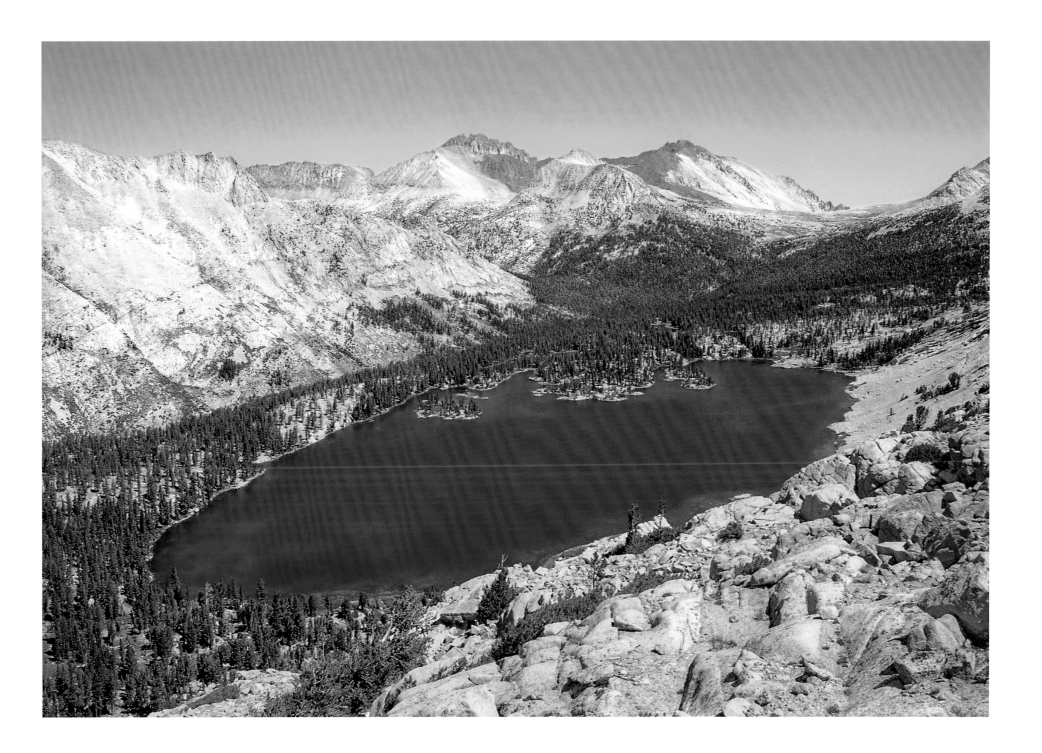

Bench Lake and Arrow Peak
"The view of Arrow Peak (12,958 ft.) from Bench Lake is one of the classic views in the Sierra." –R. J. Secor

Secor's book *The High Sierra, Peaks, Passes and Trails* is the finest guide to exploring the Sierra and has been indispensable in selecting routes and locations in advance and on the spot.

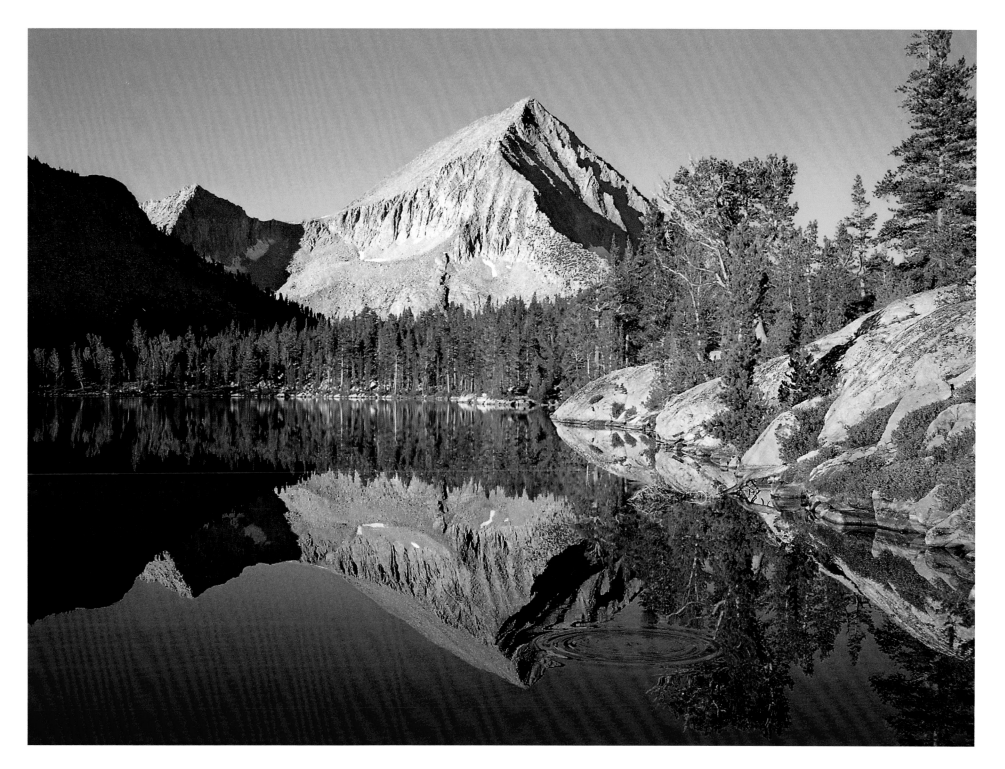

Bench Lake and Merion Peak

Lake Marjorie

Behind Lake Marjorie (11,132 ft.) is the broad Upper
Basin, the headwaters of the South Fork Kings River.
Six miles away is Mather Pass (12,100 ft.) backed
by the Palisades.

Fin Dome

The small rise just up the ridge from Fin Dome,
flanked by beautiful Rae Lakes and somewhat scenically
disappointing 60 Lake Basin, had been circled on my map
for several years, but upon arrival my camera battery was
very low and my spare was dead. Scattered clouds
created unappealing contrasty patches of light and
dark across the basins. But the clouds gradually
thickened, creating generally more even light,
and when a spotlight of diffused sun was headed
to Fin Dome I warmed the battery in my hands and
managed to squeeze out this and the next photo.

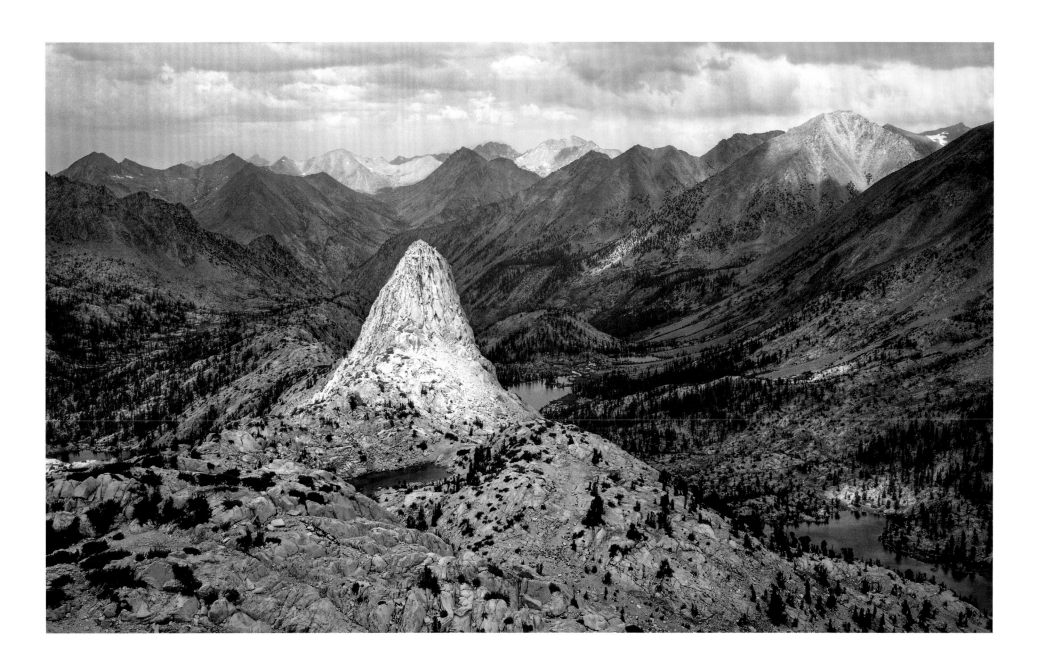

Rae Lakes

Rae Lakes (10,540 ft.) are halfway around a popular
multi-day backpacking loop that starts at Roads End in
southeastern Kings Canyon National Park. Dragon Lake is
perched between Black Mountain (left, 13,289 ft.) and
colorful Dragon Peak (right, 12,955 ft.).

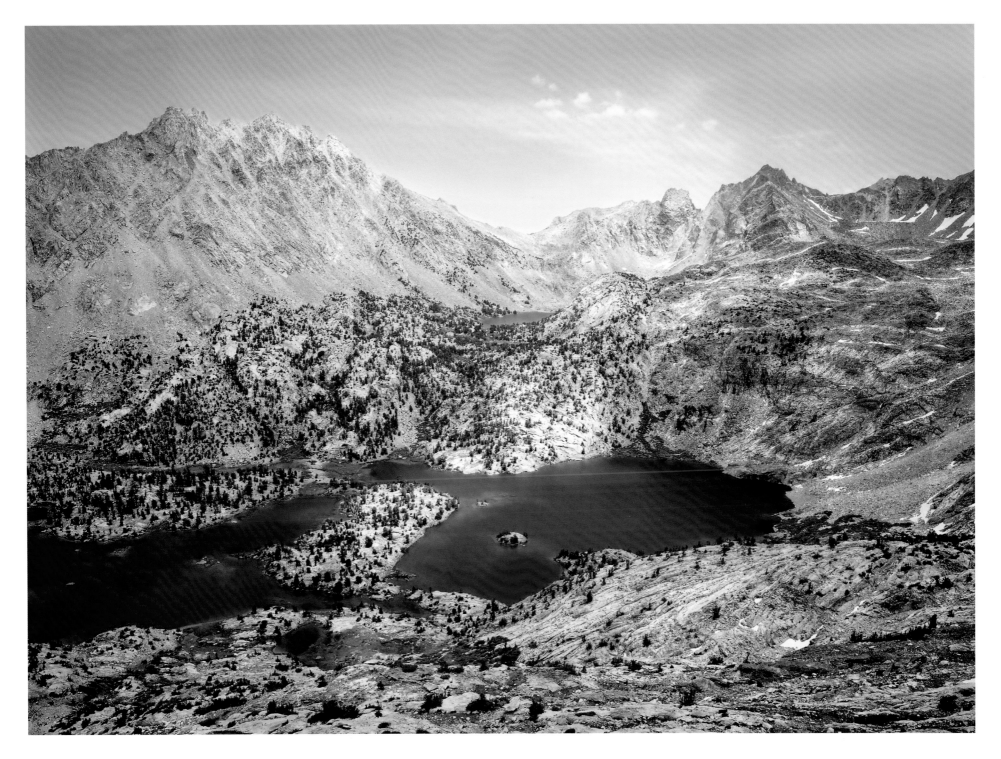

Bullfrog Lake

"The mountains were so wild and so stark and so very beautiful that I wanted to cry. I breathed in another wonderful moment to keep safe in my heart." –Jane Wilson-Howarth

Potential foregrounds for this scene at Bullfrog Lake (10,610 ft.) covered about 1,000 vertical feet on the southern flank of Mt. Rixford. However, none were better than the first one I saw just a few feet off the Kearsarge Pass Trail. Many pines at treeline develop vivid orange, red, and yellow colors as they age. These were enhanced by the diffuse colorful light created by dust in the Central Valley and a few thin clouds in front of the setting sun.

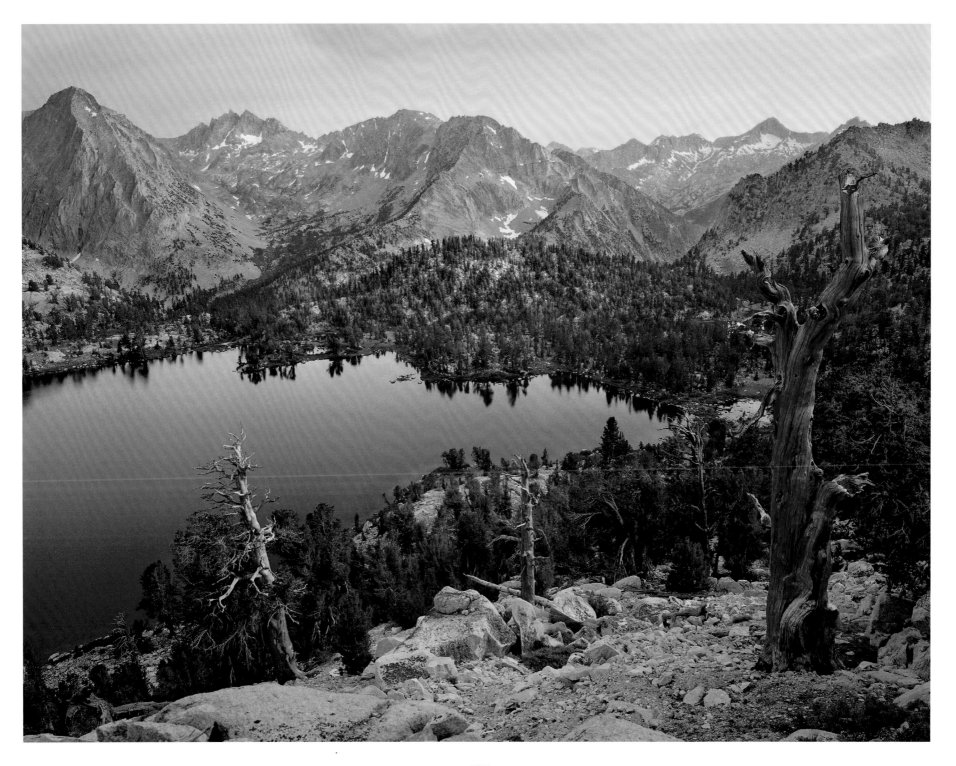

Kings River

"The creeks are an active mystery, fresh every minute. Theirs is the mystery of the continuous creation and all that providence implies: the uncertainty of vision, the horror of the fixed, the dissolution of the present, the intricacy of beauty, the pressure of fecundity, the elusiveness of the free, and the flawed nature of perfection. The mountains are a passive mystery, the oldest of them all. Theirs is the simple mystery of creation from nothing, of matter itself, anything at all, the given. Mountains are giant, restful, absorbent. You can heave your spirit into a mountain and the mountain will keep it, folded, and not throw it back as some creeks will. The creeks are the world with all its stimulus and beauty; I live there. But the mountains are home." –Annie Dillard

At an elevation of 4,900 feet, this sunset scene from the bridge on the Kings Canyon Highway over the South Fork Kings River near Roads End is the lowest in this collection and one of three taken from a paved area.

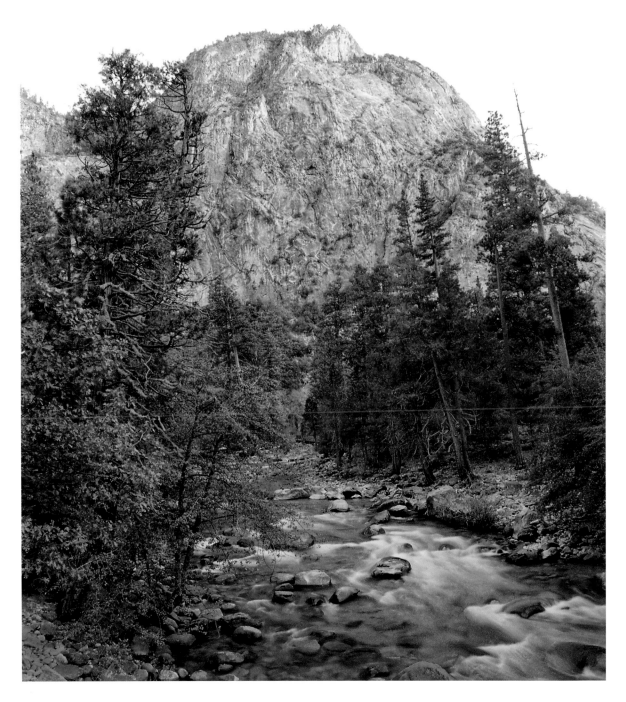

Lake Reflection

"Because in the end, you won't remember the time you spent working in the office or mowing your lawn. Climb that goddamn mountain." –Jack Kerouac

If I had been able to balance my tripod a bit quicker, this Lake Reflection (10,005 ft.) scene would have been even better. By the time I got set up midstream on some slippery rocks and shifting logs the orange-finned brook trout that would have been easily visible in the lower left had slipped away. A key prop for this photo is the sunlit cliff just outside the right edge. This east facing, reddish cliff reflected warm colored light back across the lake onto the lodgepole pines. It filled and warmed the shadows just like a reflective screen or flash would in a studio setting.

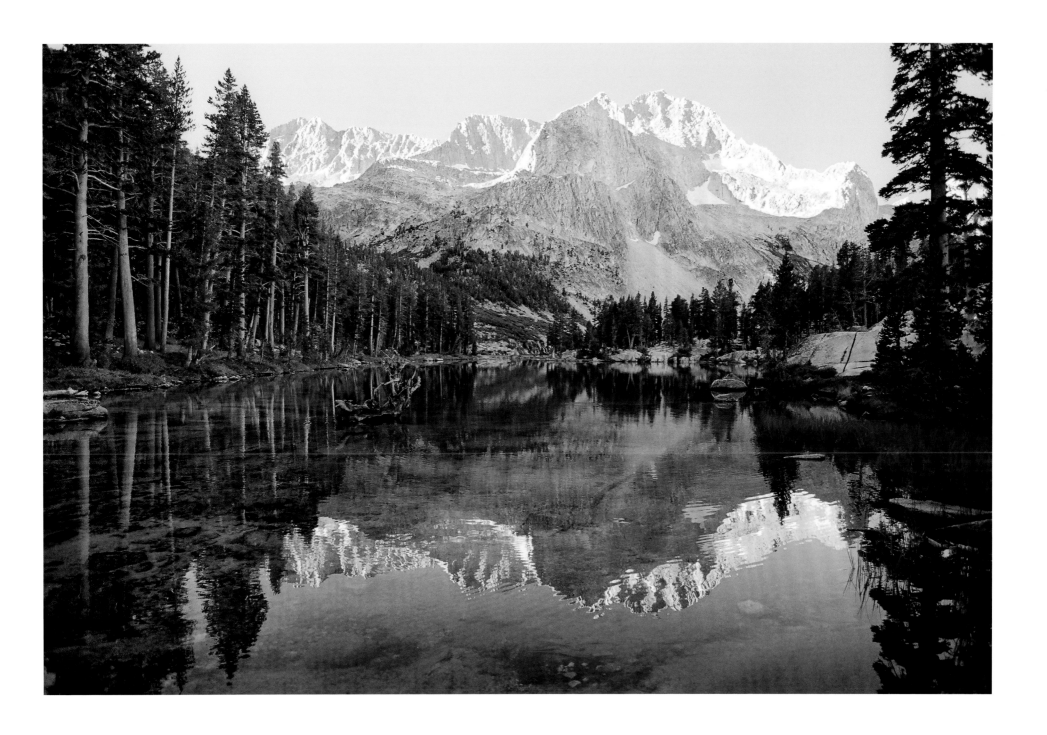

Lake Reflection

With a steady wind and a slow shutter speed, Lake Reflection blurs the huge northern face of Mt. Jordan (13,344 ft.), one of the largest lakeside escarpments in the range.

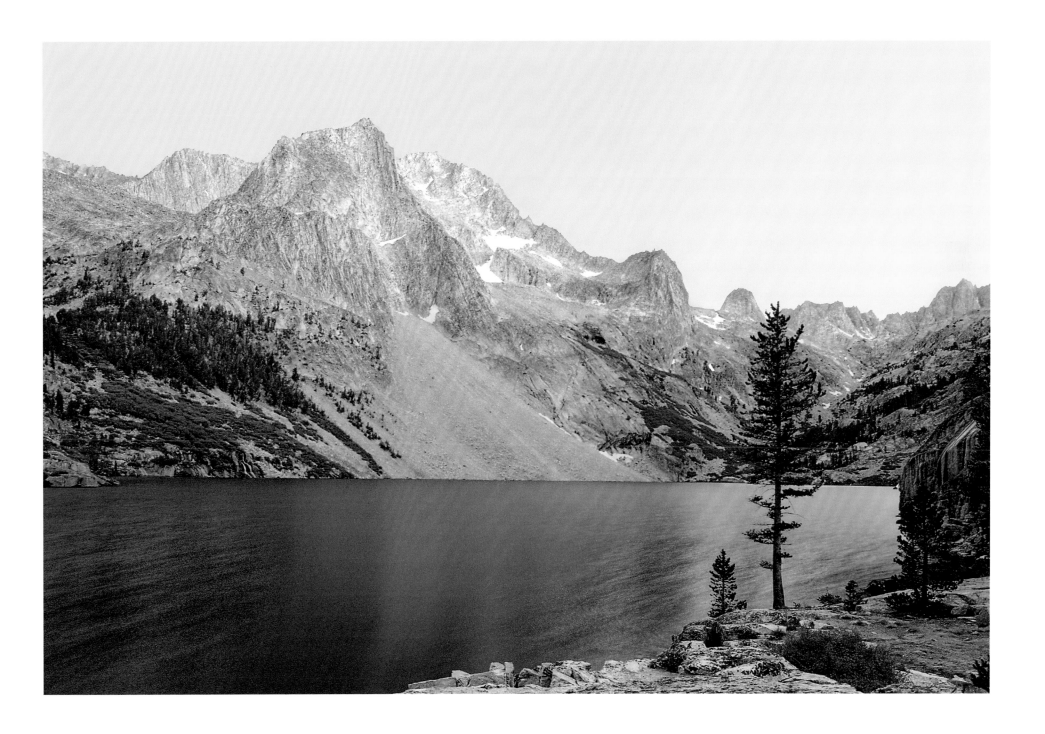

Lake Reflection

Wildflowers occur less frequently above treeline. Their colors and textures contrast with trees and bare granite, making them desirable foreground elements. This patch found enough soil in an avalanche chute at 12,400 feet just below the Kings-Kern Divide, on the boundary between Kings Canyon and Sequoia National Parks.

I may have been the first to describe the route that uses this chute because a fellow hiker named it "Weyman's Chute." It is slightly easier than the other routes that cross the Kings-Kern Divide.

I dislike vertically oriented landscapes because, like a horse wearing blinders, they give an unnatural, constrained view of a scene. I occasionally make exceptions when it is the only way to combine features. But even then the resulting composition often looks awkward, with attention-getting elements close to the top and bottom edges of the image. Fortunately this one had a continuum of depth in a nicely bowled shape and important elements in the middle.

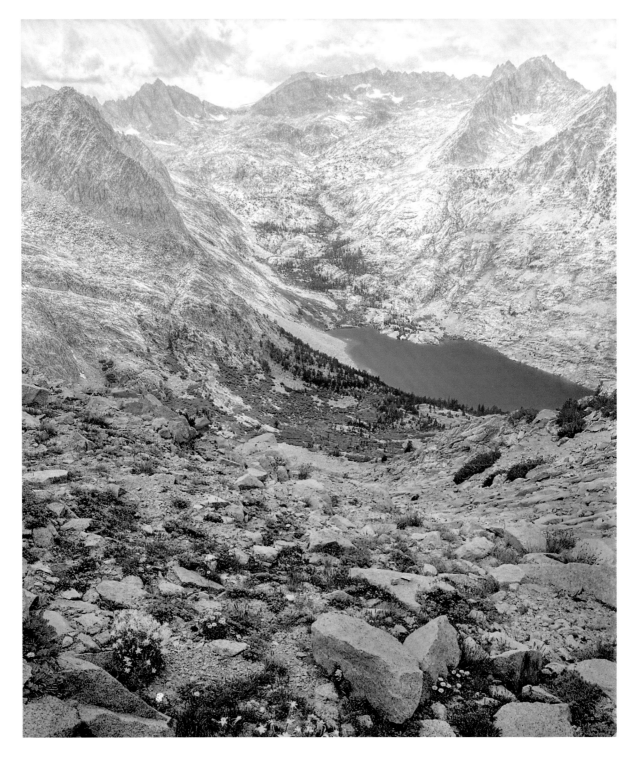

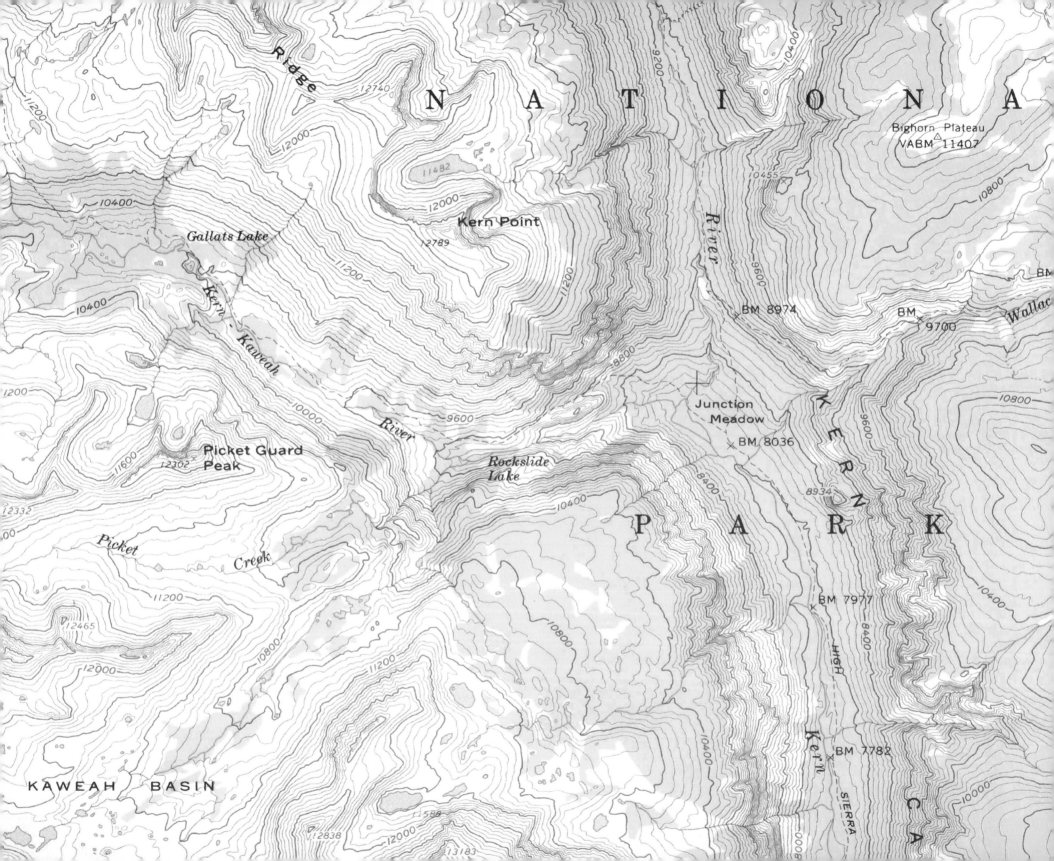

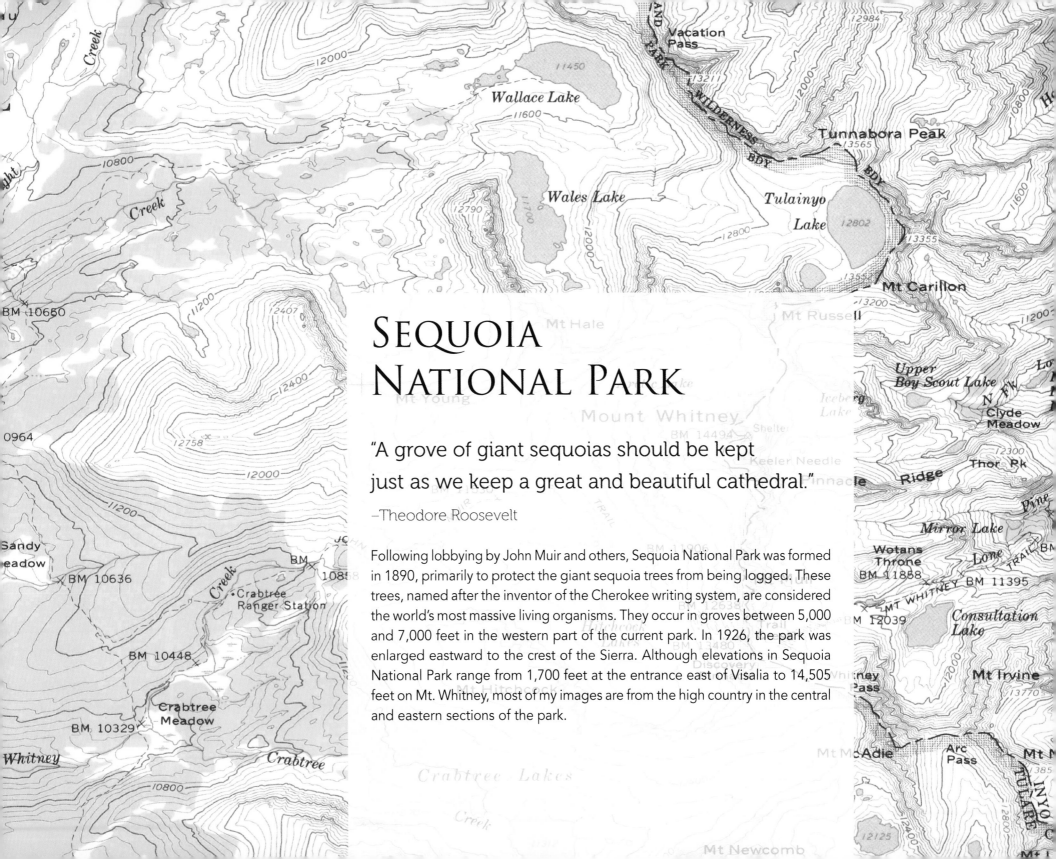

SEQUOIA NATIONAL PARK

"A grove of giant sequoias should be kept just as we keep a great and beautiful cathedral."

–Theodore Roosevelt

Following lobbying by John Muir and others, Sequoia National Park was formed in 1890, primarily to protect the giant sequoia trees from being logged. These trees, named after the inventor of the Cherokee writing system, are considered the world's most massive living organisms. They occur in groves between 5,000 and 7,000 feet in the western part of the current park. In 1926, the park was enlarged eastward to the crest of the Sierra. Although elevations in Sequoia National Park range from 1,700 feet at the entrance east of Visalia to 14,505 feet on Mt. Whitney, most of my images are from the high country in the central and eastern sections of the park.

General Sherman Tree

"No one has ever successfully painted or photographed a redwood (sequoia) tree. The feeling they produce is not transferable. From them comes silence and awe. It's not only their unbelievable stature, nor the color which seems to shift and vary under your eyes, no, they are not like any trees we know, they are ambassadors from another time."

–John Steinbeck

The "General Sherman" Sequoia in Sequoia National Park is not the tallest, but it is the most massive tree in the world. Although a person in red (lower left) provides some scale for this 278 foot tall, 40 foot diameter, approximately 2,500 year old giant, the photo does not portray the surreal feeling of being in the presence of such an abnormally sized common object.

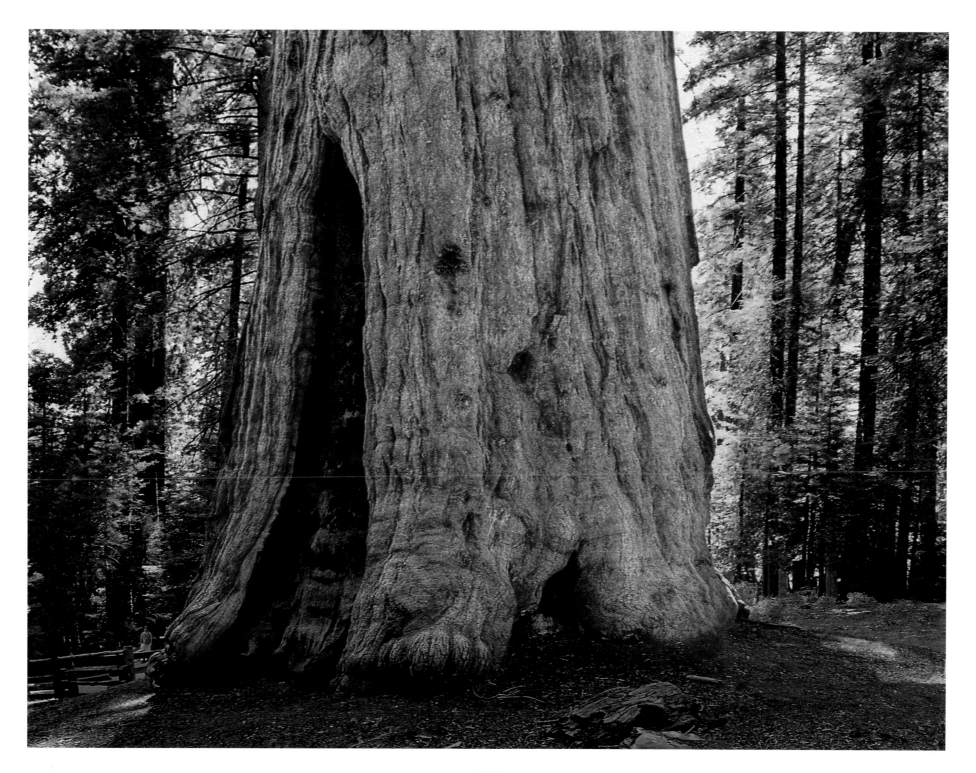

Tokopah Valley

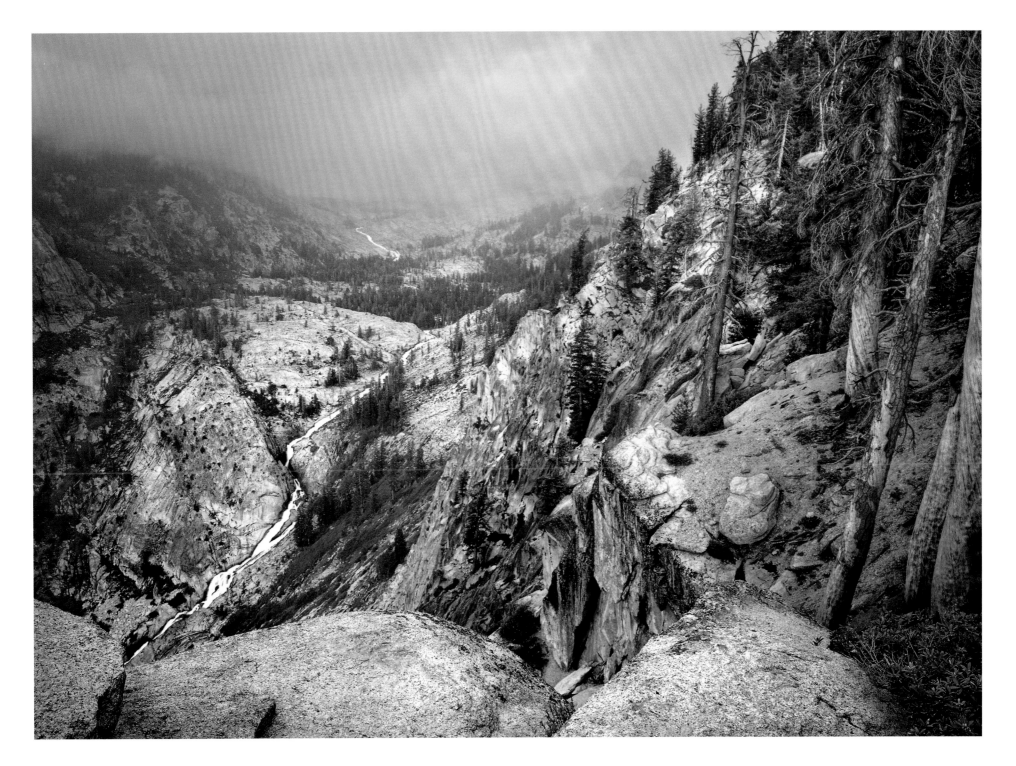

Moose Lake

"May your trails be crooked, winding, lonesome, dangerous, leading to the most amazing view. May your mountains rise into and above the clouds." –Edward Abbey

On the longest day of the year there was still snow and ice on and around Moose Lake (10,530 ft.), perched high above the Kaweah Canyon. Although summer weather is fairly predictable, there is a short window of opportunity of ideal conditions for visiting the high Sierra. In spring and early summer lingering snowfields create difficult-to-cross swollen streams and patches of bright white that are often distracting in photographs. Mosquitoes can be annoying throughout the summer and until the first fall freeze. Late August and early September were my favorite times, before the nights get long and cold and before the threat of winter storms increases.

This lake's name perplexed me, since moose do not live anywhere near the Sierra. It wasn't until I had returned and was browsing the proofs that I saw the bellowing moose profile with the chopped off nose. In case you are as slow as I was, the moose's eye is the island on the far left, the foreground peninsula is the bellowing mouth, and the Kaweah Peaks and Great Western Divide form the ten-mile-long left antler.

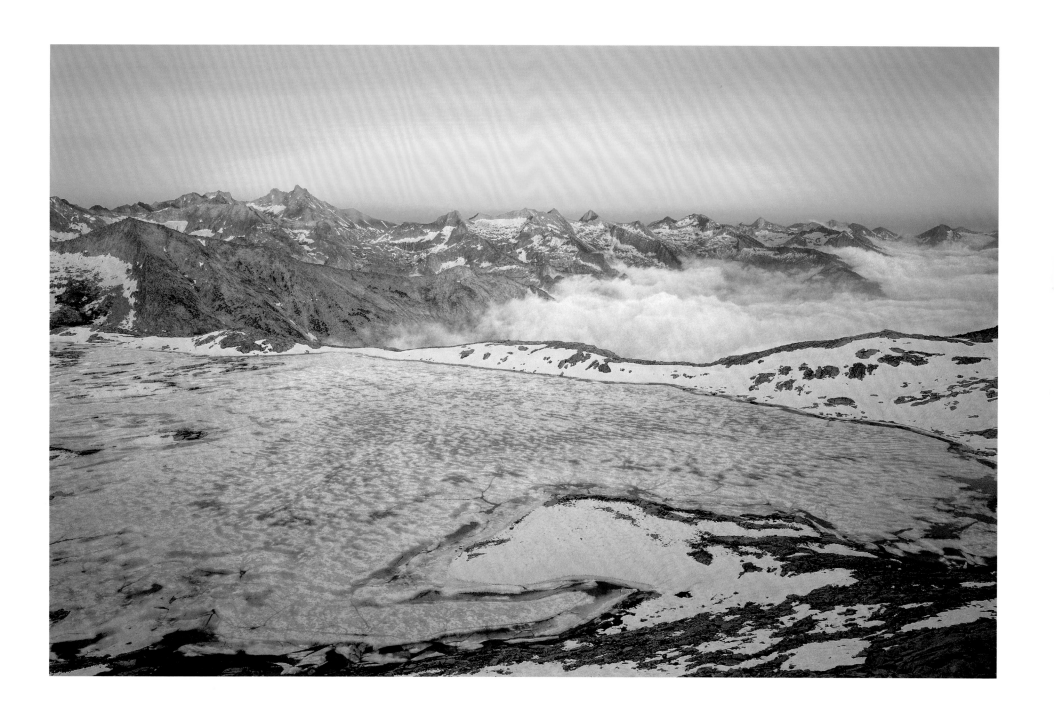

Hamilton Bowl

Bucket lists hadn't been invented yet, but I immediately circled my map at Hamilton Lakes, in Sequoia National Park, when I saw the countless tightly packed contour lines surrounding the upper lake; the largest bowl in the Sierra. On the far distant left is Morro Rock near the origin of the High Sierra Trail. To the right of the lake it switchbacks up the green slope and then traverses to this vista near lower Precipice Lake at 9,800 ft. At about 2,000 feet tall Valhalla or Angel Wings—the cliff behind the lake—is the tallest rock face in the Sierra outside Yosemite.

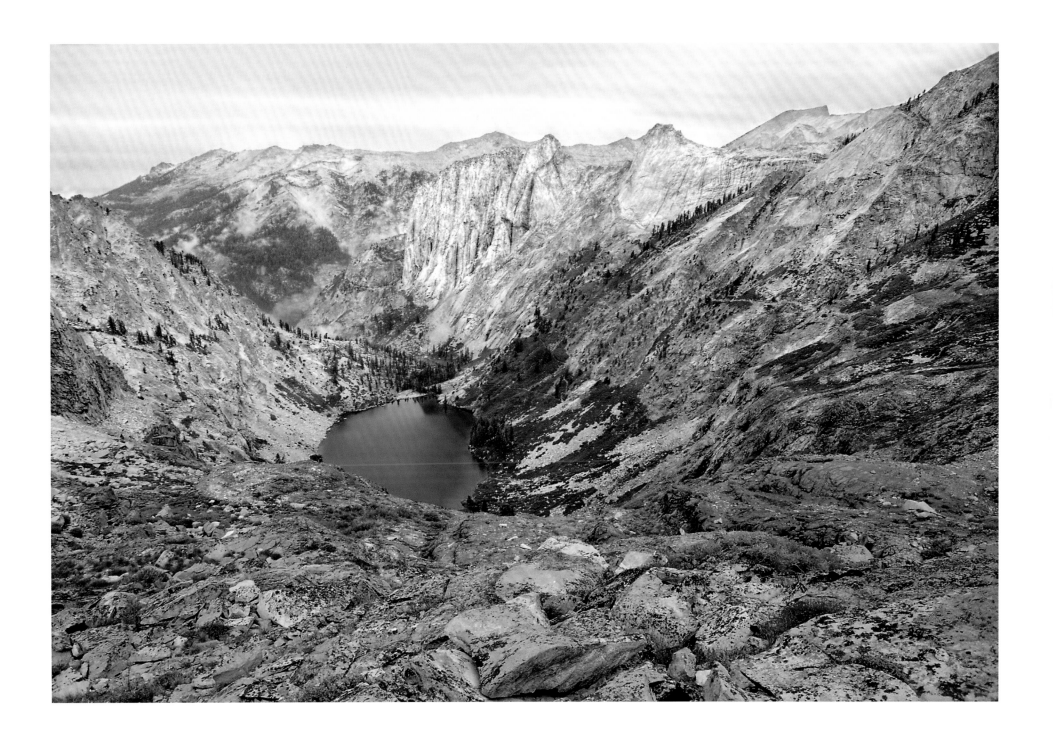

Hamilton Lake

Down-slope night winds (katabatic winds) occur when warm air that has risen on a warm summer day cools at high altitudes and descends down the valleys at night. Normally they are gentle breezes, but not at the narrow end of this huge funnel where I was camped. In the middle of a calm night the approaching roar coming across the lake woke me about fifteen seconds before being hit by a wall of tent-flattening, equipment-scattering wind. To prevent them from breaking I reached out and disconnected my tent's poles and rode out the gale that persisted until dawn inside a flat, flapping tent.

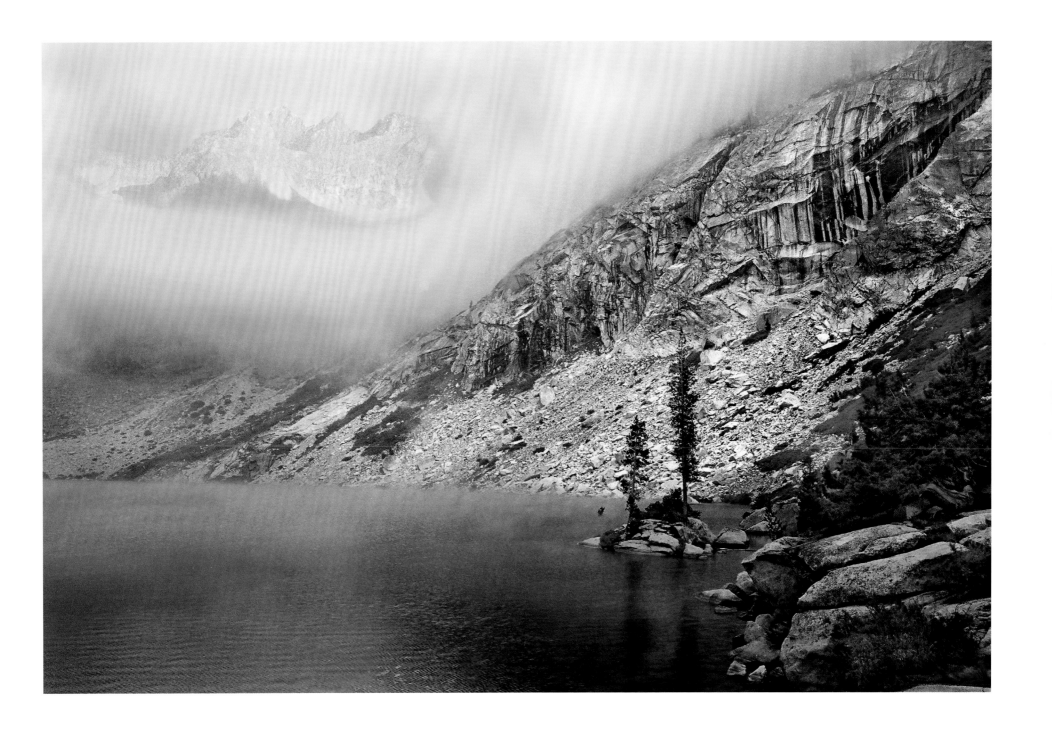

Hamilton Lake

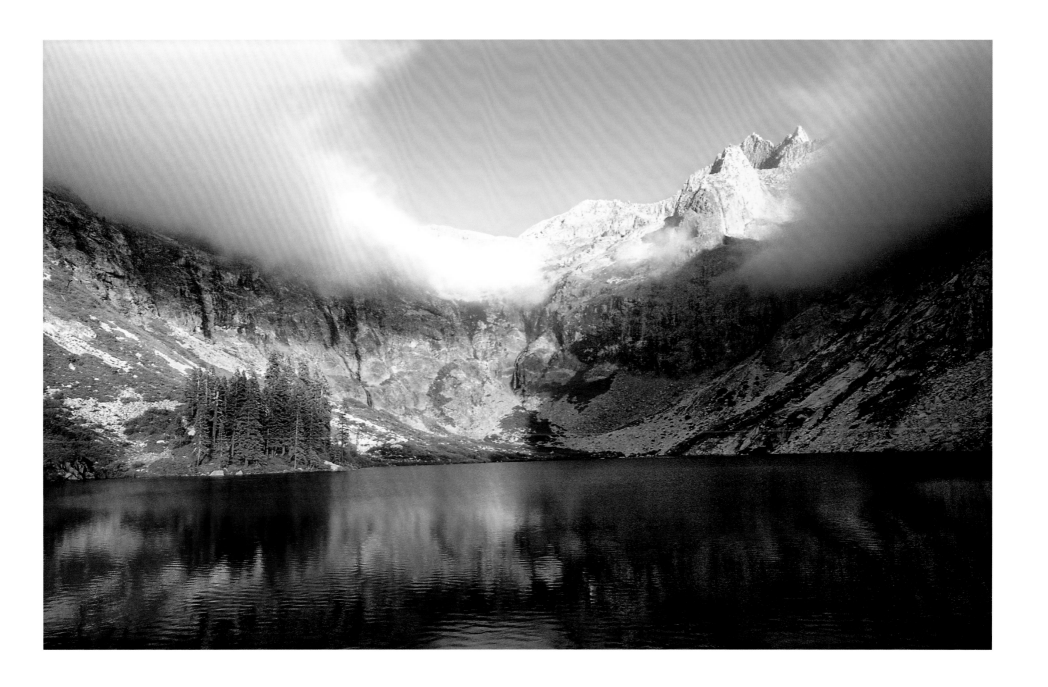

High Sierra Trail

Construction of the High Sierra Trail (left and upper right) began in 1928. It had to be blasted out of this steep cliff 1,400 feet above Hamilton Lake. It was the first Sierra trail constructed solely for recreational use.

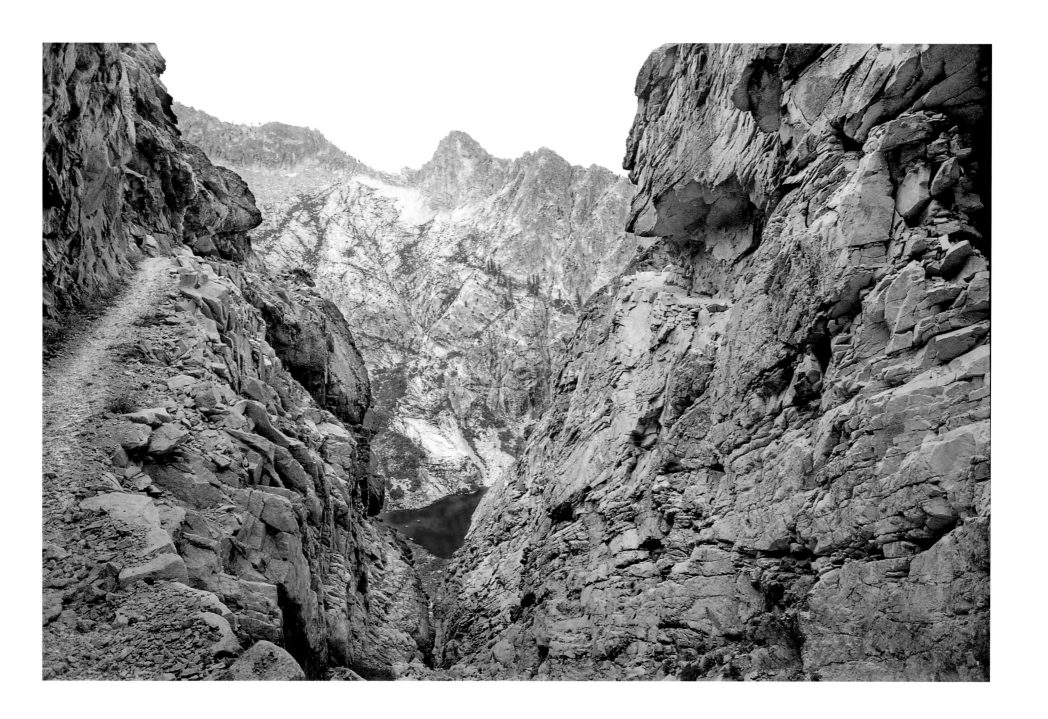

Precipice Lake

In remote Sequoia National Park near Kaweah Gap, the striped and incised cliff on Eagle Scout Peak (12,040 ft.) on the far side of Precipice Lake (10,380 ft.) has become known as "Ansel Adam's Wall" after his well known close-up abstraction of the central portion of the cliff titled "Frozen Lake and Cliffs."

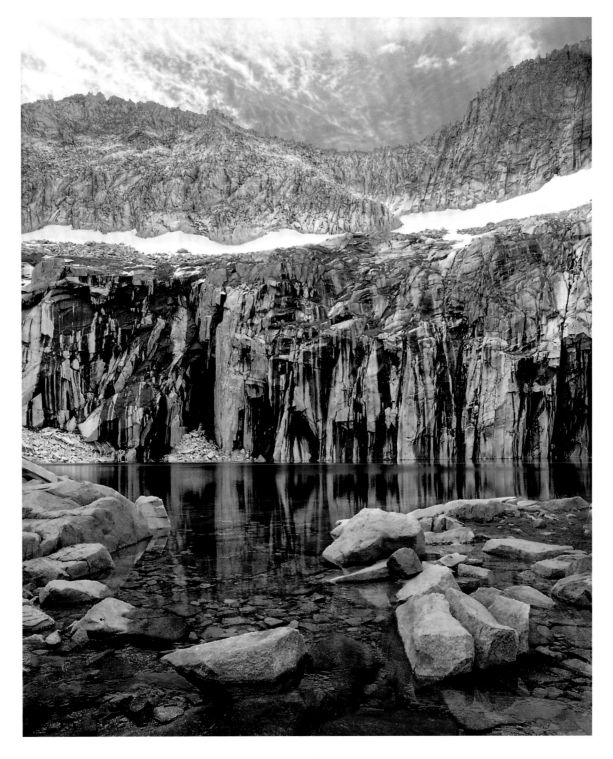

Lawson Peak

Immediately south of the junction of the Great Western Divide and the Kaweah Ridge are the rust-splashed ridges of Nine Lakes Basin.

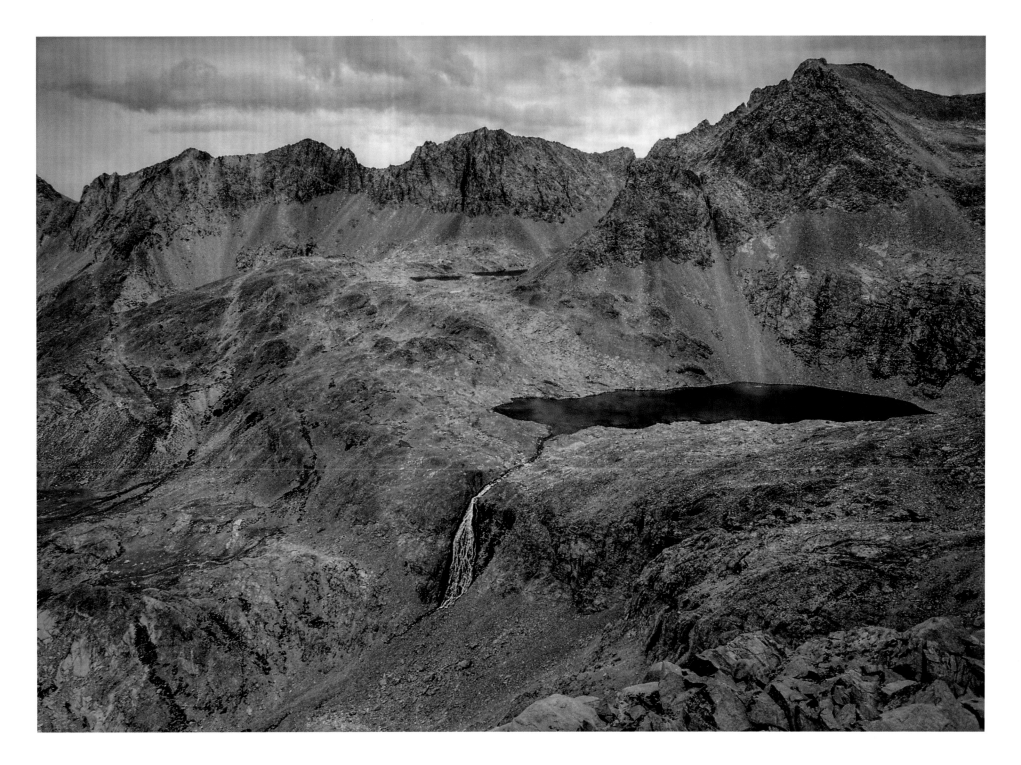

Mt. Stewart
Red-shouldered Mt. Stewart (12,205 ft.), part of the
Great Western Divide, overlooks rocky Nine Lakes Basin.

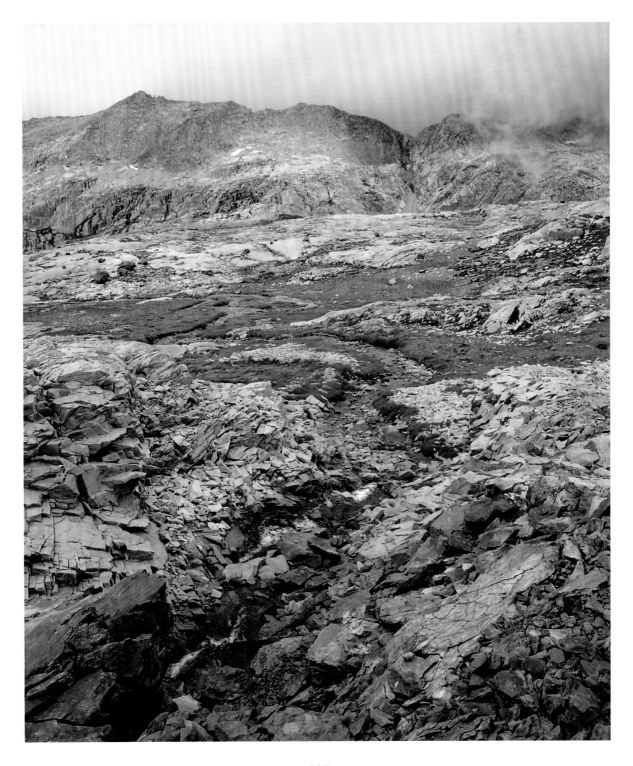

Big Arroyo

On the far side of Big Arroyo, Lippincott Mountain
(center, 12,265 ft.), distant Mt. Eisen (12,160 ft.), and many
unnamed peaks forming the southern end of the Great
Western Divide catch the morning sun.

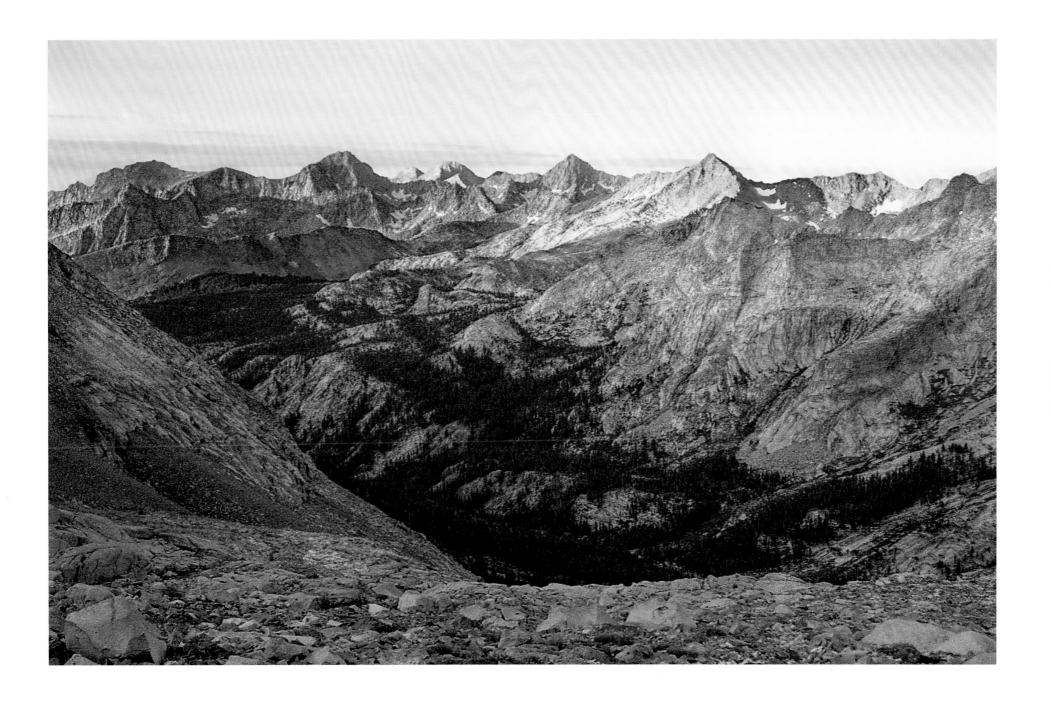

Pyramidal Pinnacle

The highest of the lakes (11,682 ft.) in Nine Lakes Basin sits at the foot of the imposing north face of Black Kaweah (right,13,765 ft.) and Pyramidal Pinnacle (center, 13,665 ft.). Dark clouds loomed all around, but opened in the west, allowing the setting sun to illuminate the cirque.

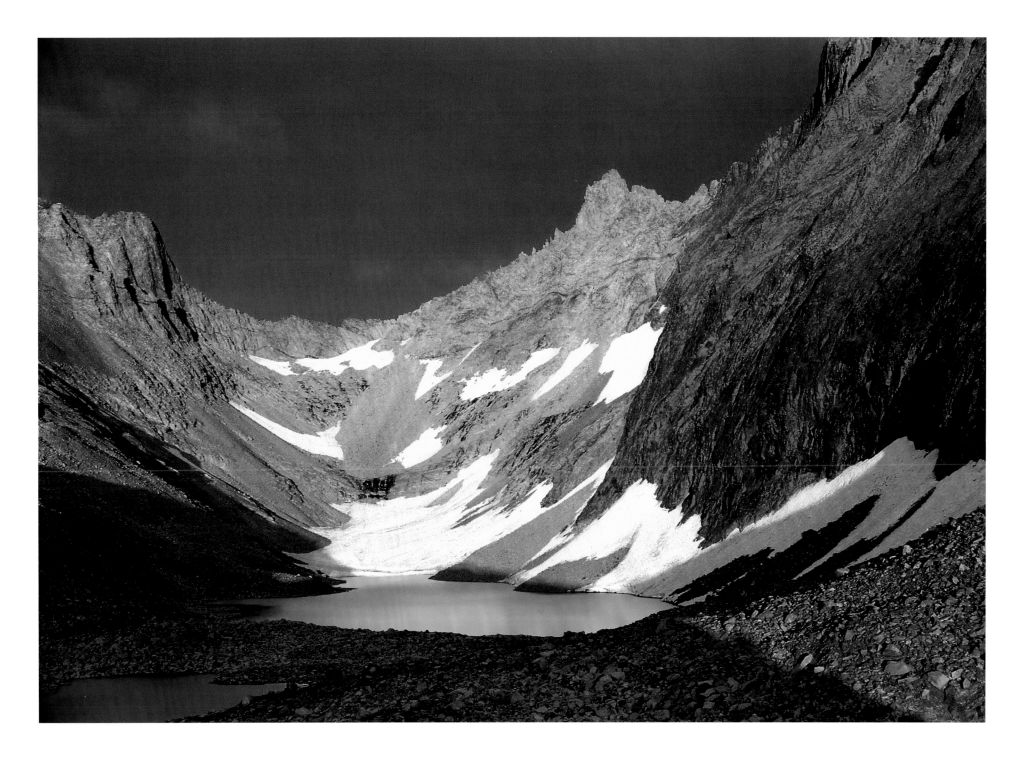

Foxtail Pines, Tyndall Plateau

Most of the world's Foxtail Pines occur in scattered groves at treeline in Sequoia National Park. There is also a smaller stand in the Klamath Mountains. These stands on the flats of lower Tyndall Creek and Bighorn Plateau are some of the largest. It is six miles, as the raven flies, southeast to Mt. Whitney (center 14,494 ft.). Snow, or perhaps hail, dusts Mt. Bernard (left, 13,990 ft.).

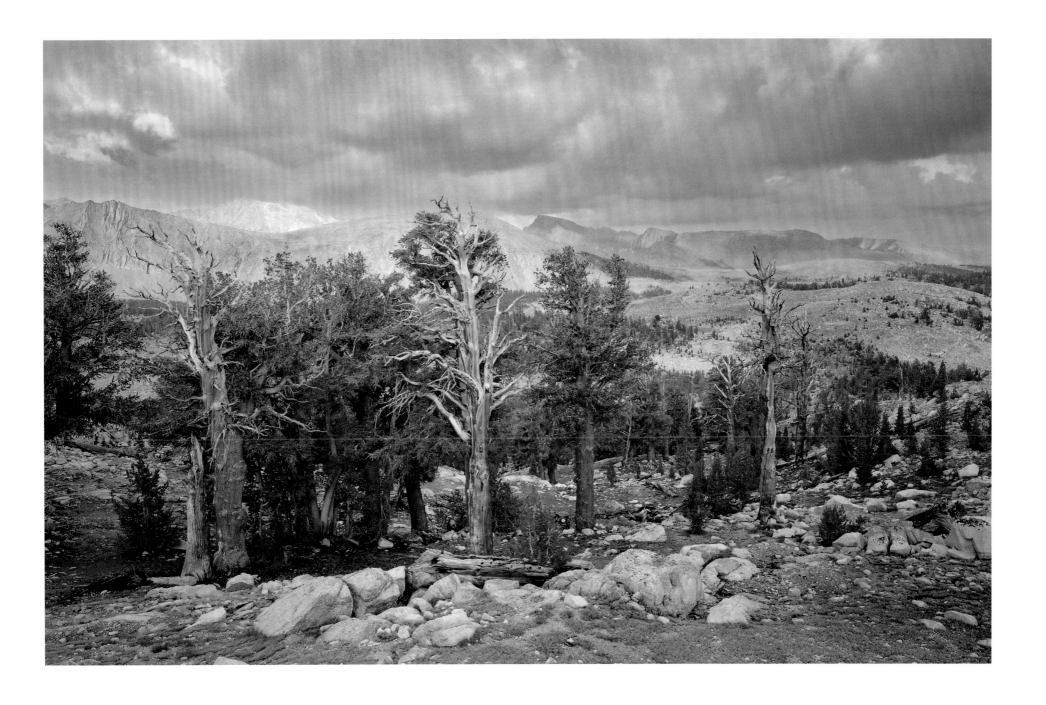

Milestone Basin

"Exhausting and exhilarating."

–Fred Weyman

My most difficult day of Sierra backpacking was to reach
this spot from the Shepherd Pass Trailhead. Overlooking
two unnamed ponds on the edge of Tyndall Plateau,
dawn begins on the Great Western Divide. Milestone
Mountain (13,641 ft.), Midway Mountain (13,666 ft.),
and Table Mountain (13,630 ft.) are on the far side
of the canyon of the upper Kern River.

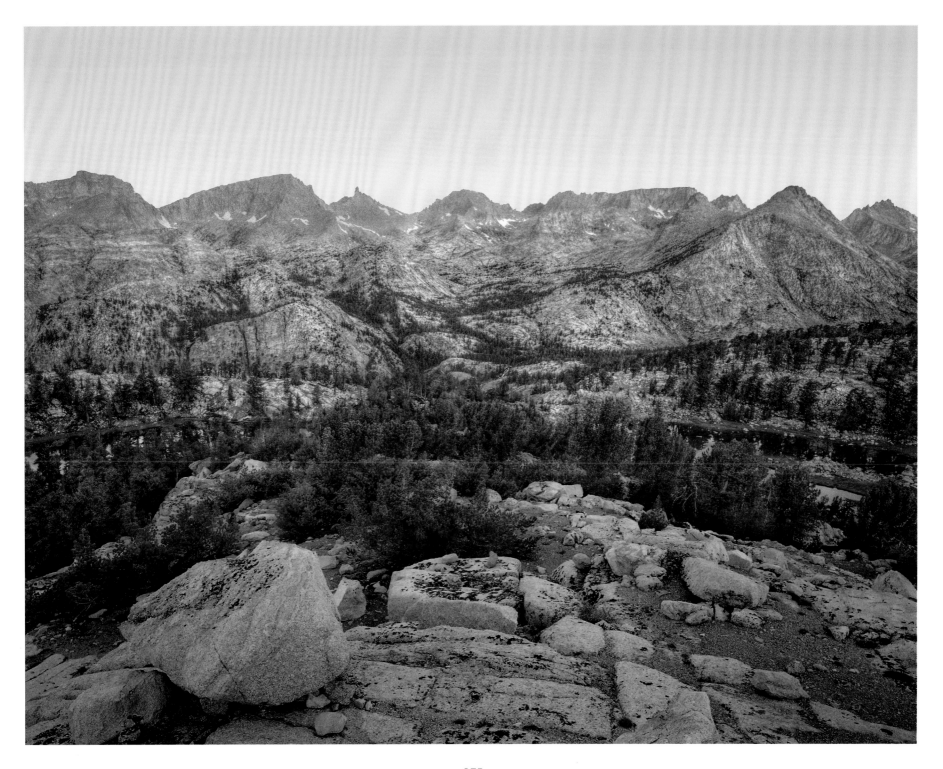

Kern River Headwaters

Unnamed lakes and white-barked pines are scattered across the broad and roughly smooth basin of the upper Kern River. The granite backdrop contains Table Mountain (left), Thunder Mountain (left center, 13,588 ft.), and Mt. Jordan (right, 13,344 ft.).

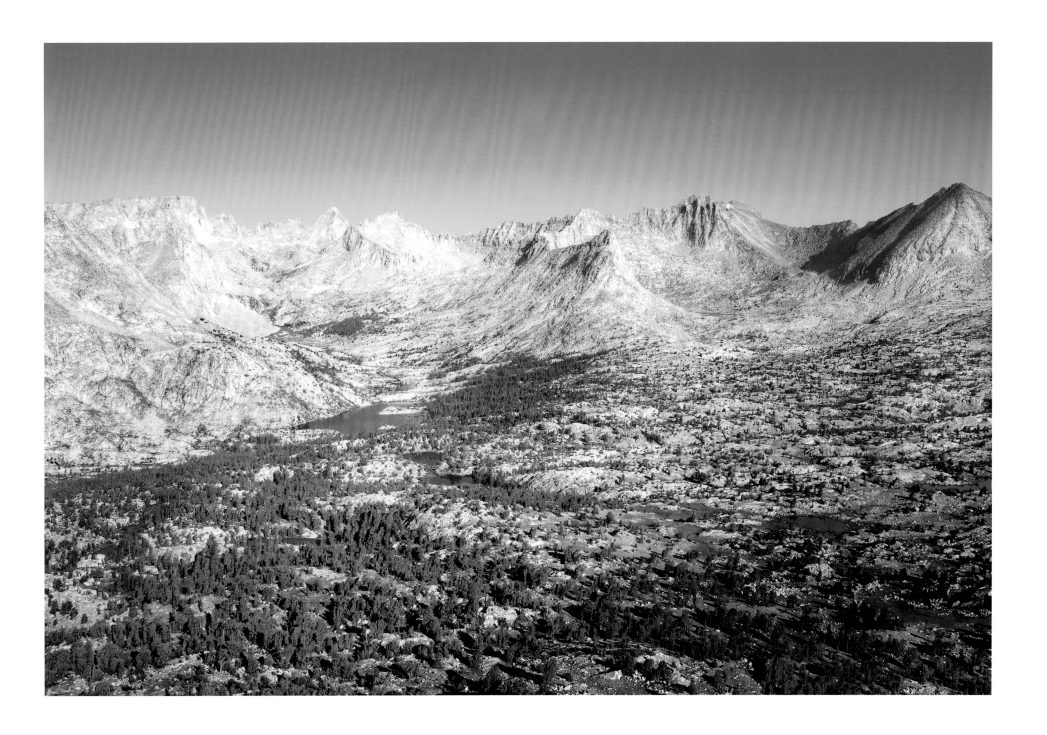

Snag on Tyndall Plateau
Tawny Point is immediately right of the snag next
to shadowed Mt. Whitney, with its top in the clouds.

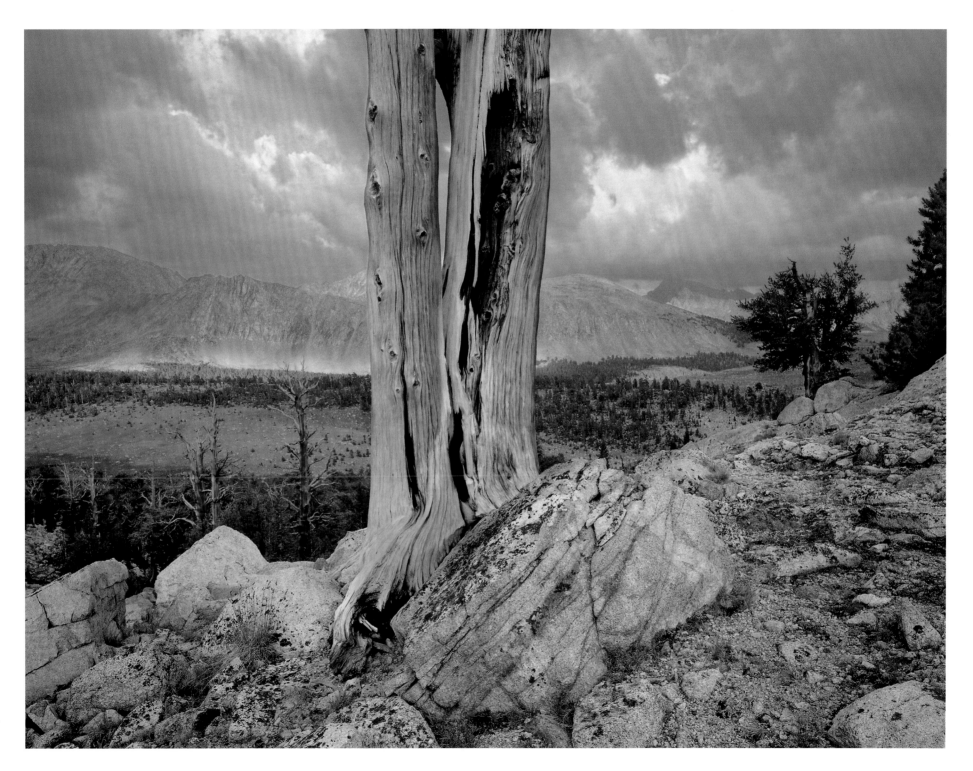

Tyndall Frog Ponds

Tyndall Creek, Tyndall Plateau, Tyndall Frog Ponds, and
Mt. Tyndall are named after the nineteenth century British
scientist John Tyndall, who first described why the sky is
blue. The Kaweah ridge is behind the ponds.

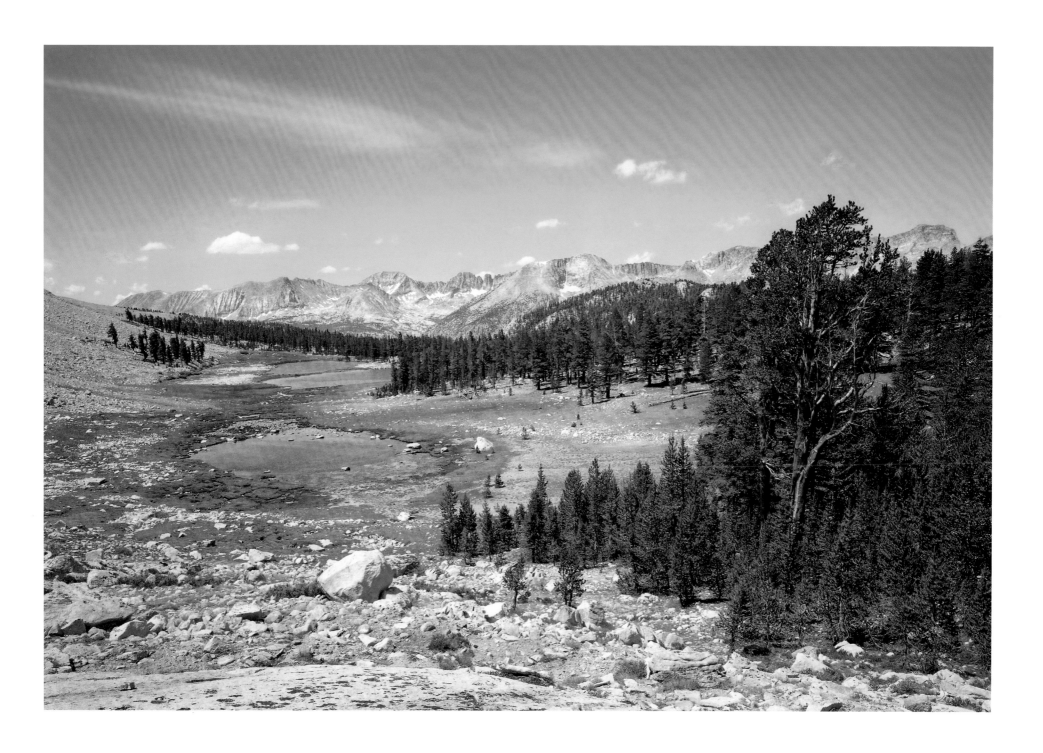

Bighorn Plateau

"These fleeting sky mountains are as substantial and significant as the more lasting upheavals of granite beneath them." –John Muir

Bighorn Plateau is one of the most scenic and remote spots in the Sierra. The jagged peaks contrast with the gentle curves of Bighorn Plateau and its stark circular lake. Nowhere else in the range are you more surrounded by large peaks: the Kaweah range to the southwest, the Great Western Divide to the west, the Kings/Kern Divide to the north, and the main spine of the highest Sierra, including Mt. Whitney, to the east.

 I was caught off guard by the heavy but brief hailstorm from this cloud, but once it had passed it created this beautiful scene. It also taught me that it is possible to set up my tent and fly while sheltered inside it.

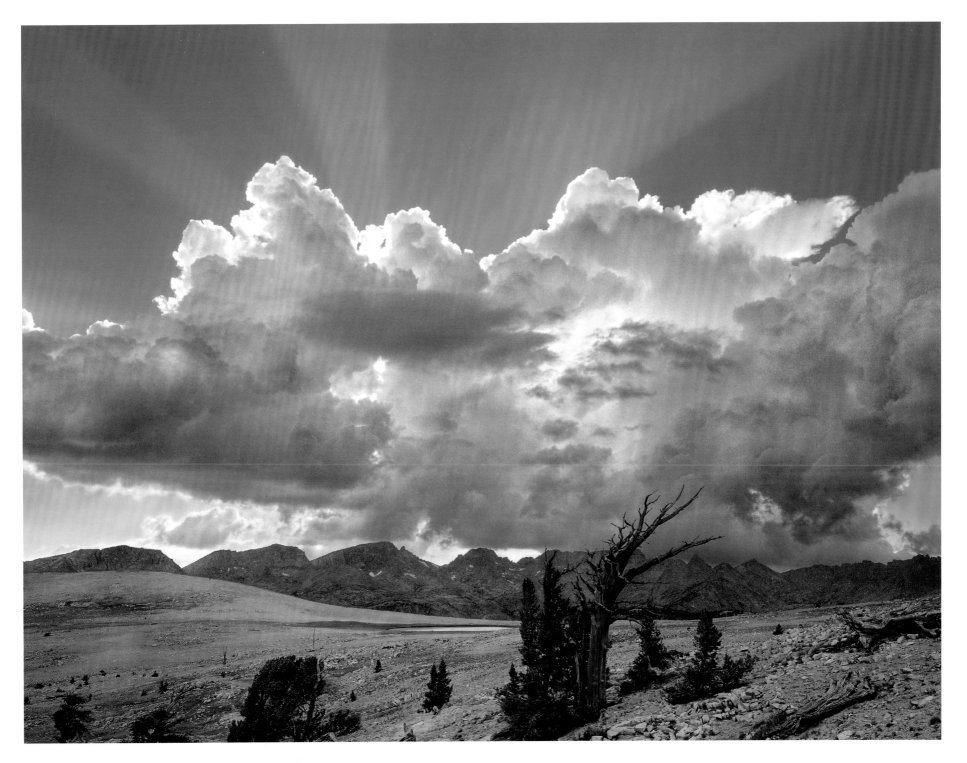

Foxtail Pines, Bighorn Plateau
After the hail stopped broken clouds and scattered late afternoon showers created this scene in front of Mt. Whitney.

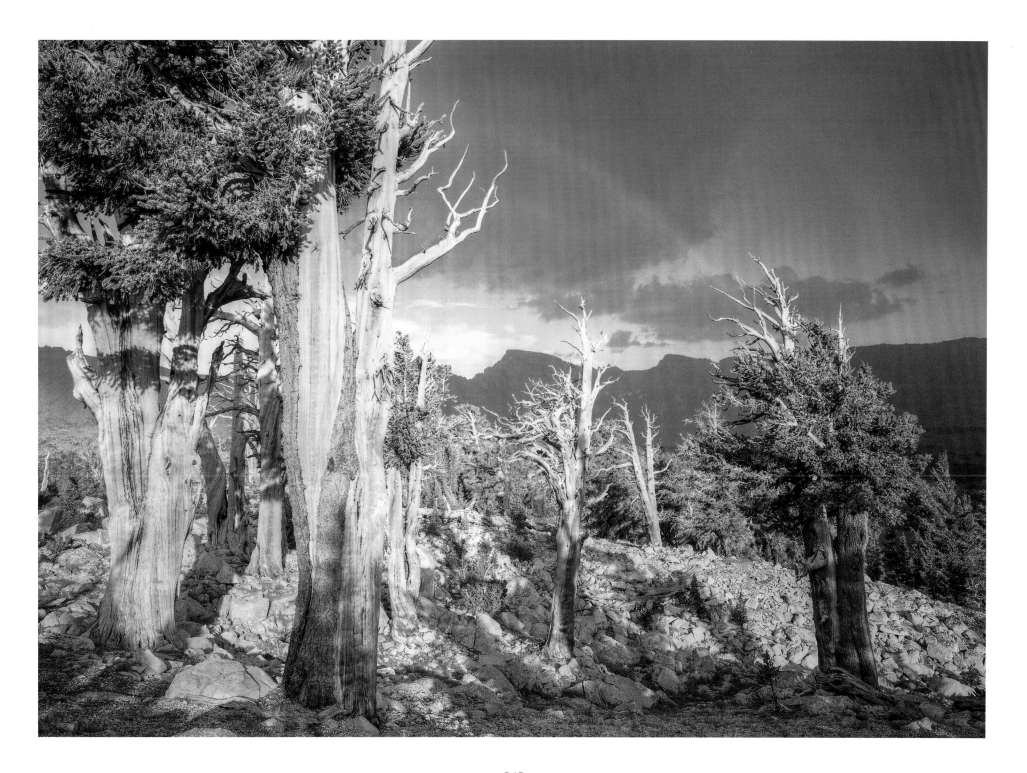

Bighorn Plateau

Perhaps the most renowned unnamed lake in the Sierra is this sublime pond perched in a smooth saddle at 11,400 ft. on Bighorn Plateau. The Kaweah Range forms the distant horizon of this view from the lower slope of Tawny Point.

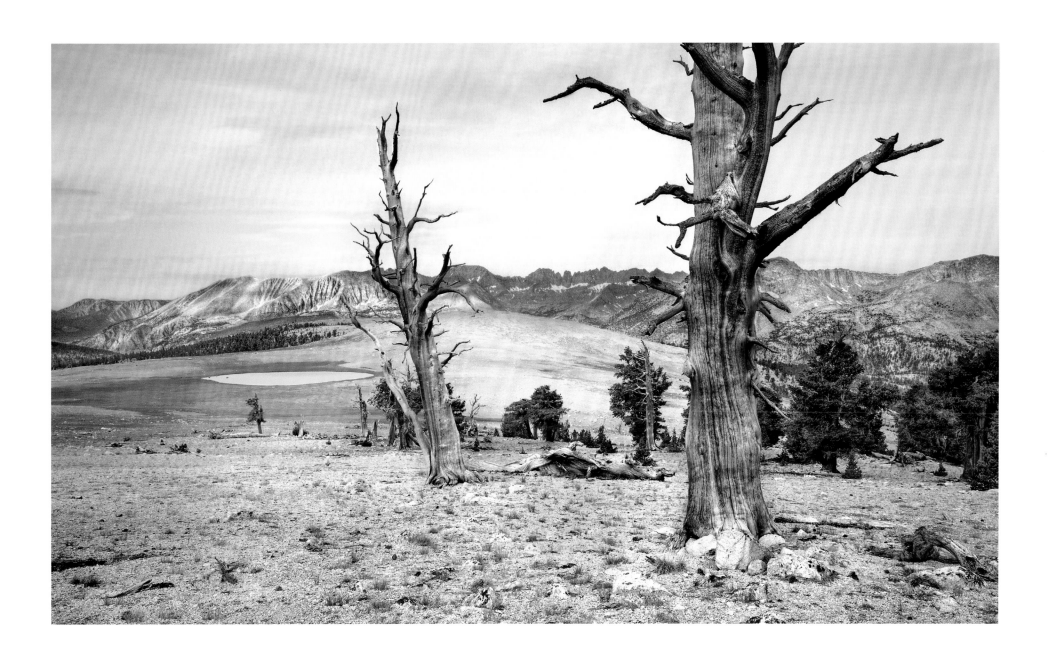

Wales Lake

"In all my lonely journeys among
the most distant and difficult
pathless passless mountains,
I never wander, am never lost.
Providence guides through every
danger and takes me to all the
truths I need to learn." –John Muir

Perhaps aided by providence, my long off-trail hike past
Wales Lake (11,700 ft.) up to Tulainyo Lake was not the
only time I used orienteering skills learned from my
brother Eric, a four-time US orienteering champion.
The high country's open visibility and surprising
interconnection of easily hikeable terrain makes
off-trail route finding an enjoyable experience. I was
fortunate to make it back to the distant forest before an
early afternoon hailstorm forced me into a tight grove.

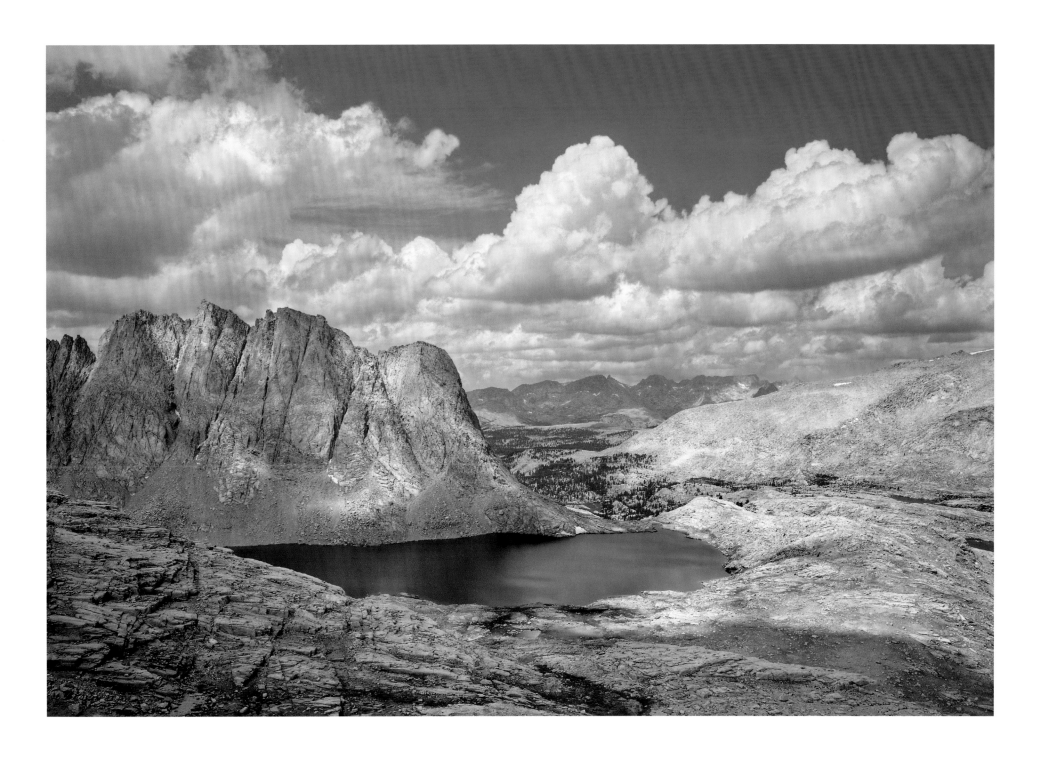

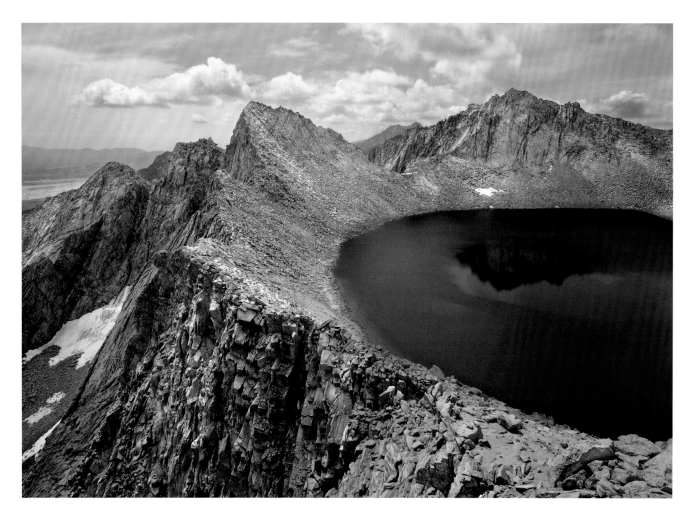

Tulainyo Lake

"This [Tulainyo Lake] is unique in its location upon the very crest of the range, with no apparent outlet. It is almost circular in form, about half a mile in diameter, and possesses an air of remoteness and isolation not often encountered. Seldom has human foot trodden its almost vegetation-less shores from which rise abruptly several granite peaks, the highest of which is Mount Russell." –Norman Clyde, 1927

Depending on the definition of a lake, Tulainyo Lake (12,802 ft.) is considered by many to be the highest lake in North America. It is perched just a few feet below the Sierra crest and 9,200 feet above hazy Owens Valley (left). The Cleaver (center 13,383 ft.) and Mt. Carillon (right 13,552 ft.) are the highest peaks.

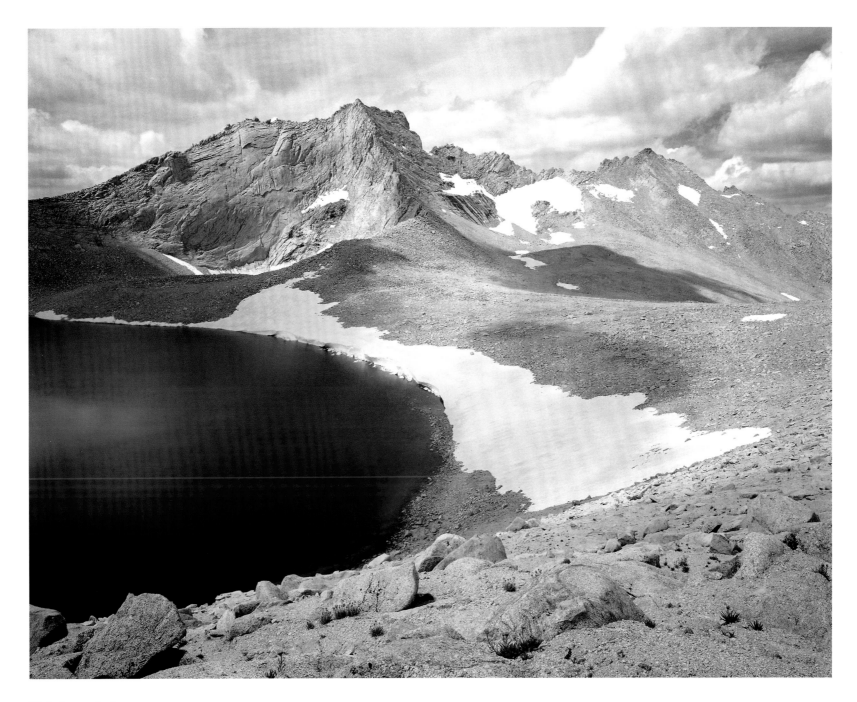

Tulainyo Lake

Tulainyo Lake sits at the base of Mt. Russell's (14,086 ft.) north face. Although entirely in Tulare County and just a few feet from Inyo County, the name comes from both. Once again, the hearty alpine sunflower livened up a plain rocky foreground.

View From Mt. Whitney
"Getting to the top is optional.
Getting down is mandatory."
–Ed Viesturs

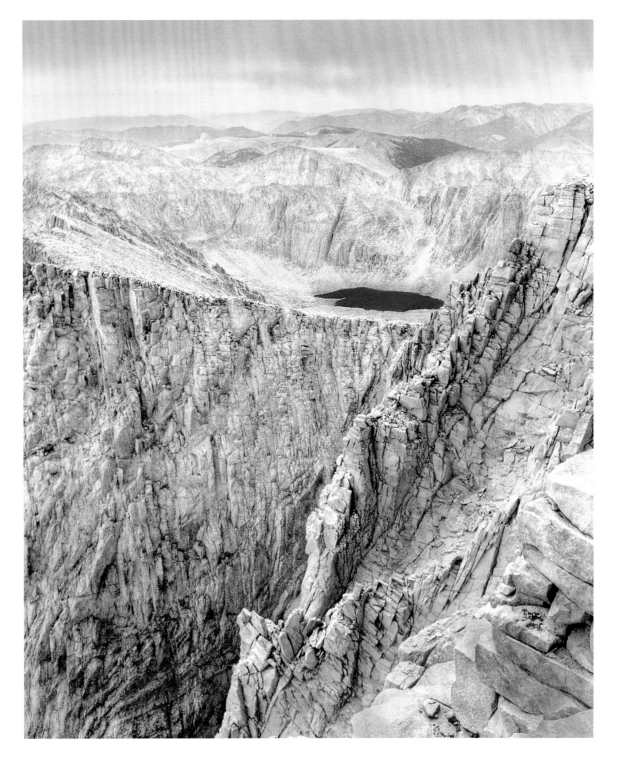

Mt. Muir and Mt. Whitney

"Climb the mountains and get their good tidings. Nature's peace will flow into you as sunshine flows into trees. The winds will blow their own freshness into you, and the storms their energy, while cares will drop off like autumn leaves." –John Muir

At the top of the Sierra is the ridge from Mt. Muir (left, 14,015 ft.) to Mt. Whitney (14,494 ft.).

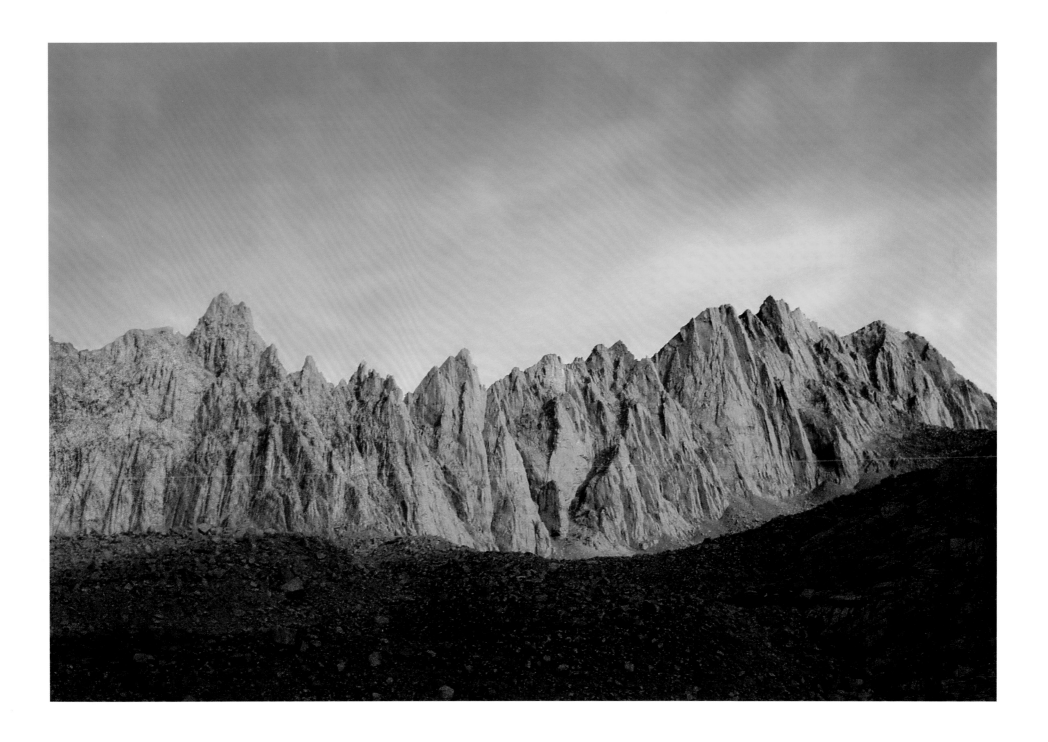

"Here ends my forever memorable High Sierra excursion. I gladly, gratefully, hopefully pray I may see it again." –John Muir

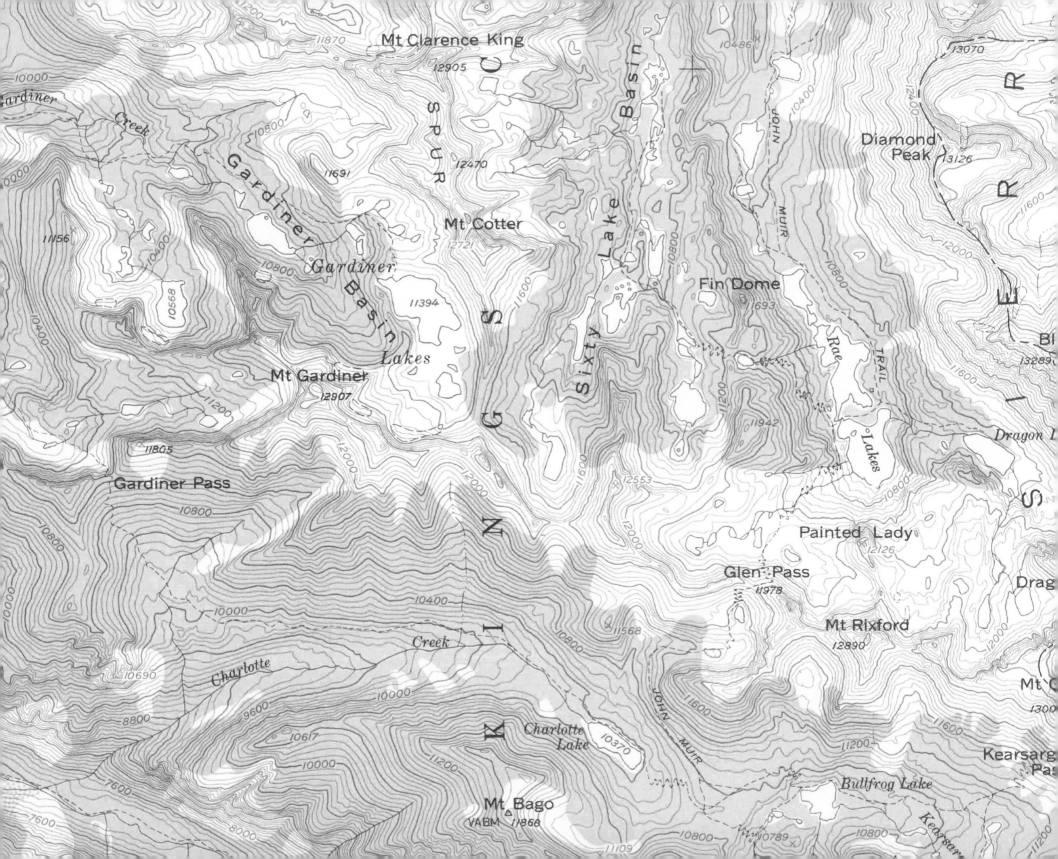